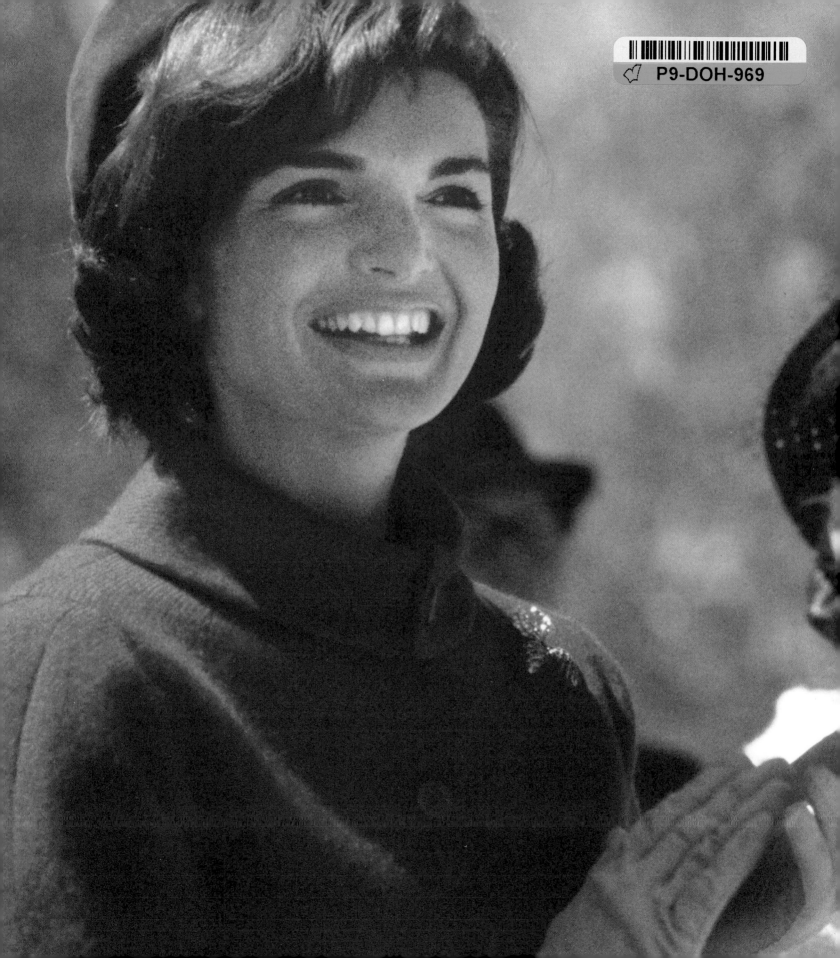

P9-DOH-969

CAPTURING CAMELOT

★ ★ ★

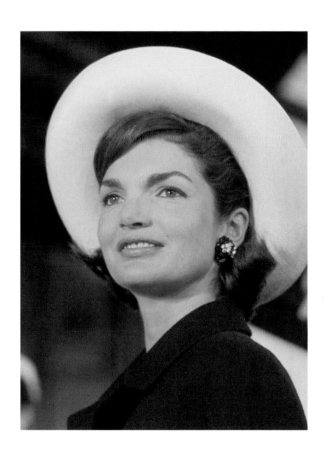

CAPTURING CAMELOT

Stanley Tretick's Iconic Images of the Kennedys

* * *

KITTY KELLEY

A THOMAS DUNNE BOOK • ST. MARTIN'S PRESS

Limited edition prints of all the photographs in *Capturing Camelot*
can be ordered at www.StanleyTretick.com.

THOMAS DUNNE BOOKS.
An imprint of St. Martin's Press.

Capturing Camelot. Copyright © 2012 by H. B. Productions, Inc.
Photographs copyright © 2012 to the Estate of Stanley Tretick LLC.
All rights reserved. Printed in China. For information,
address St. Martin's Press, 175 Fifth Avenue,
New York, N.Y. 10011.

Interior Design: Headcase Design
Production Manager: Adriana Coada
Production Editor: Eric C. Meyer
Art Director: Rob Grom

www.thomasdunnebooks.com
www.stmartins.com

ISBN 978-0-312-64342-3 (hardcover)
ISBN 978-1-250-01883-0 (e-book)

First Edition: November 2012

10 9 8 7 6 5 4 3 2 1

In memory of my husband,

JONATHAN E. ZUCKER, M.D.

(1941–2011)

who made dreams come true.

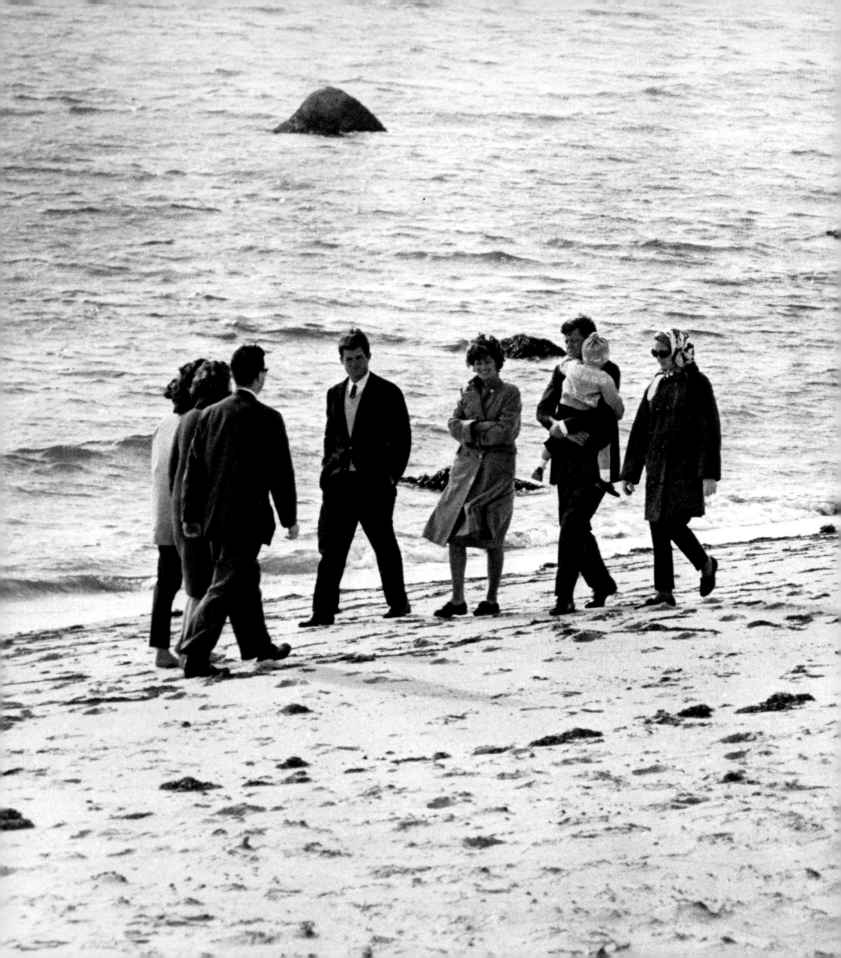

CAPTURING CAMELOT

★ ★ ★

LOOK
NOW MORE THAN 7,500,000 CIRCULATION
25 CENTS · NOVEMBER 17, 1964

THE JFK MEMORIAL ISSUE

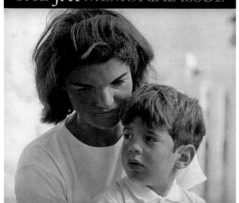

LOOK

A doctor talks about
WOMEN
AND
PREGNANCY

SONNY LISTON
The fighter
nobody likes

NOW MORE THAN 7 MILLION CIRCULATION

25¢ JUNE 5, 1962

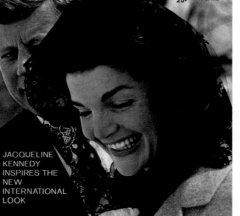

JACQUELINE
KENNEDY
INSPIRES THE
NEW
INTERNATIONAL
LOOK

LOOK

BIRMINGHAM:
I SAW
A CITY DIE

SUNDAY
FOOTBALL
MADNESS

25 CENTS · DECEMBER 3, 1963 NOW MORE THAN 7,500,000 CIRCULATION

THE PRESIDENT AND HIS SON: an exclusive picture story

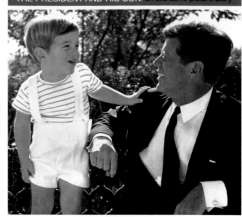

LOOK

WHAT
PRESIDENT
JOHNSON
FACES
IN
VIETNAM

NOW MORE THAN 7,400,000 CIRCULATION

25 CENTS · JANUARY 28, 1964

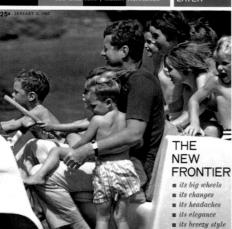

VALIANT
IS
THE WORD
FOR
JACQUELINE

LOOK

THE WORLD
WE FACE
BY JOHN GUNTHER

KENNEDY
ONE YEAR
LATER

NOW MORE THAN 7 MILLION CIRCULATION

25¢ JANUARY 2, 1962

THE
NEW
FRONTIER

■ its big wheels
■ its changes
■ its headaches
■ its elegance
■ its breezy style

LOOK
50 CENTS · NOVEMBER 26, 1968

ROSE
KENNEDY

The mother
of Jack, Bob,
and Ted
talks about
"the agony
and the ecstasy"
of her life

LOOK
25 CENTS · OCTOBER 5, 1965

ZONING
The battle that threatens
your home and your pocketbook

ISRAEL
Its treasures and its prejudice

THE KENNEDY CHILDREN
Six exclusive color pages
of Caroline and JFK JR

LOOK
50 CENTS · JUNE 25, 1968

ROSEMARY'S BABY
From best seller to movie chiller

COMPUTER DATA BANKS
Do they know too much about you?

ETHEL'S KENNEDYS
How she manages them

LIFE

MESSAGE FROM RB-47 PRISONERS
'A CHRISTMAS CAROL'
WARM, GAY PAINTINGS BY RONALD SEARLE

BASEBALL'S DISGRACEFUL MESS

THE KENNEDYS
AND THEIR SON
AT CHRISTENING

19¢

DECEMBER 19, 1960

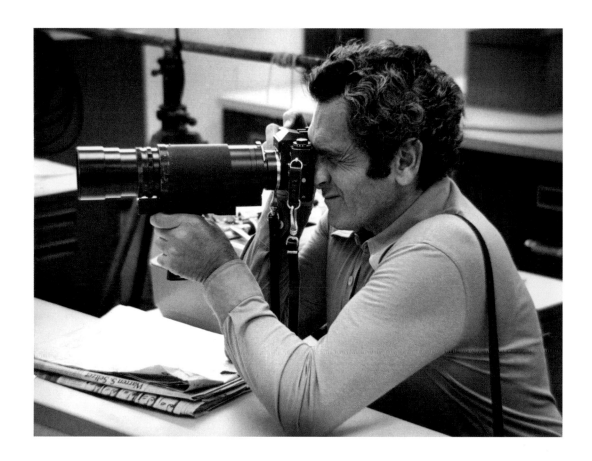

I MET STANLEY TRETICK IN 1981, AND UNTIL THE DAY HE DIED, HE WAS AN IRREPLACE-ABLE PART OF MY LIFE. WHICH IS NOT TO SAY THAT I KNEW EVERYTHING THERE WAS TO KNOW ABOUT STANLEY.

I remember once asking what he kept in the Marine Corps locker that served as a coffee table in his study. He winked and said, "nude pictures." I took him at his word, but when he died in 1999, I inherited that battered old trunk and found instead a treasure of keepsakes from his days with John F. Kennedy. Stanley had saved the PT boat tie

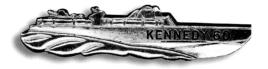

clasp that JFK had given him and the Lucite box with the gold airplane that was Kennedy's gift to those who had flown with him on the *Caroline* during the 1960 presidential campaign. There were signed photographs from the President and his wife, plus all their handwritten notes and letters and the telegram of congratulations they had sent to his wedding reception. In addition to the Kennedy buttons and bumper stickers, campaign schedules and press credentials, I found a sheaf of personal memos he had typed during those years, illustrating how he gained such personal access for his photographs.

One memo was "Notes on JFK," another was "Impressions of JFK," and the most amusing was a nine-page memo entitled "Two Weeks of Agony with Jacqueline Kennedy in England," about his frustrations in trying to accommodate the former First Lady during her trip to dedicate the JFK Memorial at Runnymede.

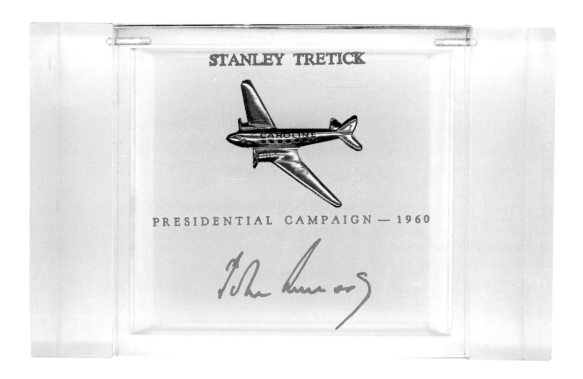

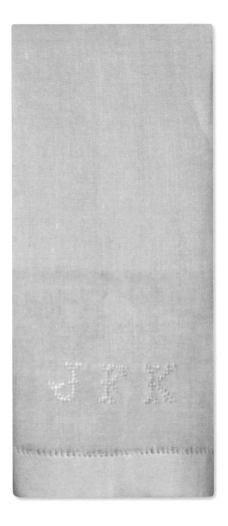

Perhaps the most intriguing item in the trunk was a yellow linen guest towel cross-stitched in sky blue with JFK's initials that might have hung in a powder room. None of Stanley's memos mentions the towel or how he came by it, nor is it referred to in any of the letters he saved. I began to wonder if maybe he had pinched it on one of his visits to the Kennedy estate in Hyannis Port. Perhaps Jacqueline Kennedy had given it to him? Either is possible, I suppose, but it seems unlikely the former First Lady would bestow such a delicate personal item on a photographer—although after the President's death she gave her secretary, Mary Barelli Gallagher, one of JFK's white shirts and sent one of his ties to Cecil Stoughton, the White House photographer, so it is conceivable that she may have given Stanley the monogrammed guest towel. I found a handwritten note in the trunk that said simply: "Stanley—Thank you. Love, Jackie," which could have accompanied the towel; then again, that note could have been for one of the many photographs he'd given her over the years.

(opposite top) The PT boat pin was distributed by the Kennedy campaign as a reminder of JFK's military service aboard *PT-109* during World War II, when his patrol torpedo boat was rammed by a Japanese destroyer. Lieutenant Kennedy saved one of his men, towing him ashore with a life jacket strap clenched between his teeth. Six days later native islanders found them and went for help, delivering a message Kennedy had carved into a piece of coconut shell. The next day the crew was rescued. When he returned home, JFK was awarded the Navy and Marine Corps Medal for his leadership and courage. *(opposite bottom)* The Lucite box with a gold airplane engraved "Caroline" presented to those who traveled with the candidate during the 1960 campaign. This box says: "Stanley Tretick: Presidential Campaign—1960. John Kennedy."

OF ALL THE STORIES STANLEY told me I don't recall him ever mentioning the JFK towel, but I do remember him driving me through a ghetto corridor in Washington, D.C., and pointing to a building that looked abandoned to rats.

"See that towel?" he asked, indicating a broken window stuffed with a filthy terry-cloth rag. "That's where I lived." He shook his head with dismay. "That towel says it all."

It was hard to equate the man wearing a Cartier watch and driving a sleek BMW with ragged poverty, but by then Stanley had traveled a long way from grinding impoverishment. The son of an itinerant salesman and an emotionally unstable mother, he was born Aaron Stanley Tretick, the oldest of three children, on July 21, 1921. He was reared by his mother's parents—his grandfather was a rabbi who read him the Torah every day, while his pragmatic grandmother tried to steer him toward something her family had never known: financial security. After he graduated from high school, she pushed him to marry the jeweler's daughter.

"When I told my grandmother I wanted to be a photographer, she spat on the floor. 'Pa-tooey on pictures,' she said. 'Bernice has diamonds.'"

"The towel" soon became a kind of shorthand between us, a way to define someone's street cred. One day Stanley ran into Ben Bradlee, then executive editor of *The Washington Post*, who mentioned in passing that one of his star editors was "a Yalie." Months later *The Post* was forced to return a Pulitzer, because its prize-winning story edited by that Yalie had been fabricated. Stanley, who prized hardscrabble hustle, did not genuflect to the Ivy League. "Bradlee should've hired himself a towelie," he said, "not a Yalie."

As I began assembling this book from Stanley's photographs and letters and memos, plus the oral history he gave to the John F. Kennedy Library, I came to see "the towel" as a metaphor for his life—the emblem of what had formed him. Born poor, he became prosperous through hard work and immense talent, which earned him many professional prizes as well as the respect and affection of his peers. Maybe "the towel" was his Rosebud.

763-61

Congratulations
by WESTERN UNION

MSA135 MS-NA340
WSA16 RX CGN GOVT PD
 THE WHITE HOUSE WUX WASHINGTON DC MAR 30 1963 106P EST

MR AND MRS STANLEY TRETICK, REPORT DELIVERY, DLR 400 PM DONT PHONE
 CARE PETER MAAS 5 GRAMERCY PARK

CONGRATULATIONS AND BEST WISHES. MAY ALL YOUR DAYS BE AS HAPPY AS THIS

ONE
 PRESIDENT AND MRS JOHN F KENNEDY.

STANLEY WAS MY BEST FRIEND: a street-smart mentor, protective brother, stalwart confidant; a pal without parallel. He was loyal, trustworthy, and funny. After watching the movie *Paper Moon* together, he was Mose; I was Addie. The scamp in me loved the rascal in him.

This is not to say we didn't scrap. There were days I'd have gladly done time for manslaughter, like when he made a special delivery to Jonathan Yardley, the esteemed book critic of *The Washington Post*. Mr. Yardley had panned my biography of Elizabeth Taylor, and Stanley took offense. So in what he considered sweet service to friendship, he stuffed a box ("It was a gold Gucci box," he told me later) with the severed heads of dead fish. Like a capo in *The Godfather*, he enclosed a card that said "From the Friends of Kitty Kelley."

> HE WAS LOYAL, TRUSTWORTHY, *and* FUNNY.

Kitty Kelley and Stanley Tretick in the East Room of the White House, 1982.

The Washington Post STYLE

Monday, November 2, 1981 ...B

The Arts/Television/Leisure D1

By Jonathan Yardley

For my 42nd birthday, which took place last week, I received a sweater, a pen knife, a picture frame, a casserole dish, a suede hat — and a large plastic bag filled with the severed heads of dead fish. This last,

Prejudices

which was delivered to Book World's offices at The Washington Post, came in a gold Gucci box (a nice touch, that) and was accompanied by a card reading: "From the Friends of Kitty Kelley."

Happy birthday, indeed! Obviously this generous and welcome gift was sent in gratitude for my review in The Post of Kelley's new book, "Elizabeth

Taylor: The Last Star," which I had characterized as "a bore" and "a tired, ordinary star bio"; to make the connection absolutely clear, on the other side of the card accompanying the fish heads was a photograph of the luscious (it was taken in 1961) Taylor that had been clumsily doctored so that it appeared she was giving me the finger. The friends of Kitty Kelley, like the friends of Eddie Coyle, clearly were out for blood.

So it is with great sorrow that I must tell them — by means of this column, since for some reason they declined to give their names — that none has been shed. Sticks and stones may break my bones, but fish will never hurt me. To be sure, in nearly two decades of writing book reviews and

otherwise expressing my opinions in print, I had not previously been assaulted by a sack of fish heads; but I have had my fair share of slings and arrows from outraged and aggrieved authors, and/or their "friends," and I have lived to tell the tale.

My first exposure to severe authorial indignation occurred many years ago when I reviewed the latest novel by a minor writer whose previous books I had liked. I did not like this one. My review appeared in a national publication, a copy of which swiftly found its way to the author in California. He decided, at midnight, to telephone me and vent his fury; this he did, refusing to identify himself but leaving absolutely no doubt as to who he was. But

inasmuch as his midnight was my 3 a.m., and inasmuch as I associate 3 a.m. calls with family illnesses and deaths, I was not deeply grateful to him, for moving with such alacrity to inform me with such exactitude as to the nature and extent of his feelings.

But he was not through. He began sending me unsigned letters, in envelopes on which he had carefully written a return address. Why? So that when I replied, and reasonably politely, he could allow himself the pleasure of scrawling "REFUSED" across the envelope and having the post office return it to me. (The guy's wit knew no end; he addressed one letter to "Morton Yardley.") These pseudo-anonymous letters were cast in

See PREJUDICES, D2, Col. 1

Fishy Revenge
The Perils of the Critic's Pan

Illustration by Joe Scopin

Night of the Frenzies

The next day's *Post* featured a front-page story in the Style section entitled "Fishy Revenge: The Perils of the Critic's Pan," in which Yardley reported that on the back of the card accompanying his smelly package was a luscious photograph of Liz Taylor that "had been clumsily doctored so that it appeared she was giving me the finger."

I didn't speak to Stanley for days.

Then there was my interview with Frank Sinatra, Jr. Stanley accompanied me to take some photographs for the book I was writing on Sinatra's father, *His Way: The Unauthorized Biography of Frank Sinatra*. The first forty-five minutes of the interview went beautifully as Stanley, a consummate professional, walked around the room unobtrusively, quietly taking pictures. Sinatra, Jr., talked about what it was like to be the son of a famous singer, about his father's famous friends, and about his father's Las Vegas crime connections. Then he lowered his voice. "Hon, I'll tell you something... I know what happened to Jimmy Hoffa."

With my tape recorder running, I held my breath and waited for the answer to one of the biggest unsolved mysteries of the twentieth century. The seconds dragged like centuries as Frank Sinatra, Jr., leaned in close to whisper his secret. Just as he opened his mouth, Stanley slammed into a chair and yelled, "Well, out with it, man. What the hell happened to Hoffa?"

Sinatra reared back as if he'd been shot. "I…I…I can't…I can't talk to you.…I've said too much. I can't… I can't.…" He jumped up and ran into the hotel bedroom, locking the door. His publicist roared that we had to leave now.

I begged to stay and finish the interview, but the publicist said we were done. Stanley picked up his camera bags and shuffled out. I kept pleading as the publicist pushed us out the door.

I turned on Stanley like a tiger with a tomahawk in her tail. "How could you?" I screamed. "How could you ruin that interview? Are you insane? Have you snapped your cap?"

"Aw, hell. He didn't know what happened to Jimmy Hoffa."

I became unhinged. "Since when are photographers clairvoyant? And did it ever occur to you that I might care to hear what the son of a man connected to organized crime has to say about Jimmy Hoffa? And furthermore…"

Stanley redeemed himself later because upon publication, just as he had predicted, Frank Sinatra, Jr., denied that he had given me an interview. Stanley produced the photo that proved otherwise.

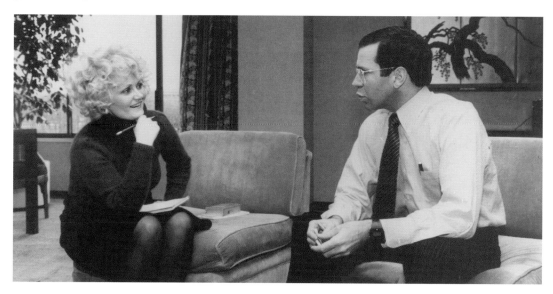

Frank Sinatra, Jr., being interviewed by Kitty Kelley on January 15, 1983, in his suite at the Hyatt Regency Washington on Capitol Hill in Washington, D.C., for her book *His Way: The Unauthorized Biography of Frank Sinatra.*

WE FIRST MET WHEN I WAS researching the biography of *Elizabeth Taylor: The Last Star*, and Michael Korda, my editor at Simon & Schuster, mentioned that Stanley had once accompanied Robert Kennedy and his wife, Ethel, to dinner in New York City with Taylor and her husband, Richard Burton, then starring as Hamlet on Broadway.

I once called Stanley to ask about that evening, but he said he didn't remember much. "Bobby was great as always and Ethel…well…Ethel was Ethel. Taylor was gorgeous and Burton drank a lot…."

Stanley said he'd see if he had notes from the evening and bring them to me in George-town, if I'd pour him a drink. I agreed. When I answered the doorbell, he was examining the front porch.

"This used to be Justice Brennan's house," he said.

"It still is," I said, feeling blessed to live in the home once occupied by the Supreme Court Justice who wrote many of the landmark opinions of the Warren Court.

THE MAN KNEW HOW *to* COAX A SMILE.

Stanley was wearing blue jeans and a navy blue turtleneck when he arrived, and, coincidentally, so was I. "Looks like we got dressed in the same closet," he said, "only you look better." The man knew how to coax a smile. He was sixty then, but claimed to be fifty-five. He had traveled the world working for UPI, *Look*, and *People* and was established as a preeminent photojournalist.

Our interview lasted for hours as we talked about Washington politicians and Hollywood movie stars, two subjects he had mastered, having covered every President from Harry S. Truman (1945) through George H. W. Bush (1991). Stanley said if he ever wrote a book he'd title it *20 Steps Backwards*, because that's how he spent the early part of his life as a wire service photographer, running backward to snap his subject. "In those days we were always hollering, 'One more, Mr. President. One more.'"

In addition to covering politics, Stanley worked as a special stills photographer on more than thirty movies, including *All the President's Men*, *Reds*, *The Candidate*, and *The Electric Horseman*. While he enjoyed Hollywood's lavish budgets and working with stars like Robert Redford, Dustin Hoffman, Warren Beatty, and Jane Fonda, he preferred politics and became best known for his images of John F. Kennedy's campaign and presidency.

Stanley Tretick's press credentials from the 1960 Kennedy for President campaign. As a photographer for UPI, Tretick logged more miles with the candidate than any other member of the working press. He later went to *Look*, the premier picture magazine of the 1960s, to cover Kennedy and his family in the White House.

WORKING FOR UNITED PRESS

International, one of two wire services at the time, Stanley traveled with Kennedy throughout the 1960 presidential campaign, logging more hours with the candidate than any other photographer. In those days only two photographers, one from each wire service, traveled on the campaign. Local photographers joined at every stop, but the wire service photographers were the mainstay. The Associated Press rotated its men, but UPI kept Stanley on for the duration.

(opposite) "Aboard Kennedy Campaign Train in California, September 8, 1960" read the *New York Times* headline. This photograph shows the candidate on his first whistle stop, copying the popular campaign mode of President Truman in 1948. Kennedy traveled the state, bashing Republicans for opposing "every single progressive measure which has been designed to improve human welfare and reduce human misery."

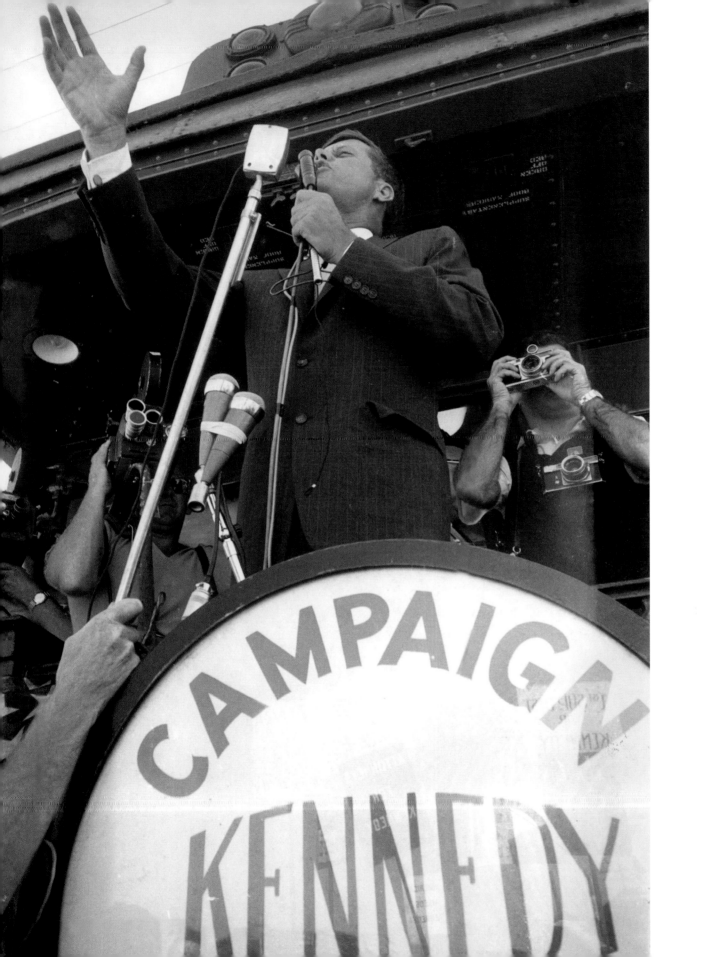

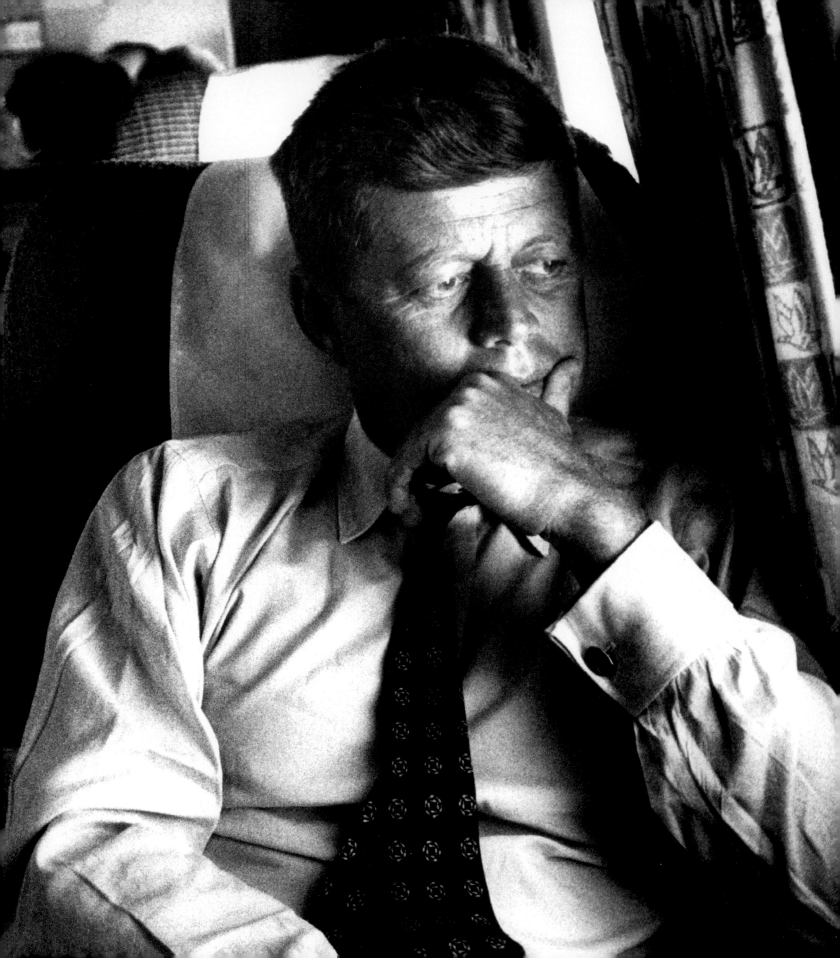

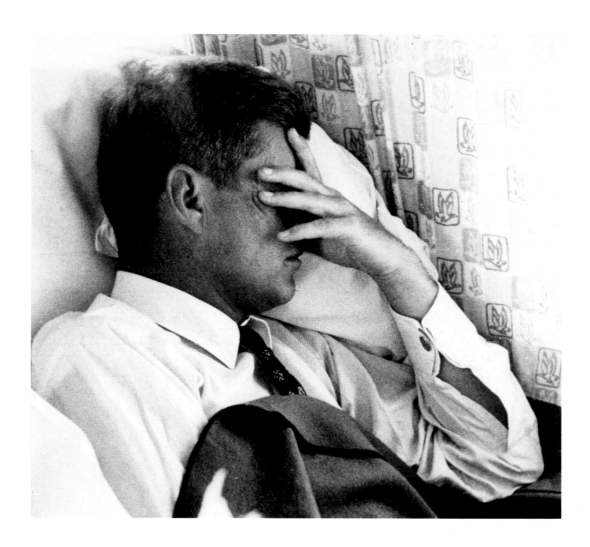

(opposite) "You don't know the exhaustion of the primaries," said Mrs. John F. Kennedy, recalling her husband's fatigue during the presidential campaign. En route from St. Louis to New York City, JFK sits on the *Caroline*, the private Convair CV-240 his father purchased for him for $270,000 (about $2.1 million in 2011 dollars) to conserve his energy during the campaign. (above) "Jack could always sleep," said his wife. "He could sleep on the plane almost like a soldier."

★ ★ ★

Jacqueline Kennedy precedes her husband off the *Caroline* as they
land in Hyannis Port on Election Day, November 8, 1960. Characterized
by President Eisenhower's wife, Mamie, as "that woman," Jackie faced
criticisms for her bouffant hair and French fashions. But she told the
historian Arthur Schlesinger, Jr., that her husband did not mind.

> *"[H]e wasn't thinking of his image,*
>
> *or he would have made me get a*
>
> *little frizzy permanent*
>
> *and be like Pat Nixon."*

★ ★ ★

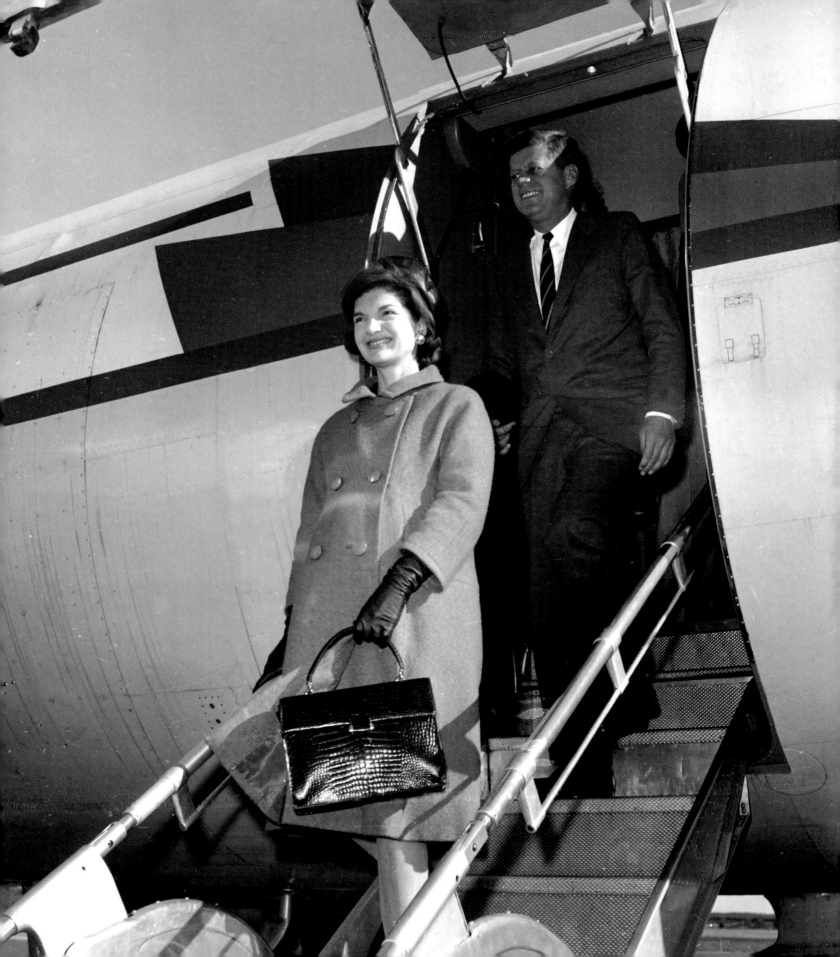

For Stanley Tretick —

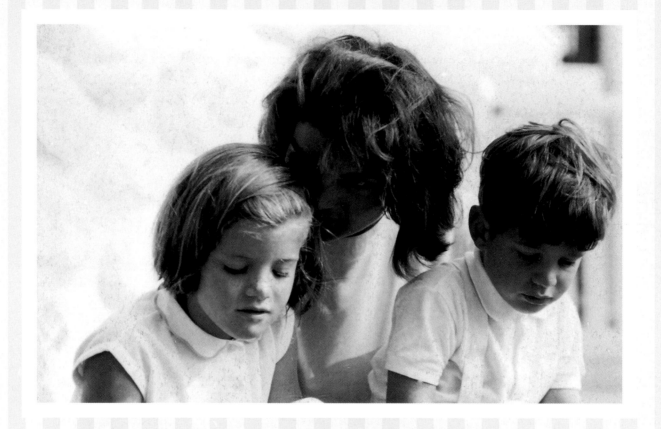

whose pictures will always revive our most precious memories
of President Kennedy —
With love from Caroline and John and me.
Jacqueline Kennedy

ALTHOUGH ABOUT 87 PERCENT of the country owned television sets then, most people still got their news from newspapers, so it was primarily through Stanley's photographs that Americans came to know the handsome, young senator from Massachusetts who would become the country's first Irish Catholic president. Not surprisingly, Stanley became one of Kennedy's favorite photographers and was described by *Look* in its 1964 JFK memorial issue as "President Kennedy's photographic Boswell." That description was aptly acknowledged by the President's widow when she signed a photograph: "For Stanley Tretick—Whose pictures will always revive our most precious memories of President Kennedy. With love from Caroline and John and me. Jacqueline Kennedy."

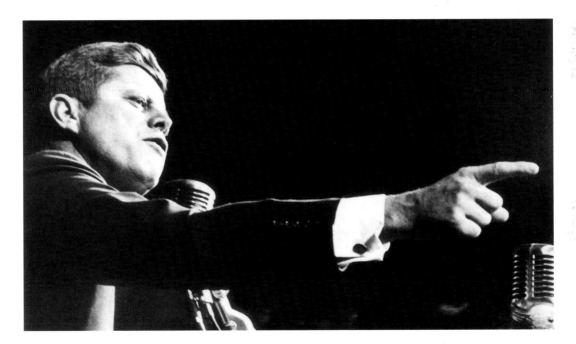

On September 12, 1960, John F. Kennedy delivers the "Houston speech" to Protestant ministers to address the religious issue. The previous week a group of prominent clergymen led by Rev. Norman Vincent Peale, minister of the Marble Collegiate Church in New York, announced that Kennedy's Catholicism made him unacceptable for the presidency. Kennedy responded strongly that he believed in the separation of church and state. "I do not speak for my church in public matters, and the church does not speak for me."

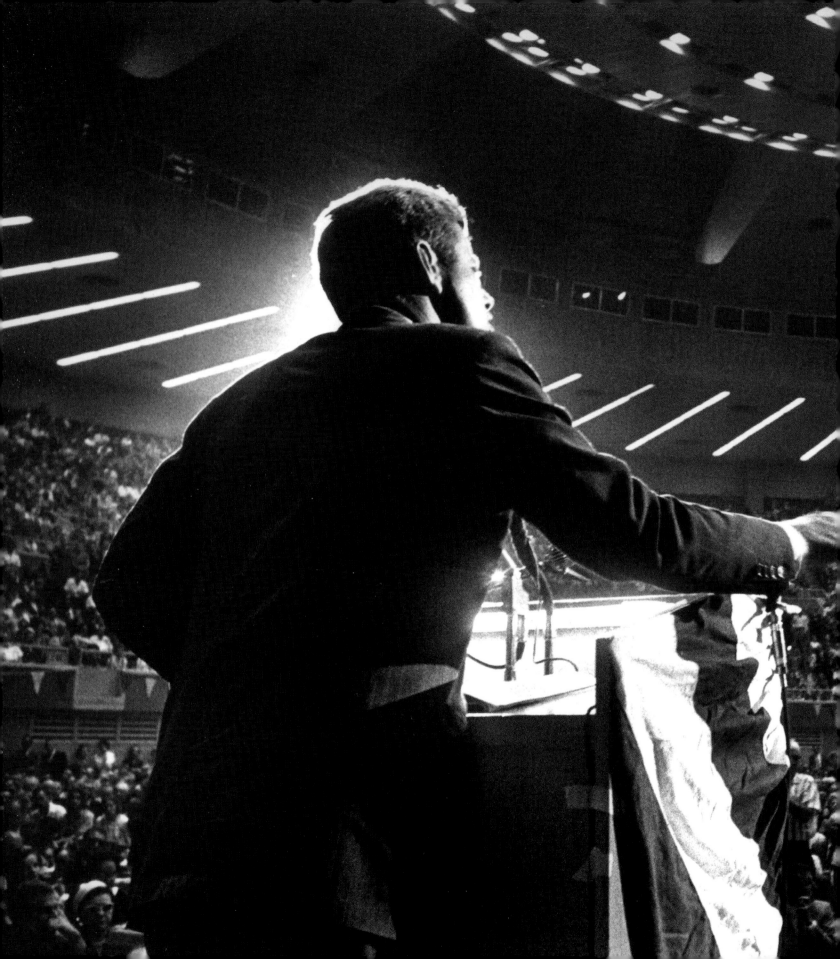

"Big Crowds Cheer Kennedy in Texas" headlined *The New York Times*, September 13, 1960, during the candidate's two-day tour of the state. Following the "Houston speech" Kennedy drew 10,000 people in Dallas, who erupted in applause when one of the speakers pointed out that no one asked John F. Kennedy where he went to church when he volunteered for military service in WW II.

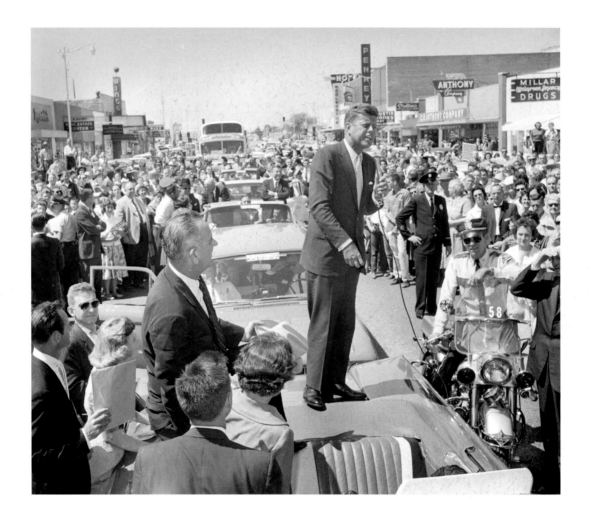

JFK campaigns in Texas with his running mate, Senator Lyndon Baines Johnson (left) and Lady Bird Johnson. Kennedy's controversial selection of LBJ as Vice President was made in order to carry the state of Texas, which they did in 1960. Johnson campaigned throughout the hill country for the Democratic ticket. Addressing the small German town of Stonewall, Texas, he said: "Your grandfathers sought to get away from religious persecution. Remember when those who wore masks sought to divide our country and persecute people because of where they came from. It's not important what church you worship in. What is important is that you have a God."

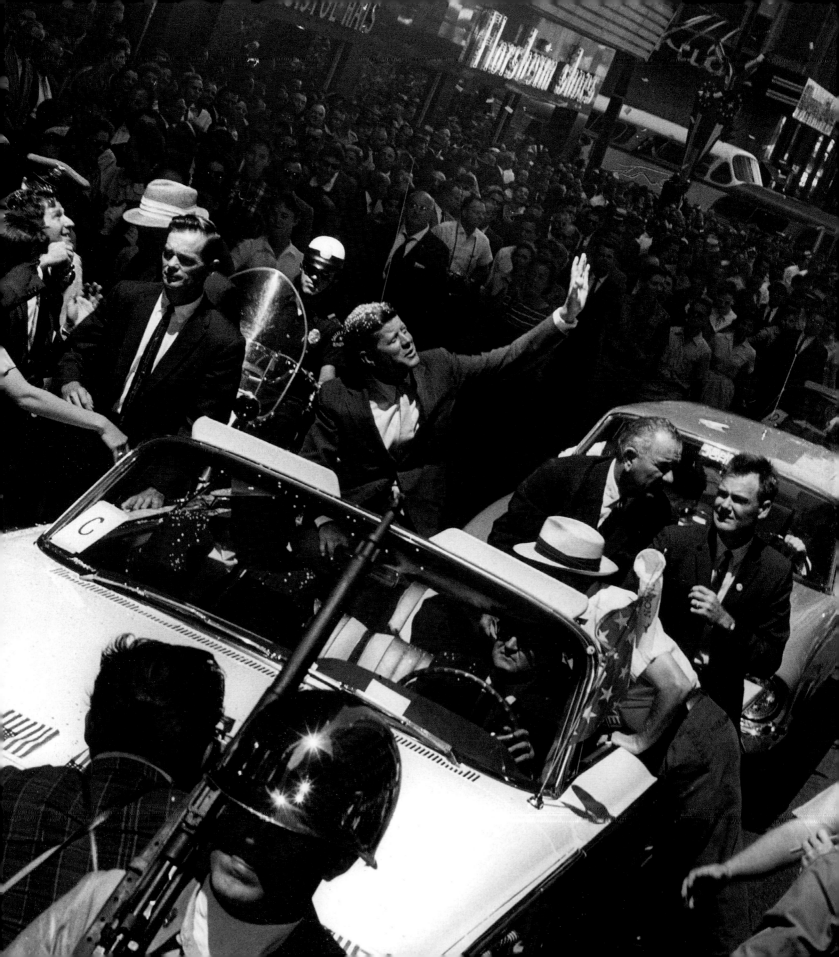

S TANLEY ESTABLISHED A WARM
rapport with JFK, whom he described in one memo as "extremely polite, great
sense of humor, quick as a rapier on the uptake, hard to top, cannot stand pos-
ing for pictures, expresses displeasure if he knows you caught him off guard in
a photo that might not be to his liking and will ask you please not to use it, absolutely
rebels at any photo that shows him eating or drinking." He developed such a good work-
ing relationship with Kennedy during the 1960 presidential campaign that he was offered
a job at *Look*, the premier picture magazine of the 1960s with a circulation of 16 million
copies, more than *Life*, its main competitor. Stanley's assignment was to cover the Presi-
dent, his family, and his administration in and out of the White House, which he did
assiduously, producing some of his most memorable work.

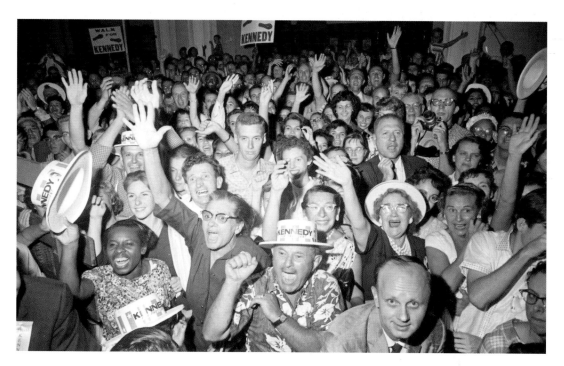

Kennedy received a rousing reception when he appeared in East Los Angeles and stated that if a
white baby and a black baby were born on the same day, the white child had three times more
chance of going to high school or college than the black child, and the black child had four times
the likelihood of becoming unemployed. The unemployment rate then was 6 percent.

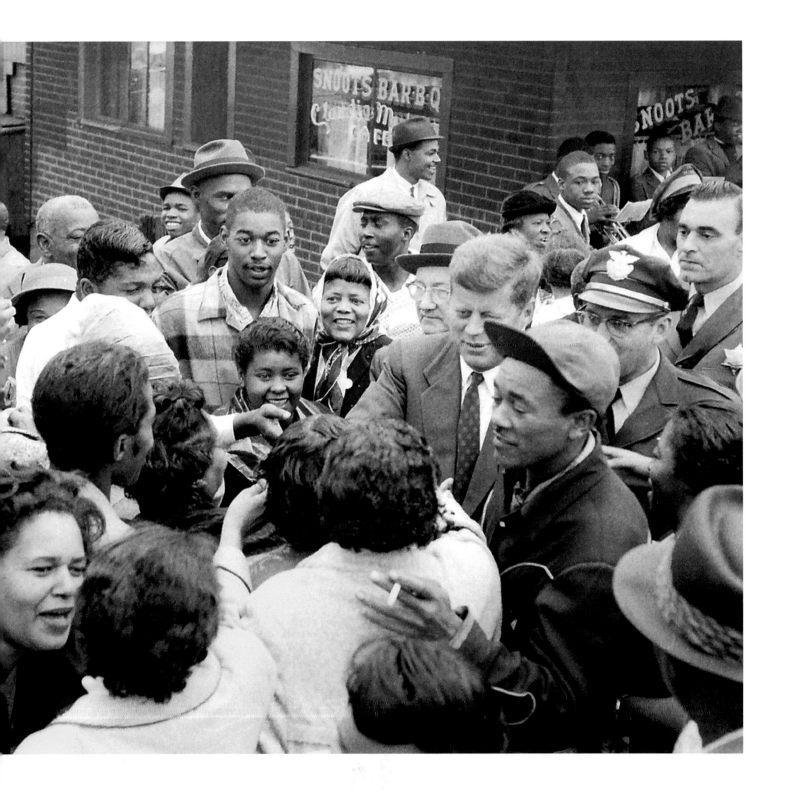

During one presidential debate Kennedy was asked about Harry Truman's profane language, and said, "I really don't think there's anything I can say to President Truman that's going to... change him.... Perhaps Mrs. Truman can, but I don't think I can."

Vice President Nixon then responded: "One thing I have noted...[is] the tremendous number of children who came out to see the presidential candidates...mothers holding their babies up.... It makes you realize that whoever is President is going to become a man that all children of America will either look up to or will look down to.... And I only hope that should I win this election...whenever any mother or father talks to his child he can look at the man in the White House and say...."

Nixon was elected President in 1968 and reelected in 1972. He was impeached in 1974 for high crimes and misdemeanors.

* * *

Jacqueline Kennedy, then eight months pregnant, joined her husband in her last campaign appearance, for a parade down lower Broadway in New York City, October 19, 1960, which Mayor Robert Wagner described as

"the greatest reception anybody has ever received in this section of the city in its history."

* * *

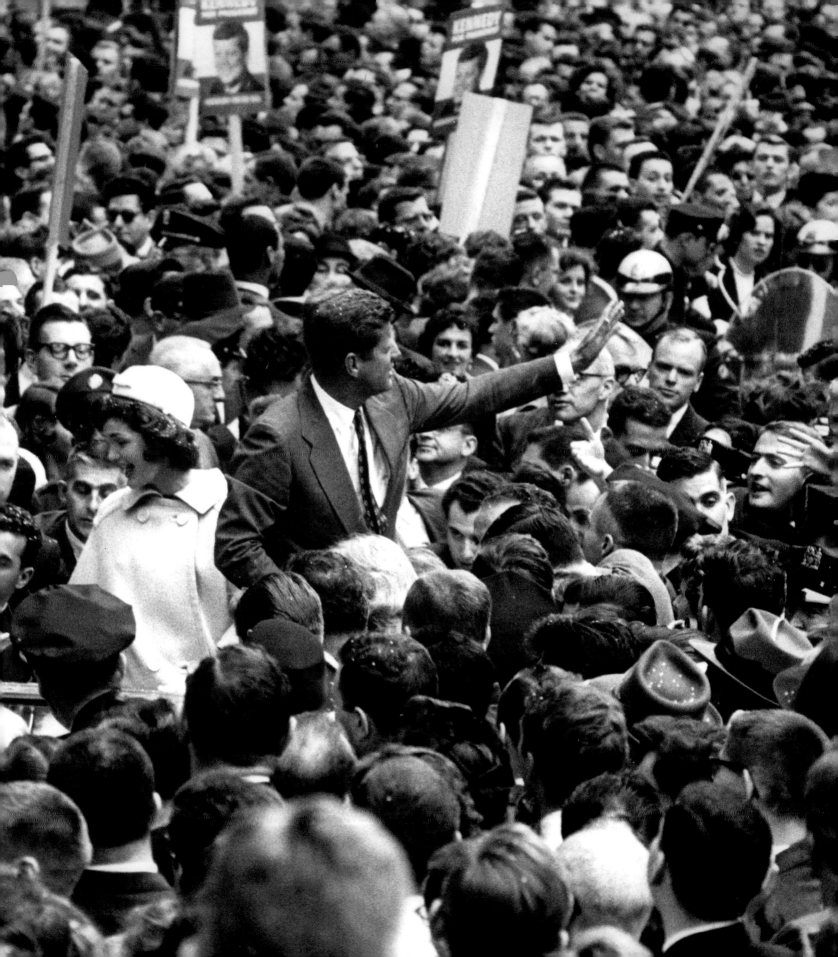

STANLEY VISITED JFK'S WIDOW in her Georgetown residence a few months after the President's assassination. In a long memo he typed about their meeting on April 6, 1964, he quoted her as saying: "Jack talked about you a lot—about what you were doing. I remember when I first saw you and you were running alongside the car after the convention in Hyannis Port trying to take a picture of the two of us in the car, and I said to Jack: 'My God, who's that? His days are numbered.' Then later Jack told me you were leaving UPI to go to *Look* magazine to work. I said, 'Stanley, work for *Look*—doing that kind of thing? He likes the hustle and bustle. I don't think he could do that.' Jack said, 'Oh, yes he can. He'll be just fine there.' "

Stanley produced sixty-eight *Look* stories on the Kennedys, the President, and his New Frontier policies, which all reflected extraordinary access and immense admiration. It was an odd pairing between the photographer with a high school degree and the President from Harvard, whose father had amassed a fortune worth $400 million. Both had

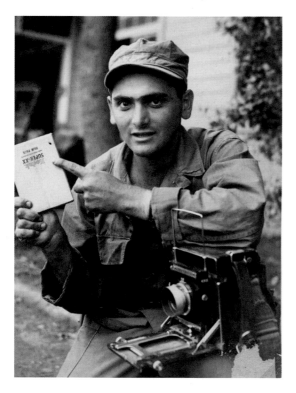

served in the military and seen combat, which was a crucial bond for men of their generation. It was how their brave fraternity assessed a man's character. JFK, a navy lieutenant in WW II, had won the Navy and Marine Medal for courage and leadership after rescuing his crewmen in the Pacific. Stanley, a Marine photographer in Korea, was featured in *Newsweek* holding up a punctured film pack "that saved him from North Korean shrapnel on the most dangerous battlefront newsmen have ever covered." His photo of a soldier crumpled with despair and holding his muddy face in his hands was selected by *Military Times* as one of the one hundred most-enduring images captured in combat.

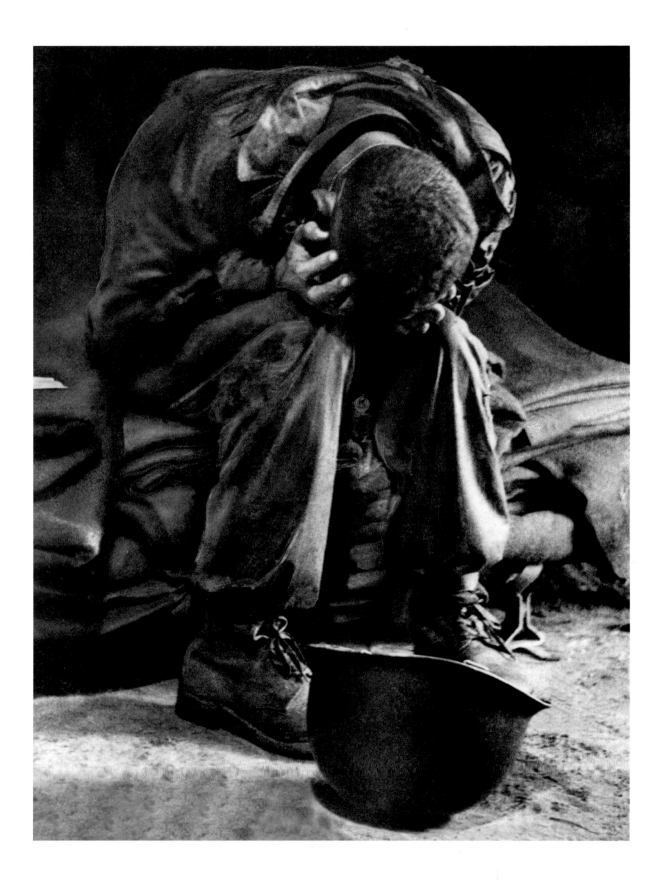

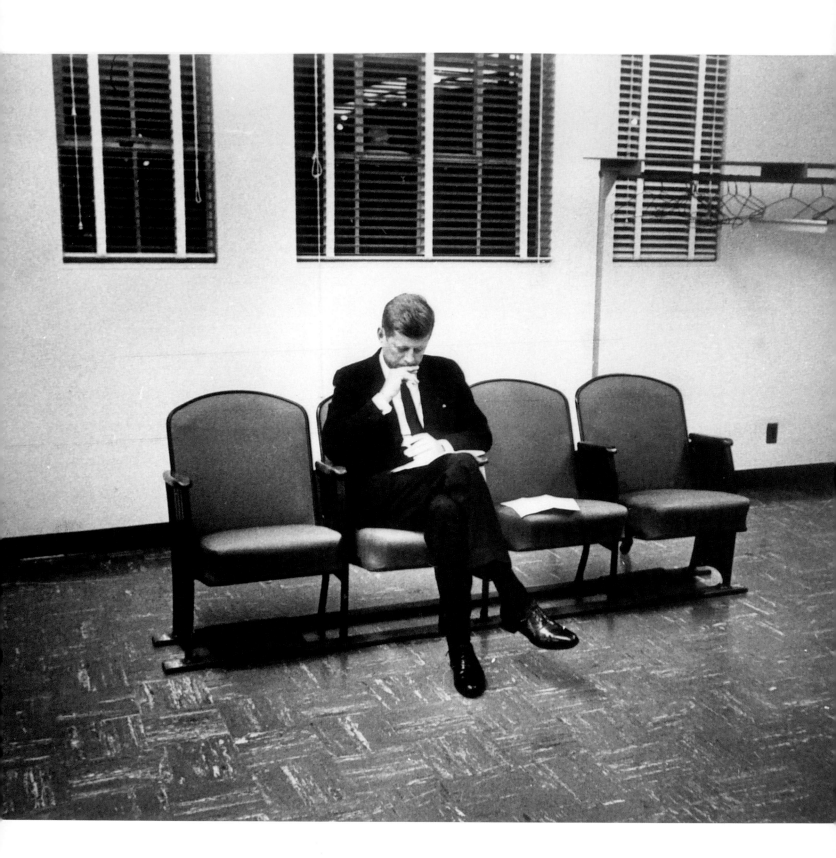

EARLY IN THE KOREAN WAR

Stanley was stuck in a remote area with no way to get to his next assignment when he spotted a small navy four-seater on the runway of a local airstrip. He was told the plane was for a rear admiral headed for the same spot Stanley was trying to get to. Seeking out the admiral, Stanley explained his situation and asked for a ride. The admiral looked at Stanley's disheveled fatigues, his mud-caked boots, banged-up helmet, and week's growth of beard. Seeing no insignia, the admiral said, "You don't look like a photographer to me. Where's your camera?"

Stanley snapped to attention. "You don't look like an admiral, either. Where's your boat?"

"Get in," said the admiral.

That brashness would not be lost on JFK. But other than shared military service, there seemed little else to bind the scrappy photographer and the soigné President, except that each saw in the other glorious opportunity from which sprang genuine affection and respect. Neither was a naïf in regard to their symbiotic relationship. Each fully understood the powerful impact of images.

(opposite) **Kennedy looks at his prepared text before a speech in Seattle, Washington, September 6, 1960. "The consensus of the newspapermen who are watching his performance," wrote columnist Roscoe Drummond, "[is] that he is more articulate than either President Eisenhower or former President Truman, more direct and understandable than Adlai Stevenson, and has much of the charm of Franklin D. Roosevelt."**

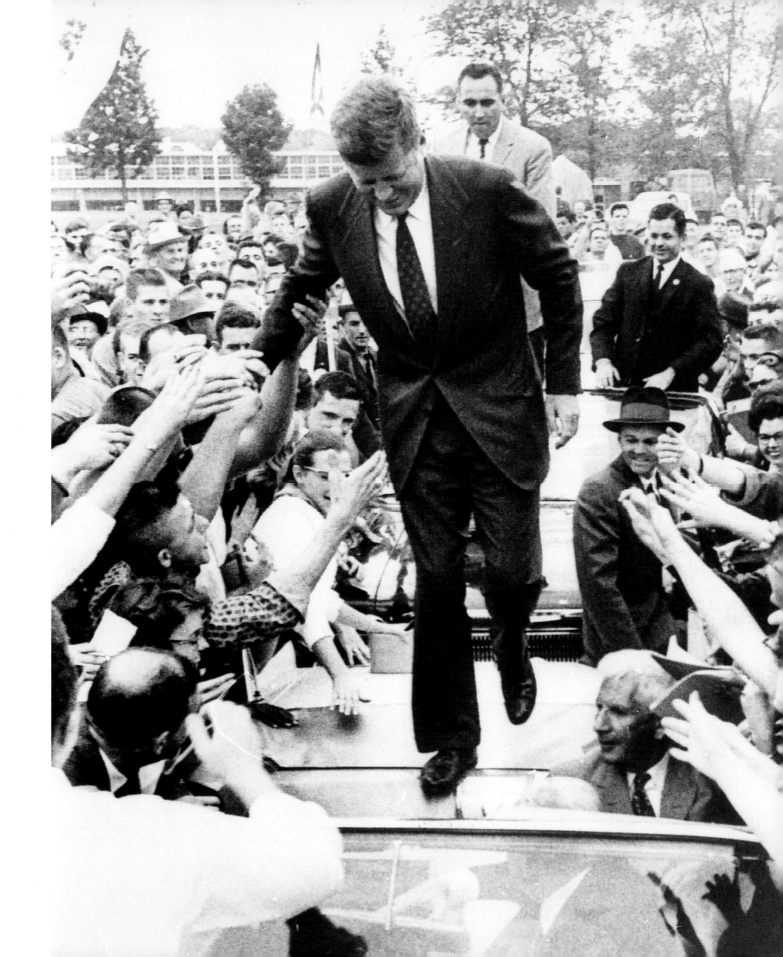

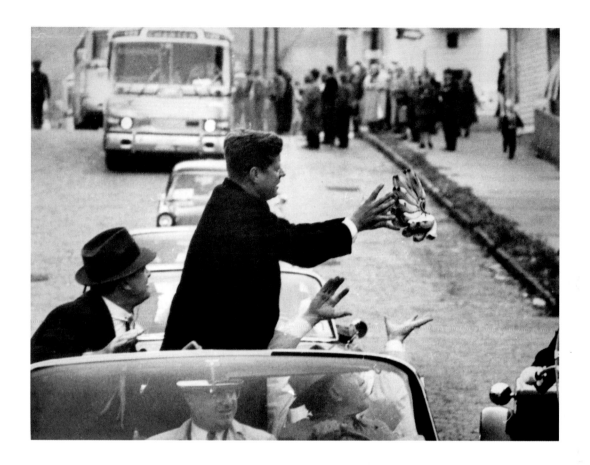

(opposite) Taking his campaign to Illinois, Kennedy made eleven stops in the state, and was mobbed by crowds in the depressed coal mining area of Carbondale, October 3, 1960. He said it is "ridiculous" that "a nation in a race for its life with Russia cannot find full-time use for the talents and energies of 7 million people "who are unemployed." (above) The candidate catches a bouquet of bananas in Nanticoke, Pennsylvania, October 28, 1960. Campaigning in one of the most depressed economic areas of the nation, Kennedy stressed bread-and-butter issues, charging that Republican inaction was responsible for declining business and rising unemployment. Governor David L. Lawrence said JFK's crowds (500,000) exceeded those for Franklin D. Roosevelt and President Eisenhower. "You must remember...these people look to this fellow [Kennedy] as a messiah who will lead them out."

Taking his campaign into the Republican territory of Valley Forge, Pennsylvania, October 29, 1960, a week before the election, Kennedy, who majored in history at Harvard, recalled the site as the turning point of the Revolutionary War. "Men here knew the deadly meaning of danger," he said, "but they also preserved the bright hope of opportunity."

A crowd of 200,000 gave JFK a blizzard of confetti and ticker tape in Los Angeles, November 1, 1960, where he made a major address on American power. "If we cannot outstrip the Russians in space and science, in technicians to underdeveloped countries, in the language training of Foreign Service officers—then our prestige suffers, our influence suffers, and the whole nation suffers."

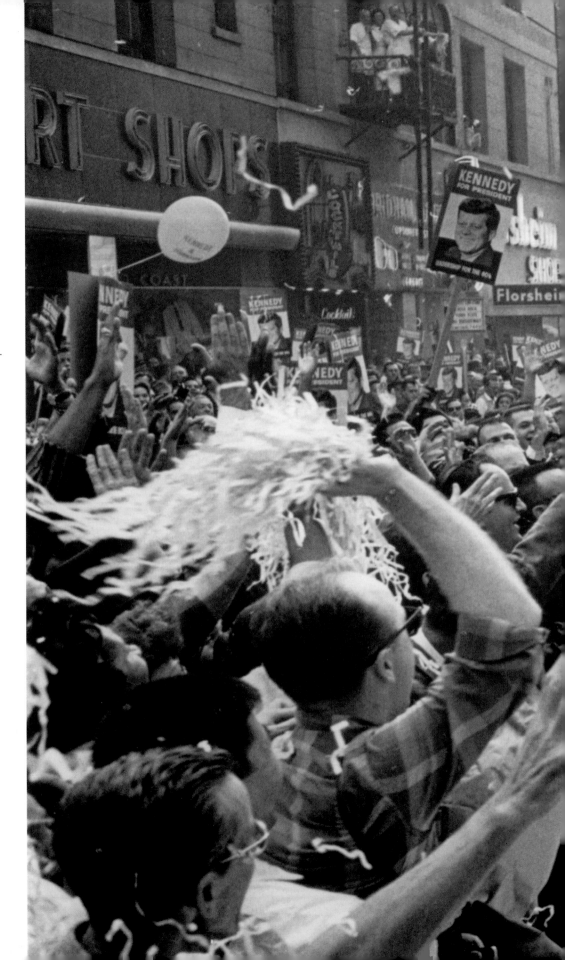

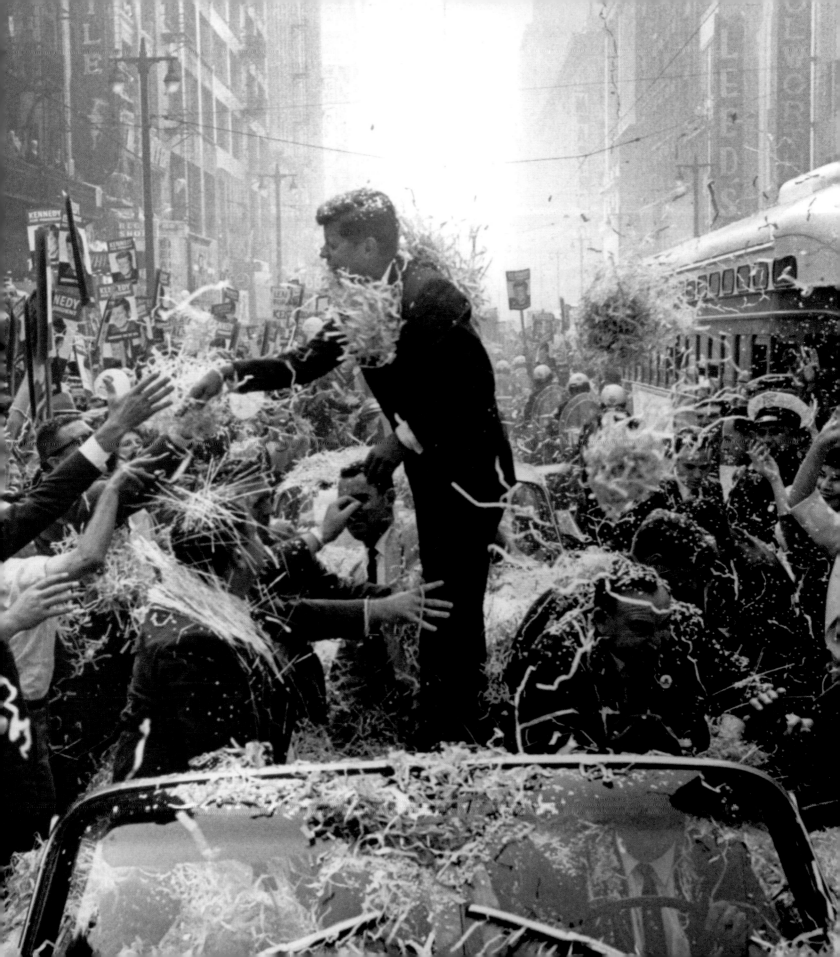

* * *

A little girl in Cheyenne, Wyoming, waits to present JFK with a bouquet of flowers on the candidate's swing through the Western states, September 23, 1960. Kennedy cut short his speech that day, and newspapers reported one little girl's disappointed response:

"For heaven's sake,"

she complained to her mother.
"They have such crummy things,
it goes on for an hour. They have good things,
it's over in five minutes."

* * *

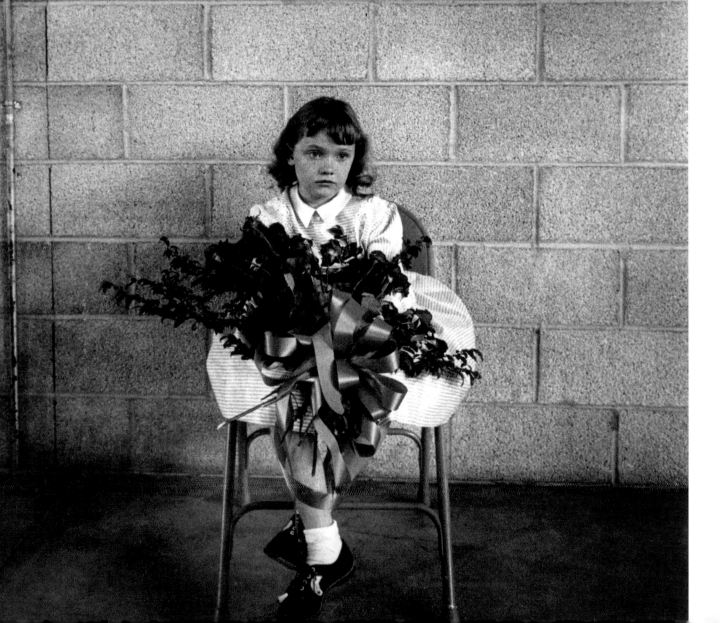

URING THE CAMPAIGN, Kennedy cared immensely about how he was portrayed to the public. "[He's] one of the few politicians I know of who actually looks at the picture credits in papers and magazines," Stanley wrote in a 1960 memo. At the start of the campaign he told the senator, "I don't want to get you into a bad situation on purpose, but if you happen to get into one, I'm just going to have to photograph it anyway." Kennedy, who had spent a year as a journalist, knew how the game was played. "That's all right as long as it actually happened," he said. "No posing."

Yet during the campaign he continually dodged Stanley's camera whenever he was eating, drinking, combing his hair, or being presented with some sort of hat.

"The Indian headdress became a game between us," Stanley recalled in his oral history. "I told him it was going to happen one of these days, that he was going to be presented with one and it was going to be put on his head as part of the ceremony.

" 'Well, I'll bridge that when I come to it.' "

"Six feet of feathers, Senator, on both sides of your head."

" 'I'll look for that, don't worry.' "

When the campaign stopped in Sioux Falls, South Dakota, Stanley knew the candidate was to be presented with an Indian headdress. He talked to the tribal chief before the ceremony. "Is it part of the presentation that you will actually put the headdress on his head?" he asked. Told that it was indeed part of the ceremony, Stanley positioned himself for the shot.

"He got up there and God, he was so nervous and he knew it was going to happen and it was killing him, really. He kind of stood there, real stiff, and sure enough they put it on his head. It only stayed there about an eighth of a second before he lifted it off but an eighth of a second is all you need. I nailed him, and it's really a silly looking picture. There's no question about it.

"The picture appeared in Denver's *Rocky Mountain News* the next day. I clipped it out of the paper and sent it to him on the plane with a notation: 'You gotta be quick!' "

Kennedy responded evenly: "There will be better days."

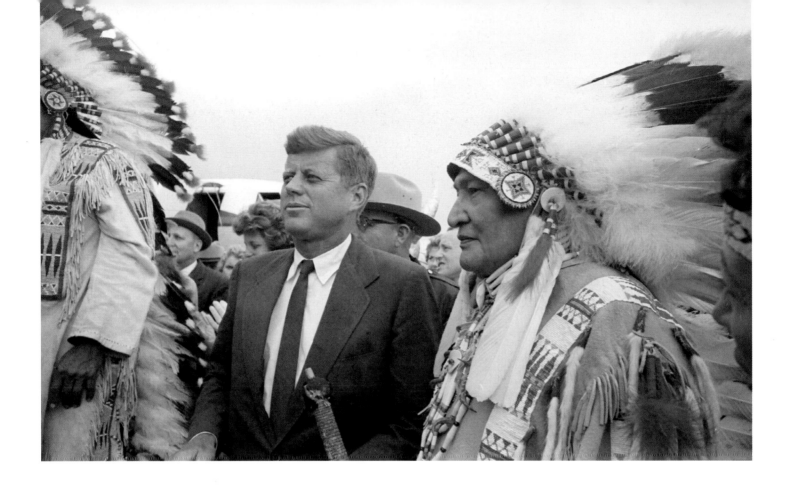

Dreading the presidential campaign ritual of being photographed in a feathered headdress, JFK turns his back to photographers as Chief Hollow Horn Bear, whose English name was George Kills in Sight, adopts him into the Sioux Indian Nation, September 22, 1960, in Sioux Falls, South Dakota. Kennedy quickly removed the headdress. Russell Baker reported the moment in *The New York Times*, saying Kennedy reacted "like a politician about to be photographed in a night club with a blonde and not his wife."

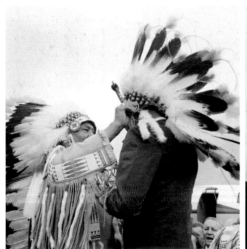
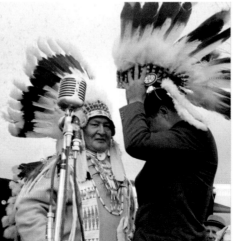
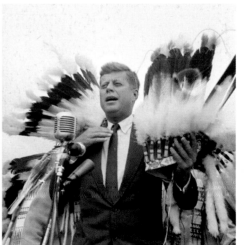

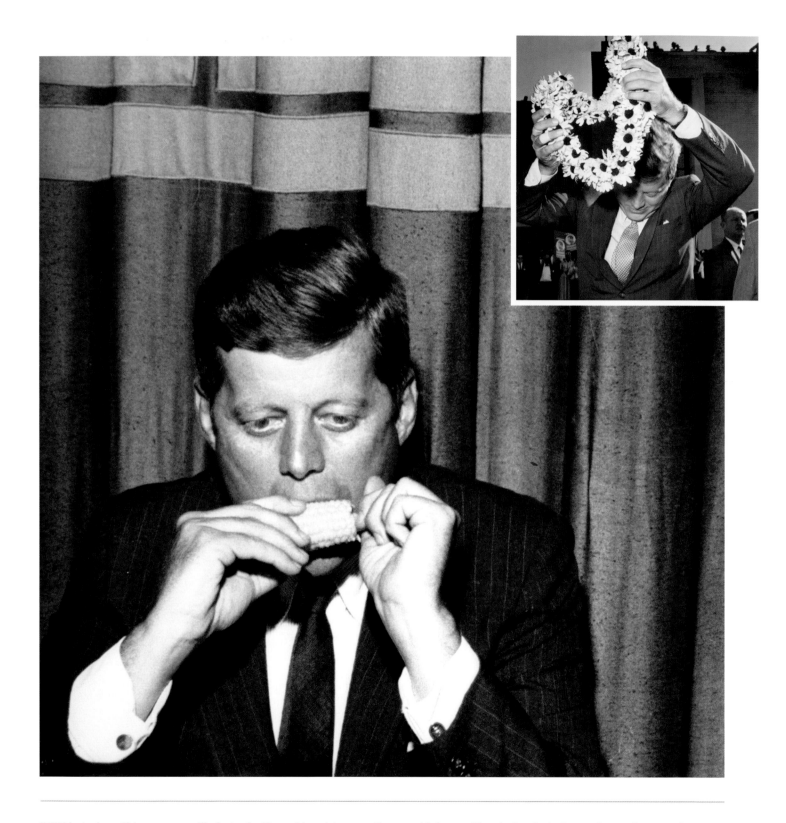

"JFK hated anything corny—silly hats, feathered headdresses, flowered leis—and he dodged photographers whenever he was eating," Stanley Tretick wrote in a memo to his editor. So these photos of the candidate putting on a lei and eating corn on the cob were considered a coup of sorts.

JFK LOVED HOWARD JOHNSON'S. "Whenever he saw one on the campaign trail, we'd have to stop so he could duck in, order two hot dogs and a soft drink. But we could never photograph him because he'd usually give us the slip. Once I aimed my camera at him in a car as he was about to chomp down, but he slid under the dashboard so I couldn't see him. After he wolfed his lunch he rolled down the window. 'Sorry, Stan, but after I saw that picture of Lefkowitz, Lodge, and Rockefeller at Coney Island…' He shook his head in disgust." Running against Vice President Richard Nixon, Kennedy kept tabs on the GOP campaign and pronounced the photo of Louis J. Lefkowitz, New York's attorney general; Henry Cabot Lodge, Jr., Nixon's running mate; and New York Governor Nelson Rockefeller eating hot dogs as "corny and ridiculous."

"In Iowa we crowded in to take a shot of Kennedy eating corn on the cob," Stanley wrote. "He held the corn in both hands, touched it to his mouth, but wouldn't eat it. Just gave us a silly grin. 'Sorry, fellas. After seeing that picture of Nixon eating poi in Hawaii, no thanks!'

"On the Staten Island ferry he stopped at a lunch counter at the terminal but the police barred us from following him.

> STANLEY WAS AMUSED BY WHAT HE CALLED JFK'S CAT-AND-MOUSE GAME *with* PHOTOGRAPHERS.

I raised hell because as a wire service photographer you're supposed to be with the candidate at all times.… It's like an insurance policy in case something happens.… I finally got an official with some rank to let me in, but by the time I got to the counter Kennedy had finished eating.

"'You outfoxed us again, Senator,' I said.

"He wiped his mouth with a napkin. 'Where you been, Stan? All the action's been in here.'"

Stanley was amused by what he called JFK's cat-and-mouse game with photographers. "I could never see it as being nasty, malicious or anything like that.… He plays a game, enjoys the game, but when he loses, he never cries about it. He never says, 'You bastard, you made a picture of me doing such and such.' He just accepted it as it was. Very refreshing in a politician."

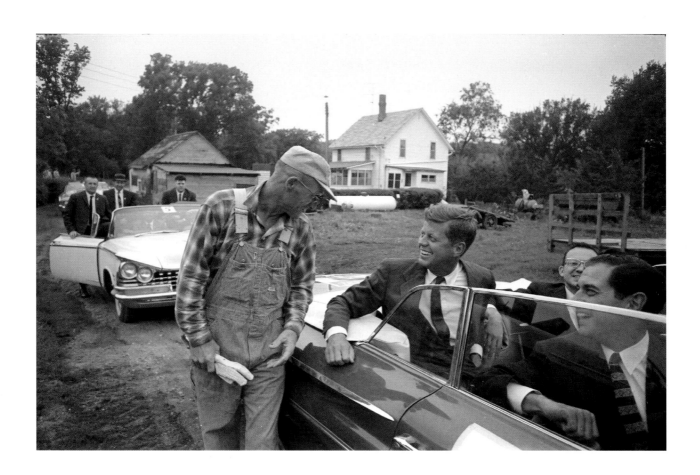

(above) JFK speaks to a farmer after unveiling his agricultural program that promised "full parity" income for farmers, reduced surpluses, and food for the needy at home and abroad. (opposite) Young Farmers of America presents JFK with a donkey, which became the symbol of the Democratic Party after President Andrew Jackson was called a jackass in 1828 and adopted the strong-willed animal as his own.

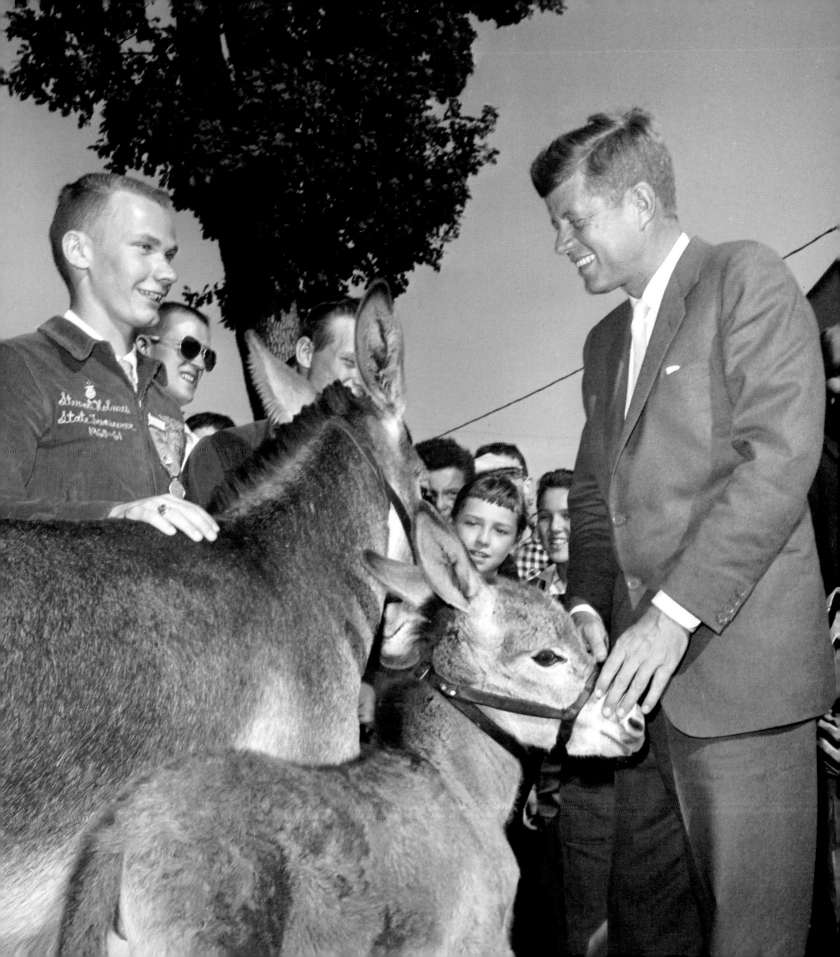

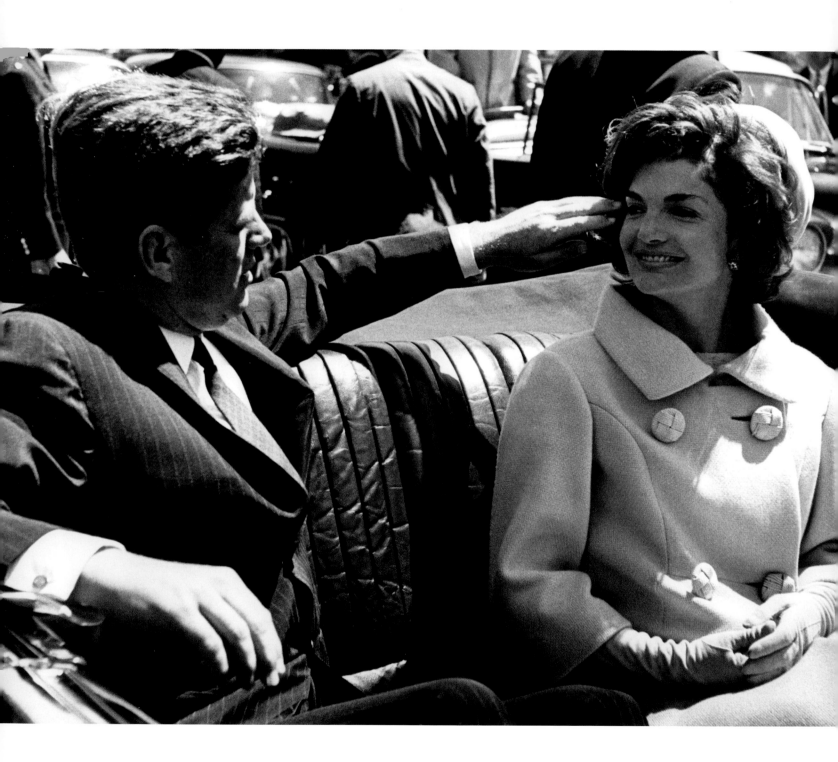

KENNEDY DISLIKED PHOTOS that showed any public display of affection. "Once in New York City he was greeted at the airport by Jackie, who kissed him on arrival, but we missed the photo because of a lot of maneuvering on Kennedy's part. He was supposed to get off the front of the plane but instead he ran out the back where he met Jackie and kissed her quickly. We all made a mad dash and started screaming, 'Kiss her again, Senator.' 'C'mon, Mrs. Kennedy. Hug him.' 'Senator, we need a kiss!' JFK looked at us and smiled. 'You're sure an affectionate group of photographers.' "

Even after his inaugural address Kennedy did not kiss his wife, which is why she later told Stanley she so loved the photograph he had taken of them in a convertible returning from Blair House to the White House. The picture shows the President reaching over to tenderly brush hair out of her face. "It's my favorite picture of the two of us," she said, "because it shows such great affection."

Stanley recollected that as a candidate "Kennedy absolutely will not pose for any picture which he thinks smacks of corn. As his good friend [journalist] Joe Alsop says, 'Two things make him nervous—nuns and silly hats.' "

The President and First Lady escorted President Habib Bourguiba of Tunisia to Blair House, May 3, 1961. On the ride back to the White House the President brushed his wife's hair out of her eyes. She later told the photographer that it was her favorite picture of herself with her husband "because it shows such great affection."

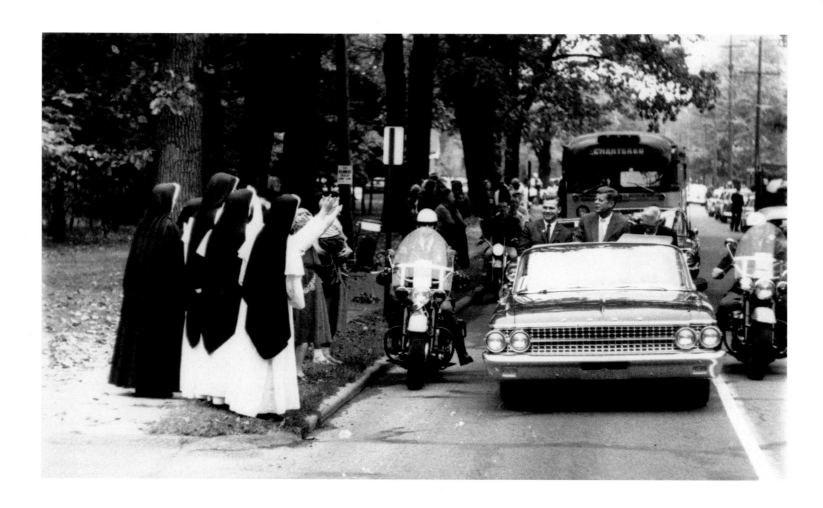

"I don't know about the nuns. He was always gracious and cordial to them on the campaign trail—even stood up in his car to acknowledge them along the streets." JFK's courtesy to nuns underscored Kennedy lore that bishops and cardinals were Republicans, but sisters were inevitably Democrats.

(above) Columnist Joseph Alsop said that nuns made Kennedy nervous, but only because he worried their presence on the campaign trail might trigger religious resentment which was so prevalent in the country at that time.

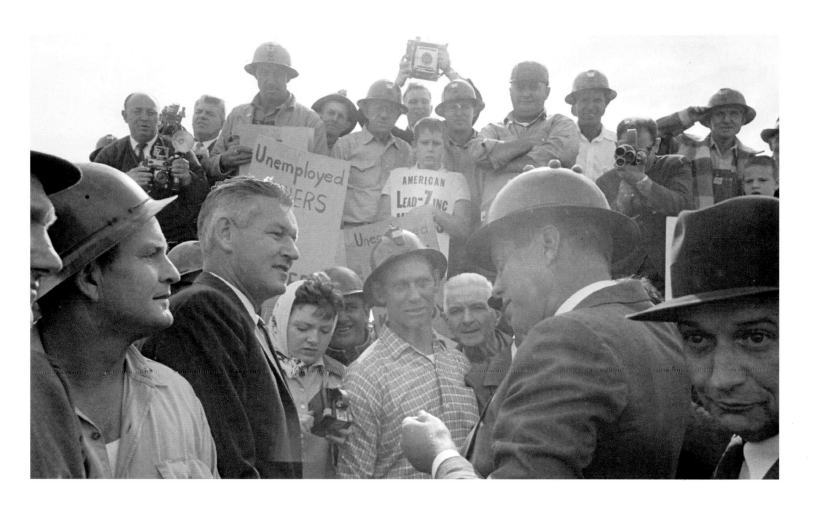

"I do know much about the hats," wrote Stanley. "He was given dozens—cowboy, sombrero, Indian headdresses…but he would never put one on once presented [except] for a workman's hard hat…. That he didn't object to [this and] one of the things which impressed me most on the campaign was the way the heavy laborers went all-out for Kennedy. Men who worked in mines, factories, construction, outdoors, etc…. This type of guy you can't fool, [they] can see through veneer to spot a phony. These guys went big for Kennedy…."

* * *

The only hat JFK did not avoid—and actually enjoyed wearing—was a workman's hard hat.

He appreciated their acceptance
of him as one of their own.

* * *

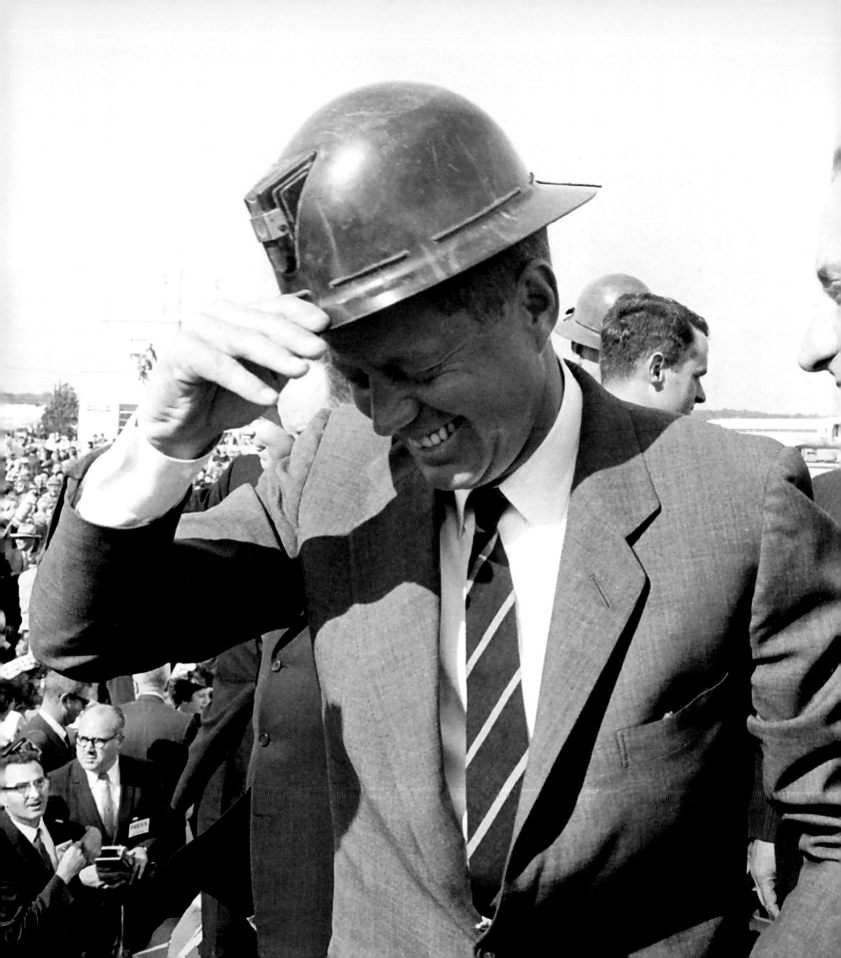

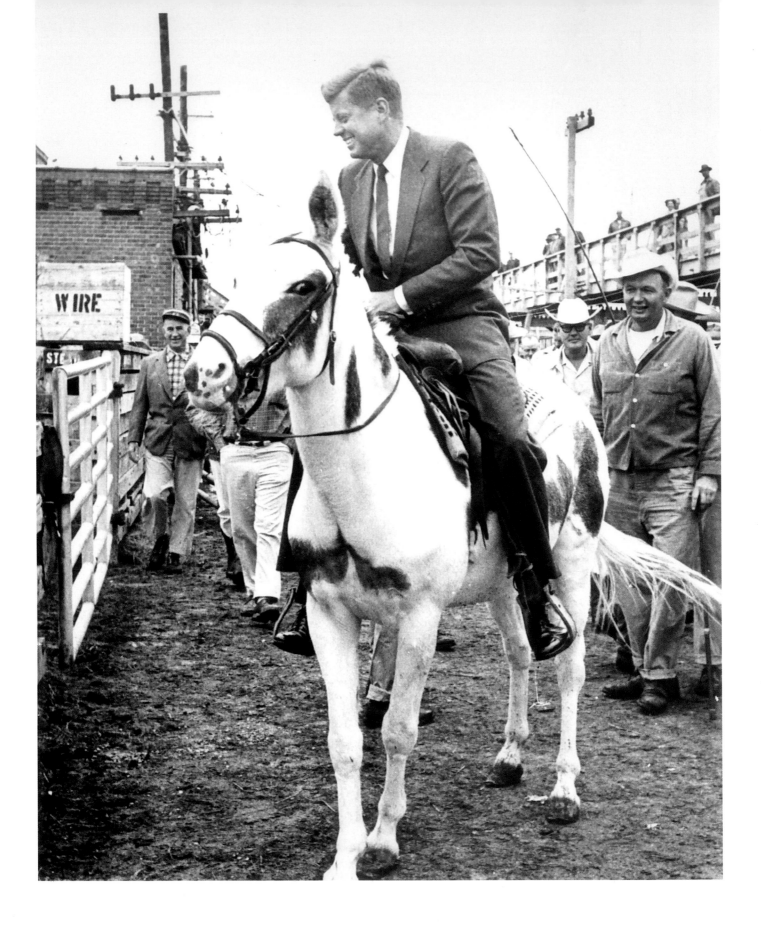

IMAGE WAS PARAMOUNT TO JFK, and Stanley's memos note that the presidential candidate "freely expresses displeasure at certain photos using rather rich language at times." Kennedy snapped at Stanley after seeing a picture of himself he did not like: "That was a terrible picture of me in this morning's *New York Times* wearing the [American] Legion hat. Did you take it? Looks like one of yours."

Yet he could also be complimentary. At a stockyard in Sioux City, Iowa, some cowboys challenged Kennedy to get on a horse, which he did—reluctantly. "I was very surprised and caught off balance," Stanley wrote, "but I managed to get an excellent picture of him.... He looked very natural and afterward complimented me on the photo." Stanley noted that JFK objected most to informal candid shots. When Stanley asked him why he didn't like a certain photo of himself, Kennedy replied, "Makes me look like a bum."

JFK OBJECTED MOST *to* INFORMAL CAMERA SHOTS.

"He watches us [photographers] very closely and will try to outwit us when he can't voice objection out loud.... In St. Louis they plunked a cowboy hat on his head, which he quickly removed before any of us got the picture. An official said, 'Would you put the hat on again, Senator Kennedy? These fellows over here missed it.' Kennedy turned toward us with a smile and said, 'I'm glad.'"

In a suit and tie, JFK was not prepared to mount a horse (actually a mule) in the stockyards of Sioux City, Iowa, September 22, 1960, but he did so after being challenged. Later he thanked the photographer for not making him look foolish.

THE "HANDS SHOT," ONE OF Stanley's favorite JFK pictures, was taken during the California primary. The image captures the movie star charisma that Kennedy radiated as he stood in an open convertible mobbed by a sea of hands grabbing to touch him. Yet there is a certain remove in the candidate even as he excites the heated grabbing mass.

"I don't think he really reveled in the adulation," Stanley said. "He wanted to win and he went along with whatever he could to win. But I don't think he reveled in the adulation like some people would."

As the Democratic candidate for President, JFK campaigns in Los Angeles, September 9, 1960, with California Governor Pat Brown and excites crowds like a movie star. The next night he delivered a major speech saying that as President he would "not stand above the battle" but would use moral force to see that all Americans are granted their civil rights.

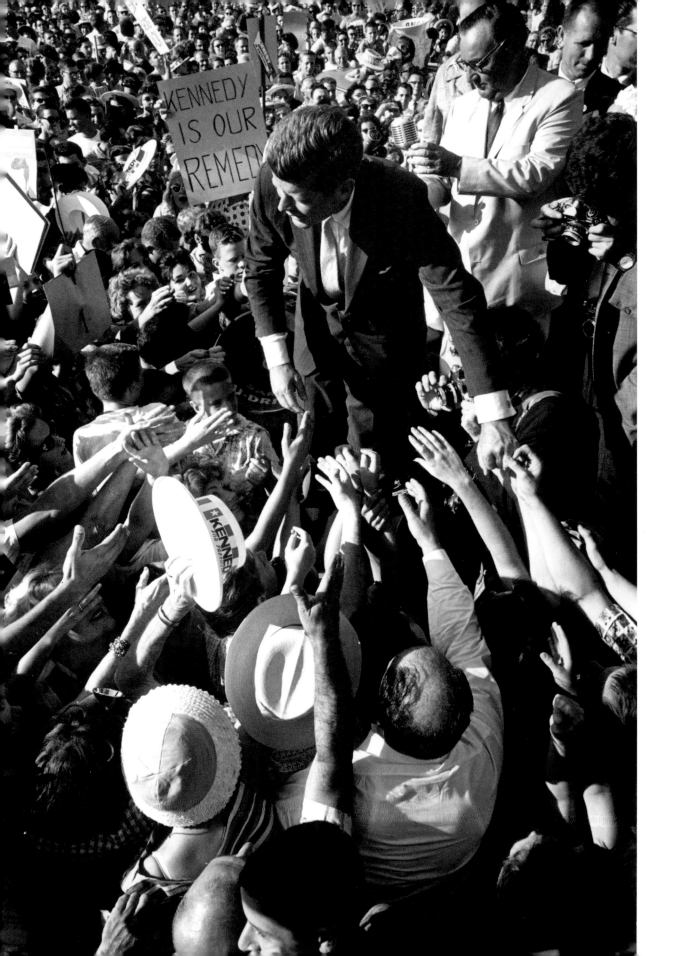

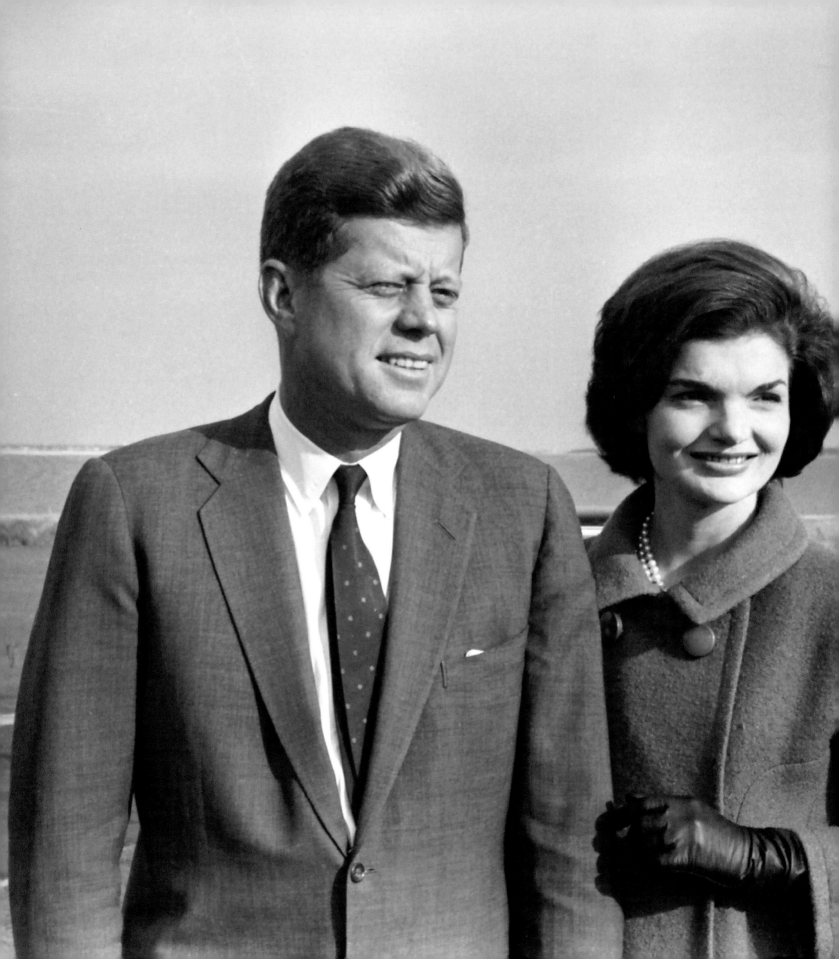

★ ★ ★

Both Kennedys appear hatless but Jackie said
if she became First Lady she would stop wearing
capri pants in public. Then she added her
greatest concession to the role:

"I'll wear hats."

★ ★ ★

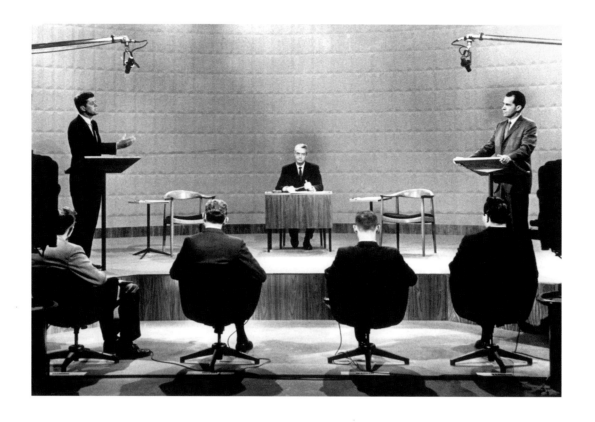

THE 1960 PRESIDENTIAL ELECTION

was the closest race of the twentieth century, with Kennedy beating Nixon by a scant two-tenths of one percent of the popular vote. Only 118,574 votes separated the two men. "No reason for Dad to buy a landslide," JFK later joked. The victory was hard won, with both sides alleging voter fraud, especially in Chicago, but it was the vote in Hyannis Port that most galled JFK. In that Republican WASP enclave where the Irish Catholic Kennedys had never been completely accepted, Nixon beat him 4,515 to 2,873.

(above) Polls showed Senator John F. Kennedy and Vice President Richard M. Nixon running neck and neck by the time of their first debate in Chicago, September 26, 1960. Nearly two-thirds of the nation's adult population—70 million people—watched on television or listened on the radio. JFK arrived looking tan and confident. RMN, recently hospitalized for an infected knee, looked thin and wan. Between the two candidates is the moderator, Howard K. Smith. *(opposite)* A very confident candidate campaigns during the last days before the November 8th election of 1960.

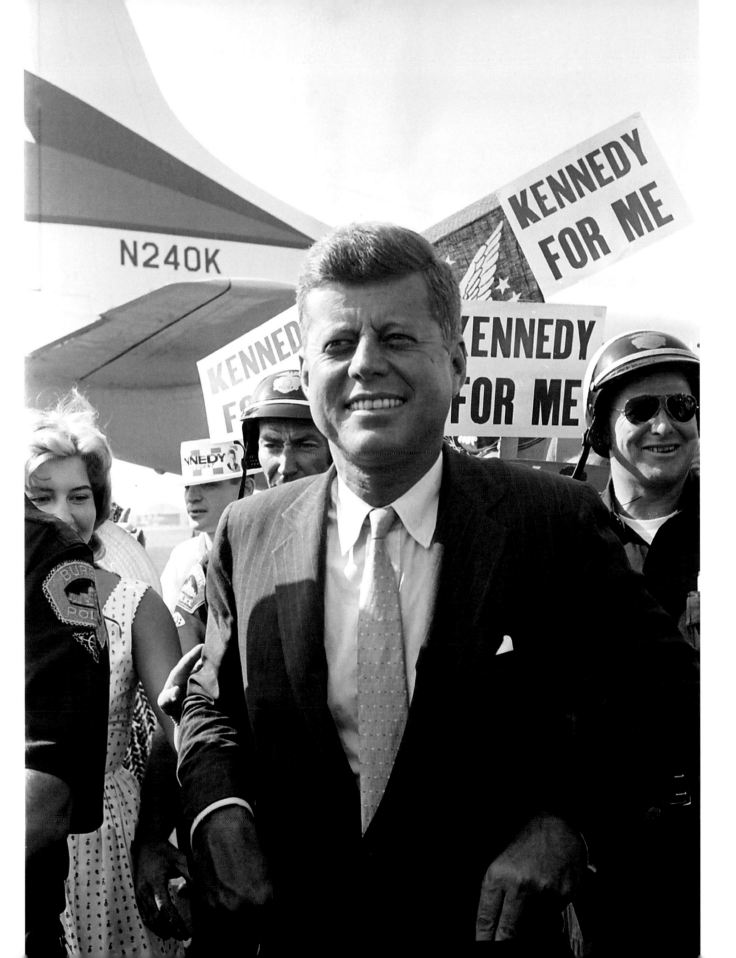

* * *

The day after the election, November 9, 1960, President-elect
Kennedy, his wife, Jacqueline, his parents, Joseph P. Kennedy
and Rose Fitzgerald Kennedy, plus his brothers and sisters and
their spouses (fourteen in all) greet supporters at the Hyannis
National Guard Armory.

The election turned out the greatest number of voters in the
country's history, more than 62 million. Yet Kennedy won by
little over 100,000 votes. Months before, Vice President
Nixon had predicted—correctly—

"the closest election

in this century."

* * *

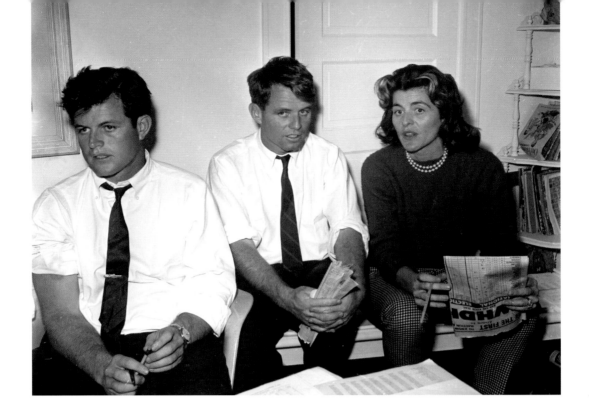

Just before leaving office President Eisenhower invited the press to a farewell dinner at the White House, where, Stanley wrote, they were served coffee, brandy, and some very fine cigars. "I managed to keep two of the cigars for the express purpose of giving one to Kennedy and one to [Pierre] Salinger on the plane to New York the next day. I handed Kennedy the cigar and said to him, 'Here, Senator, your first cigar from the White House. I got it at the dinner Ike had last night.' He accepted the cigar and immediately took one of his, a small Havana, from his pocket and handed it to me, saying, 'Here, have one of mine. Castro sends them to me.'

"Then after that he said, 'Tell me about that dinner. What kind of dinner was it? What did President Eisenhower say?'

"I don't know," said Stanley. "I couldn't hear him too well. I was drinking quite a bit."

JFK shook his head in disbelief. "How blasé can you get?"

(opposite) **The Kennedys caught off-guard during a sitting for a family portrait in "the Big House," which is how they referred to Ambassador Kennedy's house in the compound at Hyannis Port. Left to right: Rose Kennedy, daughter Jean Kennedy Smith, 32, Joseph P. Kennedy, 72, JFK, 43, RFK, 34, Patricia Kennedy Lawford, 36. Jacqueline Kennedy, 31, sits in front of her husband. In the lower right corner is Edward M. Kennedy, 28.** *(above)* **All of JFK's siblings, except for Rosemary, their mentally disabled sister institutionalized in Wisconsin, joined the campaign. Here the fatigue shows on Teddy, Bobby, who was the campaign manager, and Pat Kennedy Lawford.**

SHORTLY AFTER THE ELECTION the President-elect's second child and first son was born on November 25, 1960; thirteen days later John Fitzgerald Kennedy, Jr., was christened in the chapel of Georgetown University Hospital. Stanley was the pool photographer—the only one allowed inside. His memo of the event indicates that he met with the priest beforehand.

"You can go anywhere you'd like, through the sanctuary and all," the Rev. Martin J. Casey, S.J., told him, "but then I suppose you have covered these things before."

"Father, I've never gotten past a bar mitzvah."

The President-elect brought Jackie through the corridor in a wheelchair. She was still in the hospital almost two weeks after the baby was born by Caesarian section. Having given birth to a stillborn daughter in 1956, and failed twice more to carry to full term, she became so depressed at one point that she received electroshock therapy. The birth of this baby boy was a momentous occasion for her. Stanley's memo indicates: "She looked good, wearing a black suit, just a little pale, however. She greeted me with her usual 'Hello, Stawn. . . .'

"There were absolutely no special arrangements made for picture taking—I had to play the entire thing by ear. I had brought several floodlights which I had clamped near the area where I was working. While setting up I was looking for anything I might clamp my light to . . . Kennedy eyed me looking at a statue of the Virgin Mary. He shook his head no. He must've thought I was going to use it for a clamp-on.

"Pierre [Salinger, the White House press secretary] had told me that there were to be no pictures during the ceremony, that Kennedy didn't want this—again, the Catholic Church thing. However once inside the chapel with the ceremony starting I just couldn't conceive that I would come out of there without pictures of the christening. . . ."

Stanley wanted to capture the ancient ritual that signifies the elimination of the original sin of Adam and Eve. He photographed the priest breathing three times on the baby's face to command the spirit of evil to leave. Then the priest placed a few grains of sacred salt on the baby's tongue for wisdom; he touched the baby's nostrils "so that you may perceive the fragrance of God's sweetness," and he anointed the infant with holy oil, making the sign of the cross on his forehead, shoulders, and breast to renounce Satan.

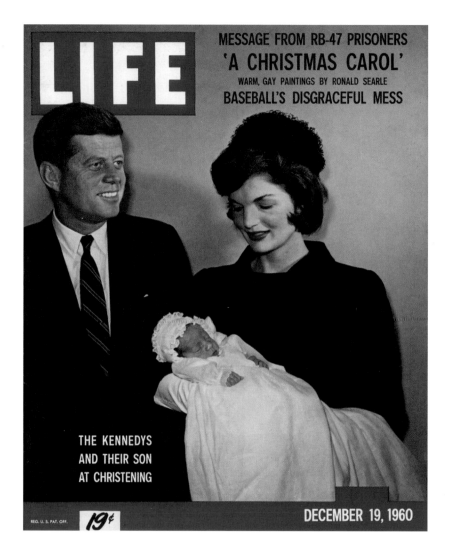

Stanley photographed it all. "Nothing was said at first, but when I went into the sanctuary and continued to photograph, Kennedy gave me a short wave away. I retired for about ten seconds and then continued to take pictures, moving about quite freely in the sanctuary. As I walked across to get a different angle, Jackie turned to me and moaned, 'Oh, Stawn!' She was getting very nervous.

"Then when the ceremony was over I started to get my lights moved for the set-up pictures of Kennedy, Jackie, and the baby. The senator was not prepared for this and when I approached him on the matter he said, 'Can't we do it some other time?' I told him no, that everyone was waiting for these pictures and I just couldn't come out of the chapel without them. He said, 'Okay. Where do you want to make them?' I pointed to some area in the chapel and he said, 'NO. I don't want a church background.' Then he turned and said, 'Let's make them here, against the wall.' I couldn't disagree at this point but it was not what I had in mind.... Jackie came to his side, holding the baby.

"Isn't he sweet, Jack?" Jackie asked. "Look at those pretty eyes."

Stanley moved in to get a close-up of the baby. "I pressed... Jackie and asked if she couldn't possibly get the baby to open his eyes for one shot. She looked at me and said, 'But Stawn, he's asleep.'

" 'Well, wake him up.'

"She just sort of looked at me in disbelief and finally when I asked her not to force her smile so much in the photograph, I knew I'd pushed too far. She put her head down and said, 'Please, Stawn, I've had enough.' "

President-elect Kennedy then asked for some family group pictures. "He likes that and I find it a very considerate trait in his makeup," Stanley wrote. "I believe he is concerned about the other people and knows they would like to be included in the photograph." The group included Mr. and Mrs. Charles Bartlett. He was the Washington correspondent for the *Chattanooga Times* and had introduced Jacqueline Bouvier and John F. Kennedy. Martha Bartlett was the baby's godmother and Prince Stanislas Radziwill, a London businessman and Mrs. Kennedy's brother-in-law, was the godfather. Mr. and Mrs. Hugh D. Auchincloss, Mrs. Kennedy's mother and stepfather, also attended with Mr. and Mrs. Robert F. Kennedy, Mr. and Mrs. Stephen Smith—brother-in-law and sister of Senator Kennedy—R. Sargent Shriver, who was married to Eunice Kennedy, the senator's sister, the artist William Walton, a close personal friend of the Kennedys, Pierre E. Salinger, Dr. John W. Walsh, who delivered the baby, and Dr. Edward B. Brooks, a Washington pediatrician.

Stanley later gave the President and Mrs. Kennedy the baptism photos, including the one that was selected for the cover of *Life* magazine. They asked for a second copy which they both signed and had framed for him.

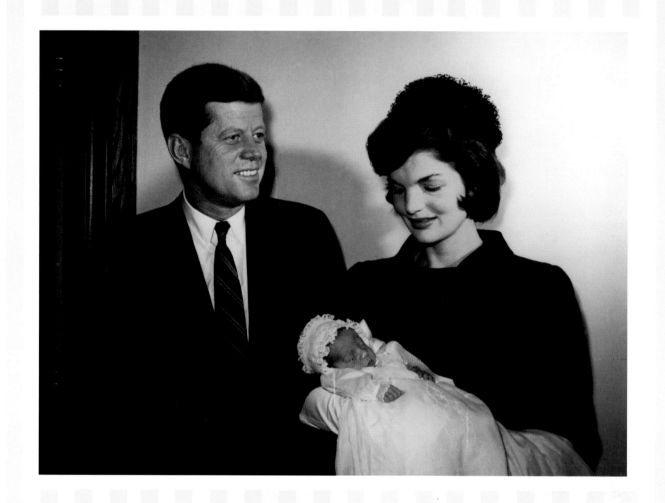

To Stanley — the only one who
could make us smile like this
Affectionately
Jacqueline Kennedy

To Stanley —
with the esteem and
very best wishes
John Kennedy

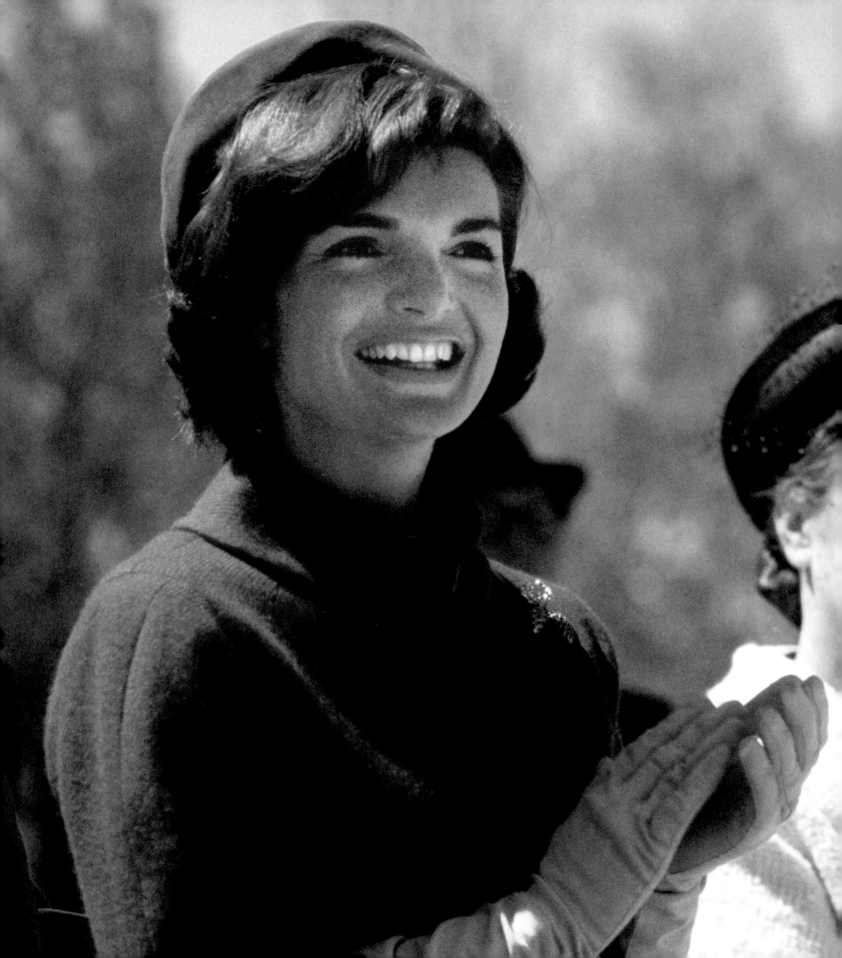

* * *

The First Lady in Canada, May 17, 1961, on her first foreign trip
with the President. She is shown here clapping for the Royal
Canadian Mounted Police in Ottawa. Mrs. Kennedy's fluency in
French was humorously noted by her husband that evening at a state
dinner. Struggling with one sentence in French, the President said:

"It's an unfortunate division of labor that
my wife who speaks French so well
should sit there without saying a word,
while I get up and talk."

* * *

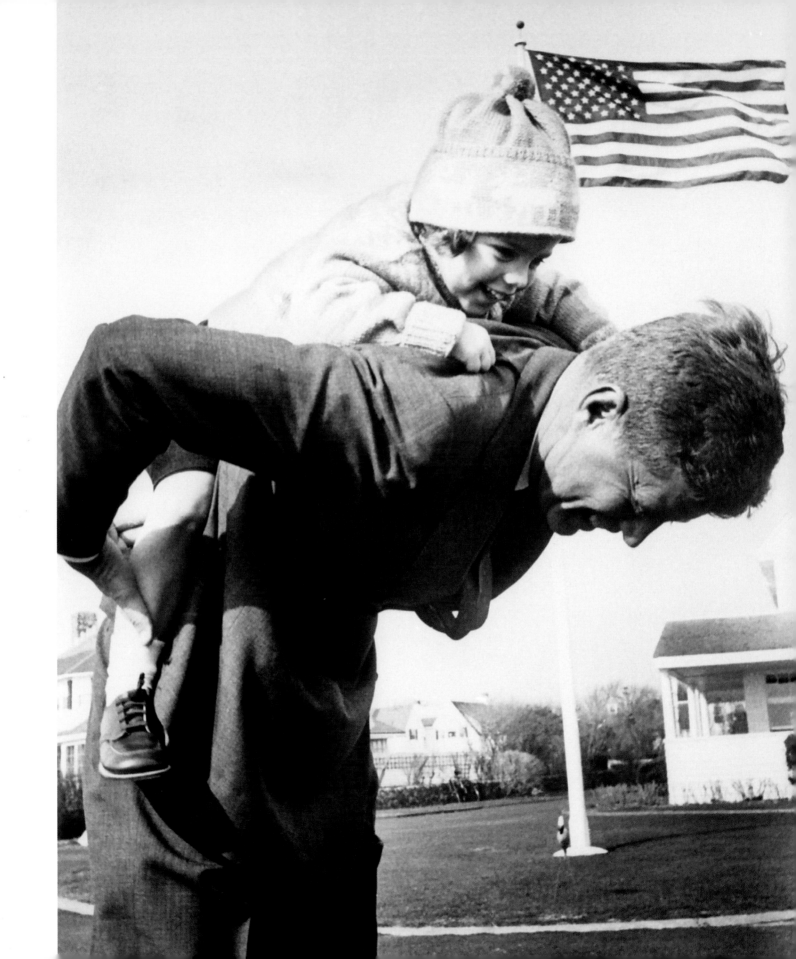

AFTER TAKING OFFICE, Kennedy became even more protective of his public image as he sought to project youth, strength, and "vigah" for his New Frontier. This meant hiding his debilitating health. From childhood on he had suffered from various undiagnosed ailments, including serious digestive problems, abdominal pain and intestinal disorders—later found to be ulcers—and colitis. By the late 1930s he experienced pain from degenerative back problems that plagued him during the war. He underwent spinal disc surgery in 1944. In 1947 he was diagnosed with Addison's disease, once terminal but manageable by steroids. The condition was never acknowledged during Kennedy's lifetime, although Texas governor, John Connally, raised the issue on behalf of Lyndon Baines Johnson during the 1960 campaign. JFK issued a public denial.

By 1954 his back pain was so debilitating that he elected to have surgery, which was dangerous for someone with Addison's. It took him nine months to recover, but his senate staff, not fully informed, minimized the difficulties of the operation and exaggerated its success. The surgery involved putting a plate in his back, which later became infected and had to be replaced, all of which was complicated by his adrenal gland deficiency. He later experienced back spasms, and had so much difficulty moving that he received regular injections of procaine to fight the pain.

As President, he was susceptible to infections and was treated for respiratory problems, sinusitis, urinary tract infections, prostatitis, and abscesses along the surgical scars on his back. He suffered from insomnia for which he took Nembutal, a sleeping pill. He was also given Stelazine, an antipsychotic drug used to control anxiety, and he regularly received amphetamine injections.

Caroline, three years old, playing piggyback with her father at Hyannis Port, November 9, 1960. His back pain became so excruciating during his White House years that he was unable to lift his children or even bend over to pick up a pencil from the floor.

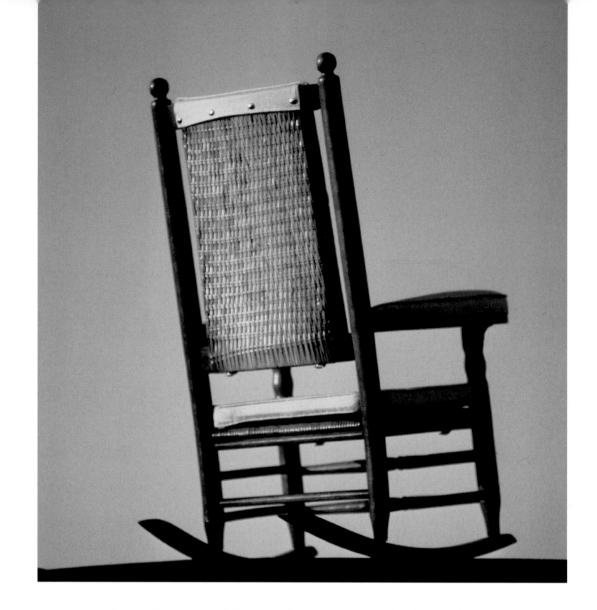

No one knew the extent of the President's precarious health until many years after his death. Stanley was aware of his chronic back pain, which he had been told stemmed from JFK's PT boat heroics during World War II. In a 1961 memo to *Look*'s managing editor, Stanley wrote: "Because of the President's back injury it's been extremely difficult to get the picture you requested. Pierre won't set anything up as long as the crutches are around and I wouldn't even entertain a notion to ask the President for anything while he is having that back pain."

(above) **White House physician, Dr. Janet Travell, the first woman to serve in that position, prescribed this rocking chair to help relieve the President's lower back pain.** *(opposite)* **John, Jr., plays on the President's rocking chair.**

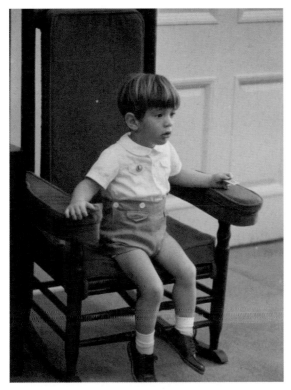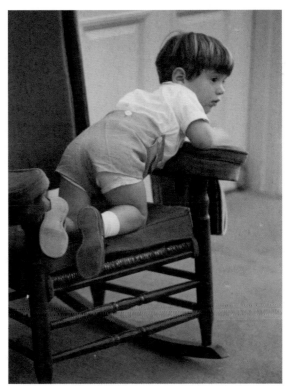

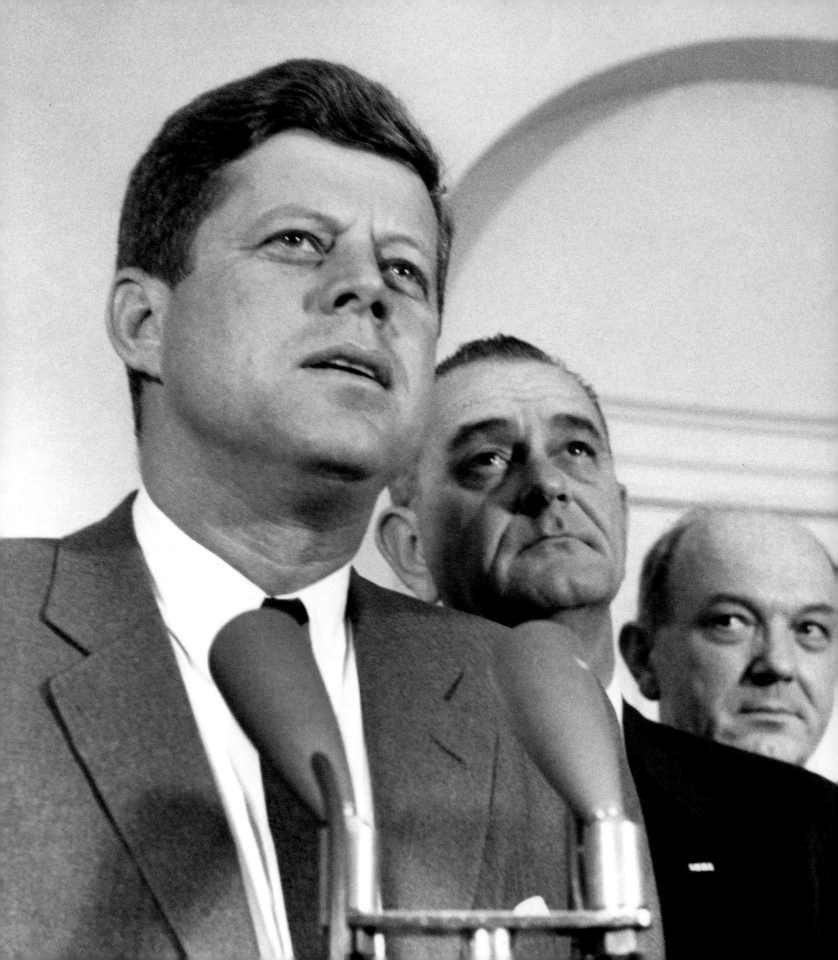

★ ★ ★

President Kennedy, Vice President Johnson, and Secretary of State Dean Rusk, August 21, 1961, at a press briefing following Johnson's trip to Berlin, where Russian Premier Khrushchev had erected a barbed-wire fence to divide East and West. Johnson's trip was to demonstrate the United States commitment to the people of West Berlin. As President Kennedy said in his 1963 trip to Berlin:

"All free men, wherever they may live, are citizens of Berlin....

Ich bin ein Berliner."

★ ★ ★

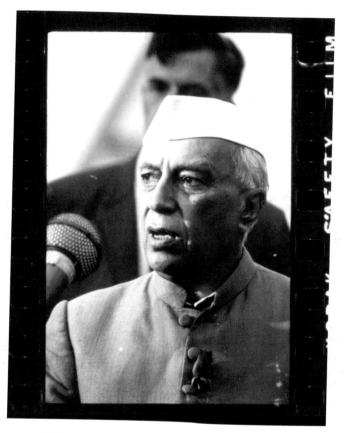

President Kennedy welcomes Indian Prime Minister Jawaharlal Nehru, to the United States, November 6, 1961, for a ten-day visit. The two leaders are shown here at Andrews Air Force Base, the President in a suit and tie, the Prime Minister in an achkan, the Indian outfit he made famous. He presented a Nehru jacket to the President's daughter as a farewell gift.

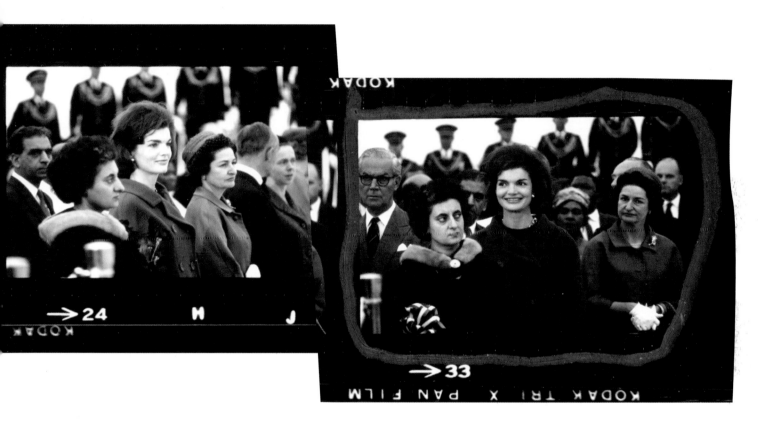

Nehru's daughter, Indira Gandhi, considered First Lady of India, and U.S. First Lady Jacqueline Kennedy at the welcoming ceremony. All smiles for the camera, Jackie admitted that the two First Ladies did not get along. Mrs. Kennedy characterized Mrs. Gandhi, a dynamic politician who would succeed her father as Prime Minister, as "a prune," "violently liberal," "bitter," and "twisted."

ONCE IN THE WHITE HOUSE,
Mrs. Kennedy, who did not like being called First Lady—"Sounds like a race horse," she once said—laid down the law to the President and Pierre that the children were off limits and not to be photographed for anything by anyone at anytime without her approval.

"Jackie has instructed all those around the kids to keep them out of the limelight, which means away from photographers," Stanley wrote to *Look*'s managing editor, explaining how difficult it would be to get any pictures of the President's children. He indicated that the White House press secretary was afraid to tangle with the First Lady over the matter. "It's getting so that I find it extremely difficult to deal with Pierre simply because I don't trust him. However, he has told me if I can deal directly with Jackie he'd support whatever she wants to do."

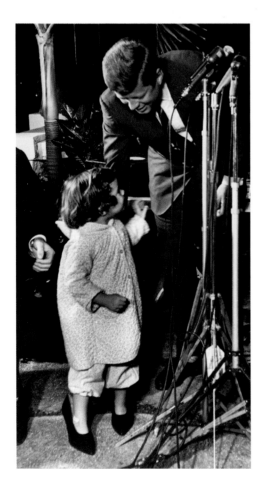

Caroline Kennedy, three years old, in her pink pajamas and her mother's high heels, walks into her father's press conference in Palm Beach on December 29, 1960. The President-elect, standing next to J. William Fulbright, chairman of the Senate Foreign Relations Committee, is about to announce the nomination of Averell Harriman to the newly created post of ambassador-at-large. Kennedy wanted to name Fulbright to the position but the Arkansas senator was a segregationist whose nomination would not have passed approval in a Democratic congress.

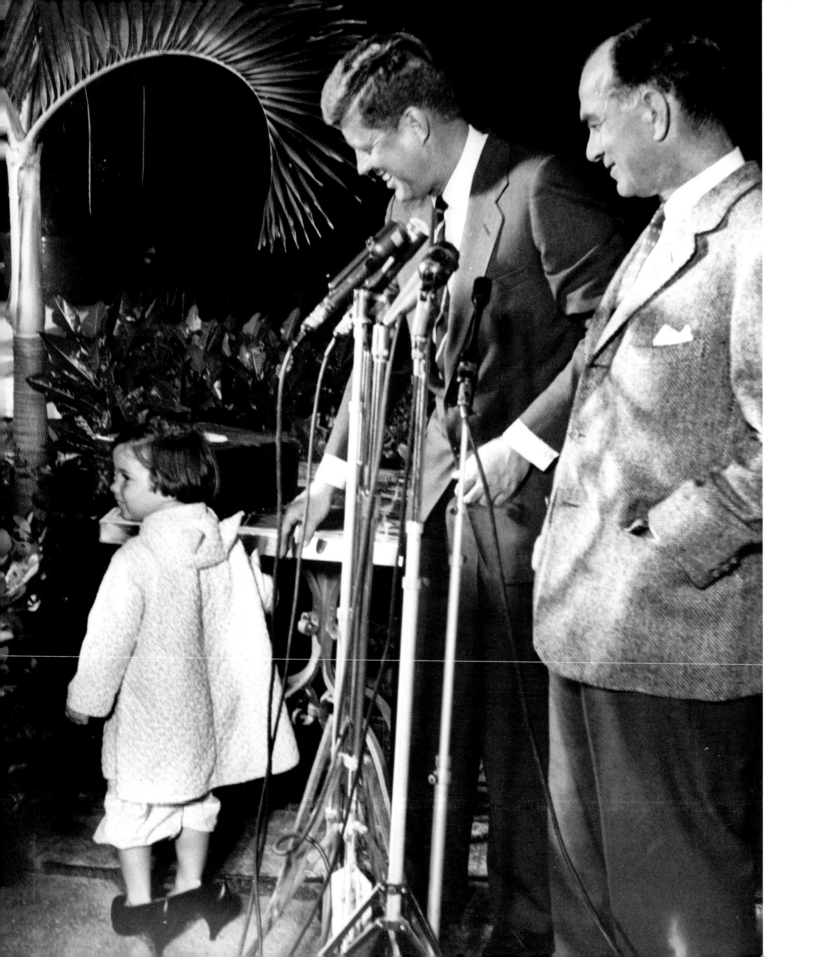

So Stanley wrote "a grovel," as he later characterized his letter to Mrs. Kennedy:

> For some time now I have been talking with the editors of *Look* magazine and find
> they are interested in allowing me to work out the necessary arrangements for
> stories on the new administration. Some of these, the most important ones, would
> of course involve yourself and the President. The fact that the photographs in
> these stories are mostly of a "candid" nature, I have proposed to them that abso-
> lutely no pictures be used until they are submitted back to you for final approval.
> It is my feeling that this type of arrangement would give you a certain "peace of
> mind" and allow me to photograph with the freedom necessary to do an honest
> and perceptive story of the highest possible standards. Because of your prior
> journalistic background [Jacqueline Bouvier was a reporter/photographer for
> the *Washington Times-Herald* before she married], I also think it might be ex-
> tremely interesting for you to see a story of your choosing take shape from the
> beginning and follow it through until it folds into final form.

Stanley proposed doing a story about the First Lady's restoration of the White House
and her first trip to Paris with the President. "With your knowledge that you will have a
say in the final layout and selection of photographs it is my firm belief the end result will
be to our mutual satisfaction."

Mrs. Kennedy did not respond.

So Stanley decided to approach the matter sideways by requesting a photo shoot with
R. Sargent Shriver, the President's brother-in-law, who was running the Peace Corps.

French President Charles de Gaulle, greets President Kennedy at the Élysée Palace in Paris, May
31, 1961. De Gaulle insisted that his government be treated equally with Britain in planning
Western strategy. He opposed integrated NATO forces and denied the United States the use of
French territory to stockpile nuclear weapons for NATO's use.

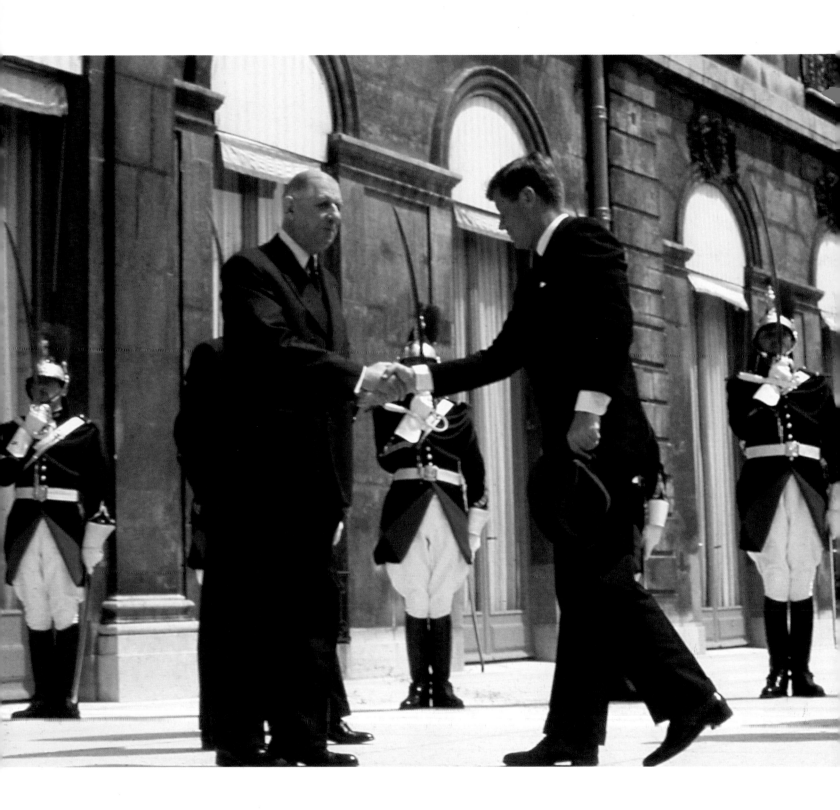

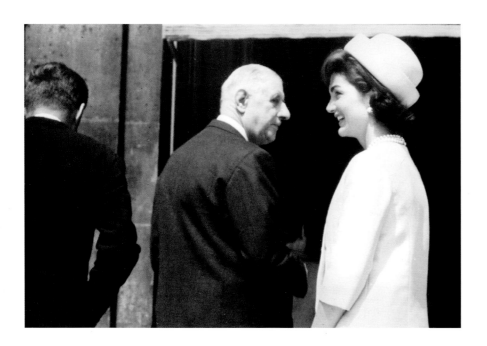

(above) "[Charles] de Gaulle was my hero when I married Jack," said Jacqueline Bouvier Kennedy, shown here with the Free French leader of World War II. She even named her French poodle "de Gaulle." Her opinion of the French President changed after the Kennedys' state visit, but de Gaulle remained impressed with her, telling the President: "Mrs. Kennedy knows more French history than most French women." (opposite) Madame de Gaulle, President Kennedy, President de Gaulle, Mrs. Kennedy, and Mrs. James M. Gavin, wife of the U.S. Ambassador to France, listen to throngs yelling "Jack-ee, Jack-ee." At a press club luncheon, President Kennedy said: "I do not feel that it is inappropriate for me to introduce myself. I am the man who accompanied Jacqueline Kennedy into Paris…and I've enjoyed every minute."

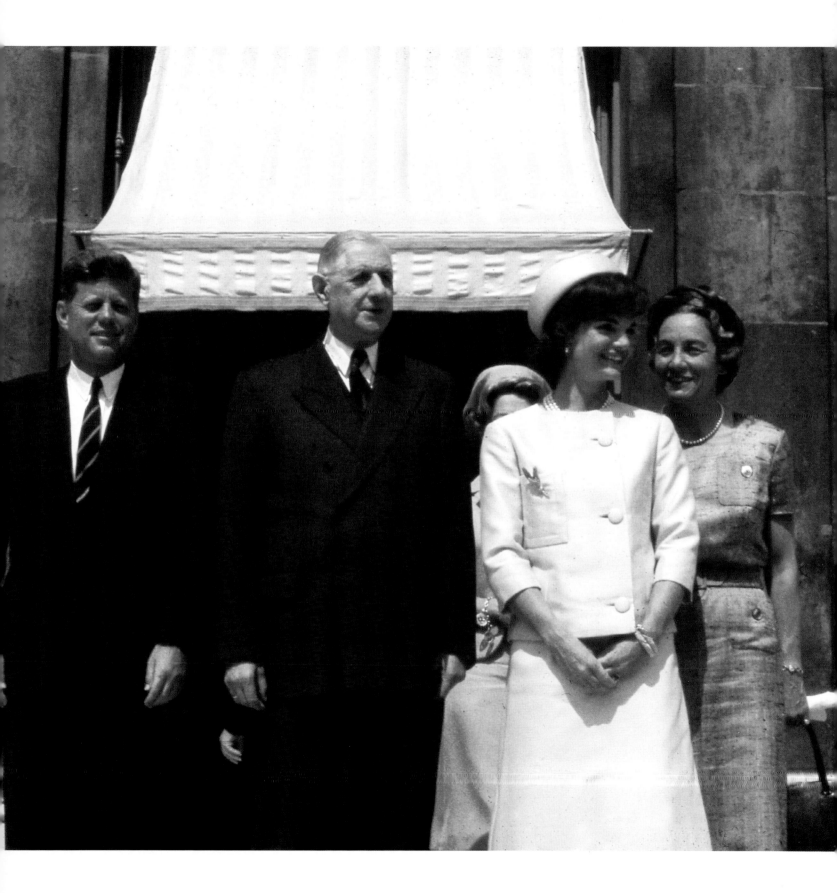

After Paris, President and Mrs. Kennedy flew to Vienna for a summit conference with Russian Premier Nikita Khrushchev, June 3, 1961. Requested by JFK, this meeting took place six weeks after his disastrous Bay of Pigs invasion, which killed 5 Americans and 114 Cuban exiles, leaving hundreds more imprisoned.

The mutual distrust and dislike of the two leaders can be seen in this photo. Khrushchev dismissed Kennedy as weak and naïve, leading the Kremlin to slip missiles into Cuba sixteen months later, bringing the U.S. and U.S.S.R. to the brink of war. Kennedy saw Khrushchev as "a thug" and left the summit shaken, saying: "It was the worst thing in my life. He savaged me."

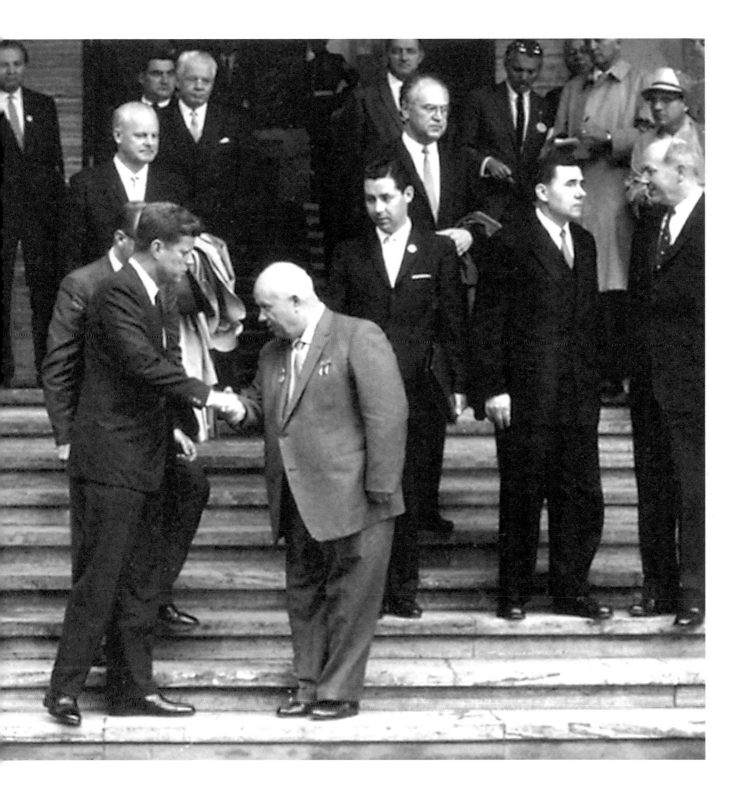

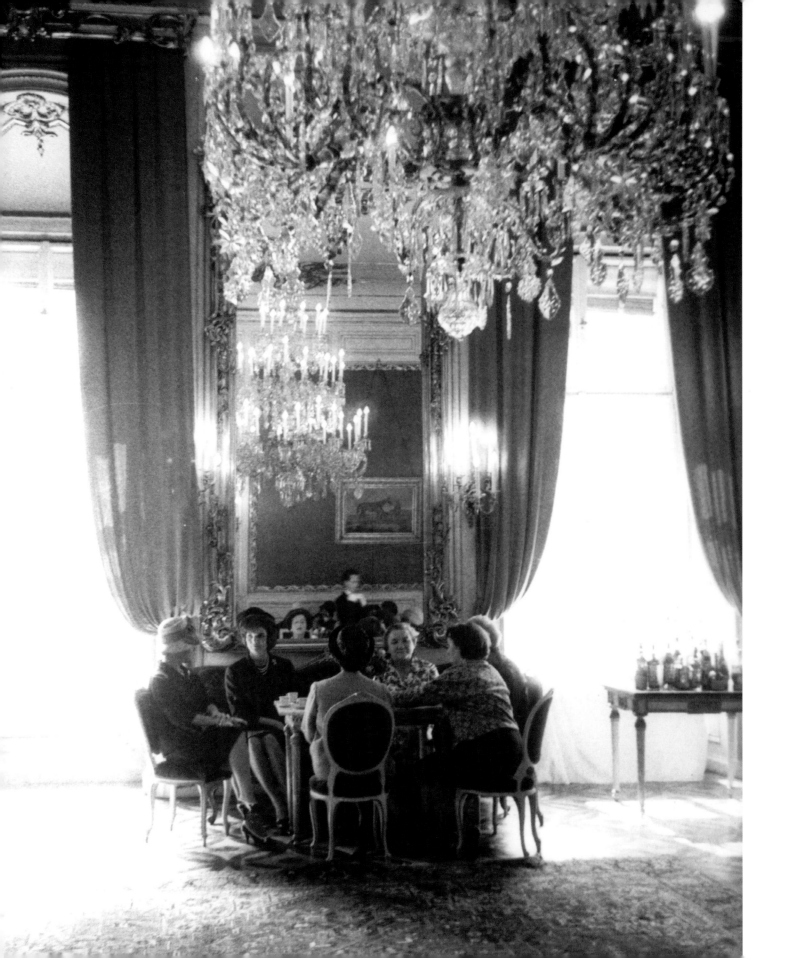

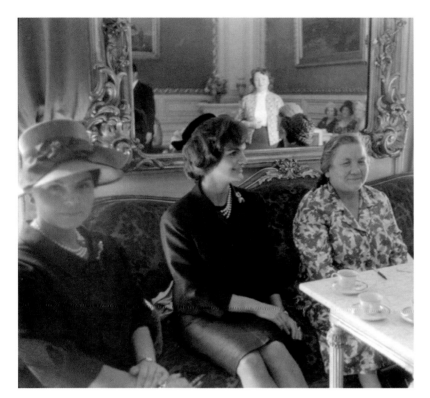 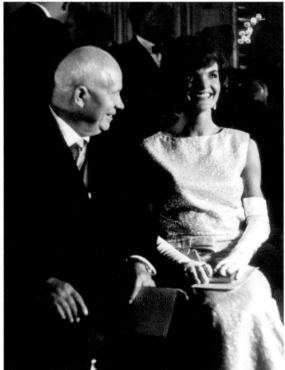

(opposite) **During the summit Mrs. Kennedy and Mrs. Khrushchev met for lunch in the Pallavicini Palace. Jackie later confided to the historian Arthur Schlesinger, Jr., that she did not like Madame Khrushchev (Nina) because the Premier's wife had chided her for smoking. "You shouldn't smoke so much. Russian women don't smoke. . . .' I got sick of all that," said the First Lady. "Those little digs all the time."** *(above left)* **Galina Khrushchev (daughter-in-law the Premier), Jacqueline Kennedy, and Nina Khrushchev meet for tea on the second day of the summit. "I really hated her," Jackie said of the Khrushchevs' daughter-in-law, whom she mimicked to Schlesinger. " 'Did you go to engineering school?' You know, always trying to make themselves seem better. I suppose it was a chip on their shoulder. But I'm trying to be polite and it didn't make it very comfortable."** *(above right)* **More relaxing for Jackie than Madame Khrushchev was her husband, despite "his heavy humor." Mrs. Kennedy said that sitting with the Russian Premier at a state dinner hosted by Austria in the Schoenbrunn Palace, June 3, 1961, was "like spending an evening with Abbott and Costello. . . . It's just one gag after another."**

S HRIVER INVITED STANLEY TO
Hyannis Port over the July 4th weekend in 1961 for a family picture session.
"I'm quite certain the President plans to spend the same weekend there also,
plus other members of the Kennedy clan," Stanley wrote to his editor. "I believe
the best way to play it is to just concentrate on the Shrivers and then if anything presents
itself with the President or Jackie, I'll go for it."

(above) The first presidential summer of 1961 was a happy time for the Kennedys, who congregated
at the family's 4.7-acre compound in Hyannis Port overlooking Nantucket Sound to swim and sail
and play touch football. Ambassador Joseph Kennedy always flew the American flag when the
President was in residence. (opposite) The senior Kennedy tried to stay in the background of his
son's campaign for President but as these photos show he was always in the forefront of the family.

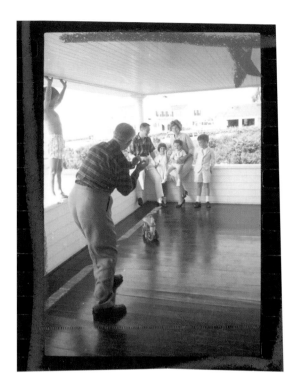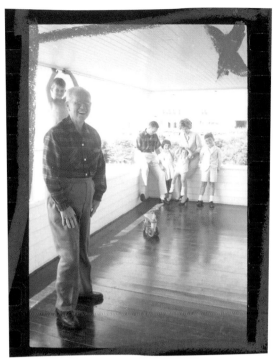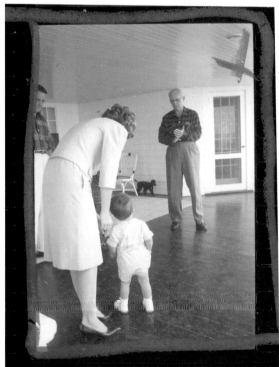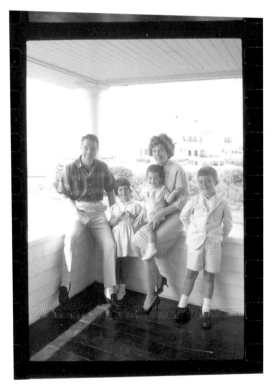

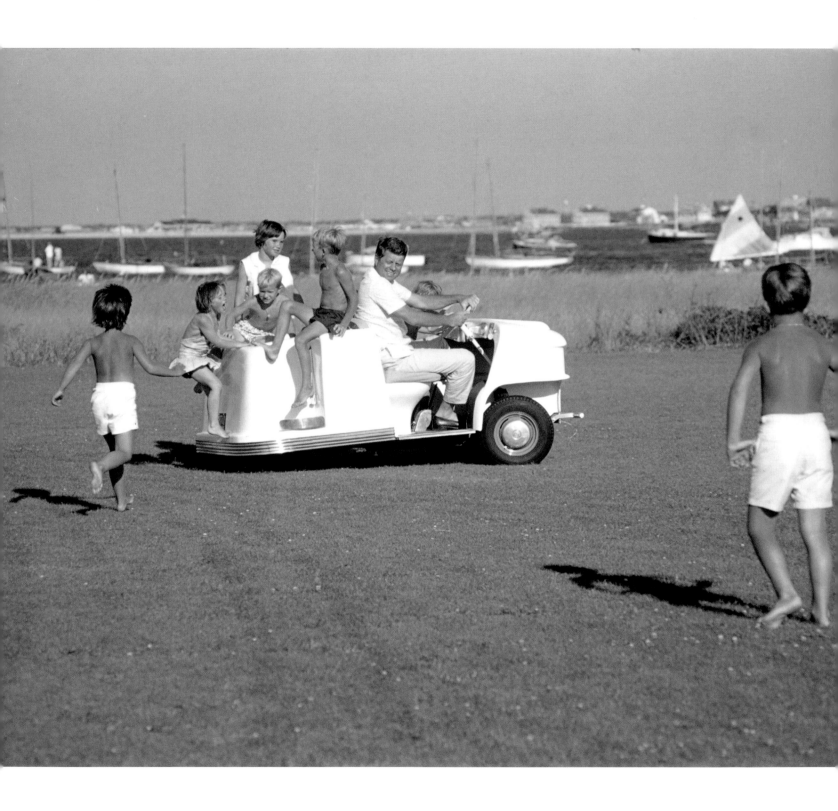

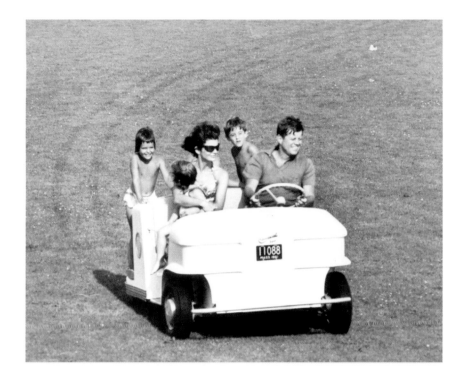

In Hyannis that weekend Stanley saw the President driving a golf cart full of Kennedy youngsters across the family compound. Recognizing a great photo op, he asked permission to make the picture, but JFK said he would have to check with his wife. He called Stanley later to say he could have the golf cart photo but without Caroline and John. Stanley leaped and *Look* landed another exclusive cover. Later he said, "Jackie was always pulling Caroline away from the picture. She had a thing about it…and the President wouldn't intervene. He bowed to her wishes. He didn't want any problems with her."

Whenever "Uncle Jack" clapped his hands at Hyannis Port the little Kennedys and Shrivers and Smiths and Lawfords came running for a ride in his golf cart, either to the beach or to the candy store. Their favorite game was to try to run over the photographer.

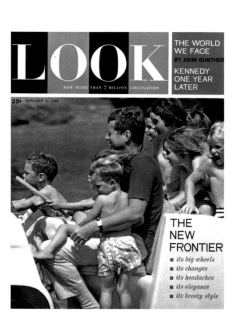

LOOK

THE WORLD
WE FACE
BY JOHN GUNTHER

KENNEDY
ONE YEAR
LATER

NOW MORE THAN 7 MILLION CIRCULATION

25¢ JANUARY 2, 1962

THE
NEW
FRONTIER

■ *its big wheels*
■ *its changes*
■ *its headaches*
■ *its elegance*
■ *its breezy style*

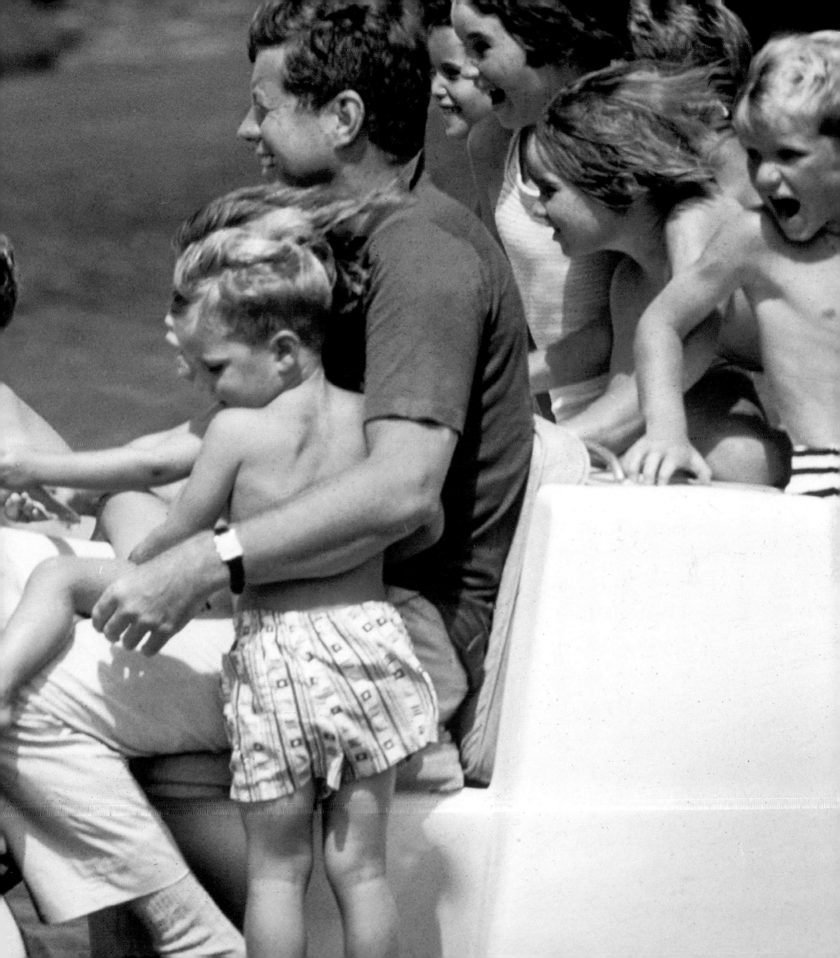

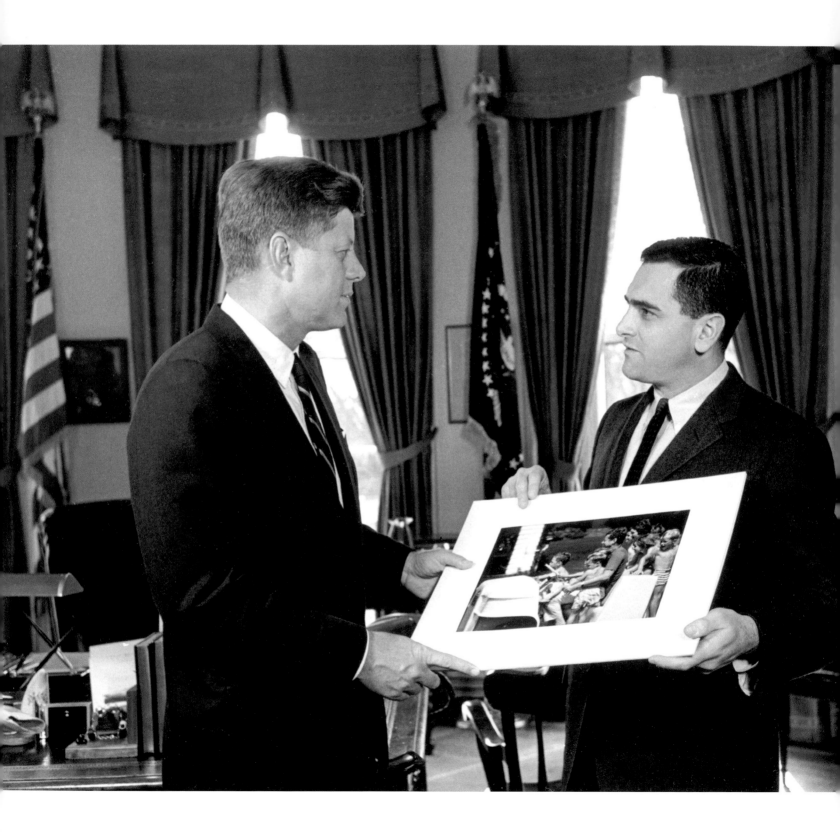

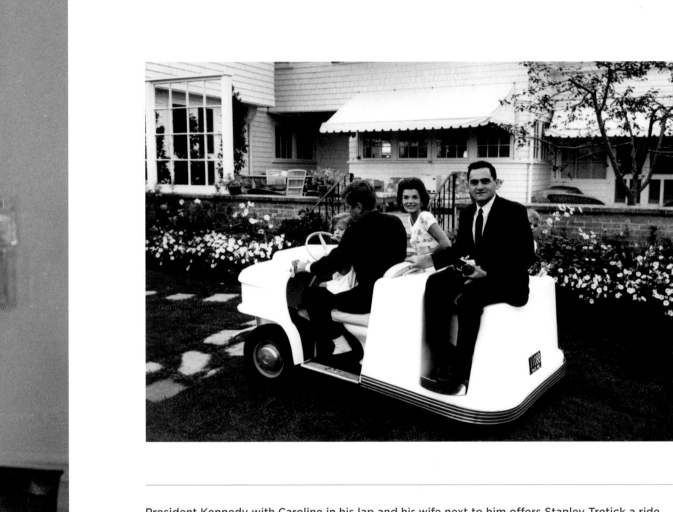

President Kennedy with Caroline in his lap and his wife next to him offers Stanley Tretick a ride in the golf cart. This photograph, taken with Stanley's camera by R. Sargent Shriver, accompanied the *Look* cover story, January 2, 1962, entitled "The New Frontier."

DURING THAT JULY 4TH WEEKEND Stanley trailed the Shriver children around the Kennedy compound. At one point, he saw Caroline playing with Maria, holding a postcard of JFK.

"This is the President," said Maria.

"No," Caroline said. "That's my daddy."

"But he's the President, too," said Maria.

"No. No. That's my daddy."

Moving in with his camera, Stanley said, "Why don't you hold the picture of your daddy up, Caroline, and I'll make a picture of you."

Although Jackie said Caroline was "off limits," Tretick said he couldn't resist, especially when she was playing with her cousin, Maria. That, too, concerned the First Lady. "I just felt so strongly about those children. It was hard enough protecting them in the Kennedy family, where some of the cousins, especially Eunice's children are—were so conscious of the position, and would always wear Kennedy buttons and would play that record, 'My Daddy Is President. What Does Your Daddy Do?'" Tretick made an album of his Caroline images for the First Lady, hoping to persuade her to allow *Look* to publish them.

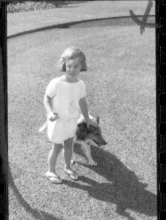
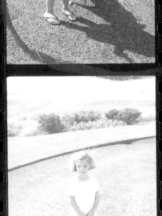
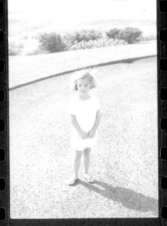

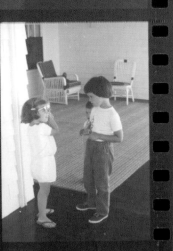
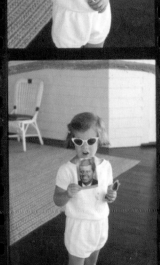
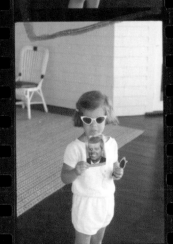
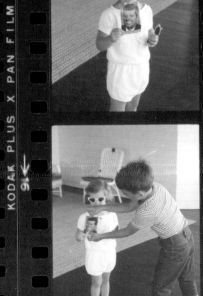

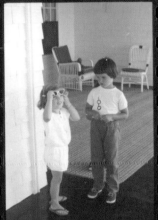
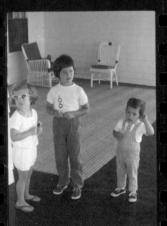

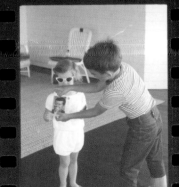

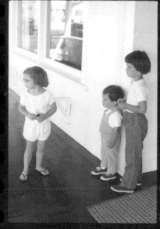
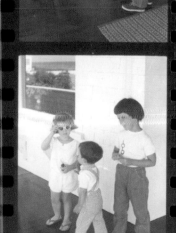

★ ★ ★

Caroline holds up a picture postcard to
Maria Shriver, who screamed:

"This is the President."

Caroline disagreed:

"No. No.
That's my Daddy!"

★ ★ ★

When Pierre Salinger saw Stanley take the forbidden shot of Caroline, he barreled across the lawn, yelling at Stanley to stop. "That's it. You're through for the day. Out." As Stanley retreated, Caroline ran over to ask what happened to their "picture taking." Stanley said Mr. Salinger was upset, but if she wouldn't tell anyone, he would teach her how to take her own pictures. Reaching into his camera bag he pulled out a small Brownie loaded with film, and showed her how to use it. He told her to go into the family compound and take pictures of her mommy, her daddy, and her little brother. "But let's do this as a secret game and not tell anybody."

Caroline did as she was told for about an hour, until Pierre came thundering out again, screaming that Stanley was going to lose his White House press credentials if he didn't surrender Caroline's film immediately. Stanley handed over the Brownie. The next day when the President saw him, he said, "Nice try."

Later in the summer the attorney general, Robert Kennedy, brought his family to Hyannis for a vacation with strict orders that no pictures were to be taken of the children—particularly Bobby, Jr., who had a broken arm, and Courtney, who had a broken leg. Both were wearing casts. The next day UPI clients around the country ran photos of the two children inside the family compound. Steamed, Robert called the White House press secretary, demanding to know how UPI had penetrated the rigid security.

Pierre Salinger, who later described Stanley "as one of the most enterprising photographers I have ever met," immediately confronted him.

"I swear to you, Pierre, I did not take those pictures," Stanley said.

Salinger reported back to Robert Kennedy, who was now livid. "Well, if you can't find out, I will," he said. After interrogating the Secret Service for the name of every person within the compound, he called Salinger back. "I'll give you one guess who took those pictures."

"I haven't the foggiest."

"Your son, Marc."

Here the President rushes down the dock of his father's house to board the family yacht, *Honey Fitz*, named for his maternal grandfather, a legendary mayor of Boston. "It was really the boat that relaxed him the most," said Jacqueline Kennedy. "This was his away from care…no phone."

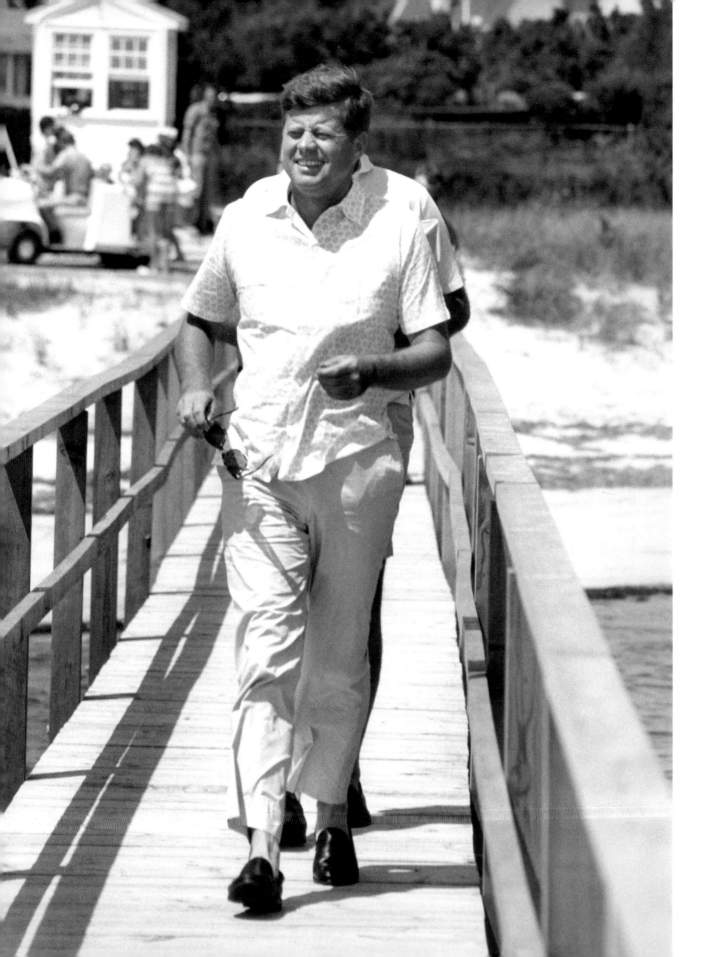

For weeks Stanley had been giving Pierre's twelve-year-old son secret lessons with a Nikon, knowing that Marc had free run of the family compound. Stanley told him to go inside, shoot a roll of film, and return it to him out of sight of the Secret Service.

At the time the "enterprising photographer" was photographing the Shrivers. Caroline, then five, joined her cousins for a sail and a picnic. "She was running loose all over the beach along with the other kids," Stanley wrote to his editor. "I finally couldn't contain myself any longer and shot some stuff on her. Pictures of her eating should be funny. She sure is messy. Then she sat up on the boat in a beach robe and I made something on that, too. I really couldn't bear down too hard on her because I didn't want to make it obvious in front of the others and it would also be discourteous to the Shrivers who I was really supposed to be shooting. However, you just can't count on an opportunity like this coming along again so I just had to record some of it. And here is one of the great quotes, the attorney general to the President's daughter: 'Caroline, will you stop spitting in the boat!' "

The next morning, Sunday, as Stanley was photographing the Shrivers after church, Caroline came around the corner. "Are you still here?" she asked.

"I didn't make any photos of her then," Stanley told his editor, "because I think I pushed it as far as I should yesterday. Also Bobby said to me this morning that Jackie was a little upset about the picnic incident, that she wouldn't have let Caroline go if she knew I had my camera along.... He said he would appreciate it if I would submit the photos to Jackie.... The last thing he said to me was, 'Will you take responsibility?' And I answered, 'Yes.' "

To persuade his editor to hold back the Caroline pictures, Stanley wrote:

> The entire thing really boils down to this: I was a guest of the Shrivers and allowed to photograph their activities on the Cape with no restrictions. I was not invited by Bobby or the First Lady so anything we have on them should be held under wraps until they okay it. This, of course, includes Caroline.

However, once the *Look* editors saw the photographs of Caroline—the first, exclusive, intimate candids of the President's daughter—they pressured Stanley to "shake them loose—and fast." In a crafty, July 17, 1961, memo to his editor, he wrote:

Our best pitch is to emphasize the fact that I was doing the Shriver kids and some of the others when Caroline got in the act. Naturally, there are some good shots of Caroline at the beach and on the boat and we would want to include some of those. However, here again Maria Shriver is with Caroline and I hope she'll [Mrs. Kennedy] understand I took the liberty of including Caroline because she was so cute and added to the pictures. I don't think we should use much of Caroline alone in photographs on this first presentation to Mrs. Kennedy lest it appear obvious we are featuring the President's daughter above all. I know it's a gamble because I know you would want to use singles on her badly but we have to consider above all else the First Lady's reaction....

Stanley added that he had cropped the photos and suggested printing them so they appeared "rich and arty-looking. I think Mrs. Kennedy goes for this."

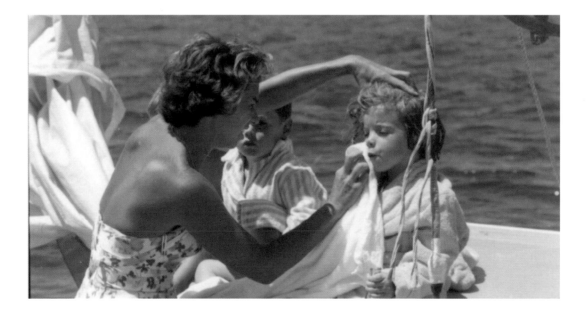

(above) Ethel Kennedy wipes her niece's face on the Kennedy sailboat at Hyannis Port during the summer of 1961. *(following pages)* Caroline waits forlornly on the dock for her father's return. The First Daughter, a natural news target, was ferociously protected from the press by her mother, but Tretick, working on a *Look* story about Sargent Shriver, took full advantage of his visit to Hyannis Port.

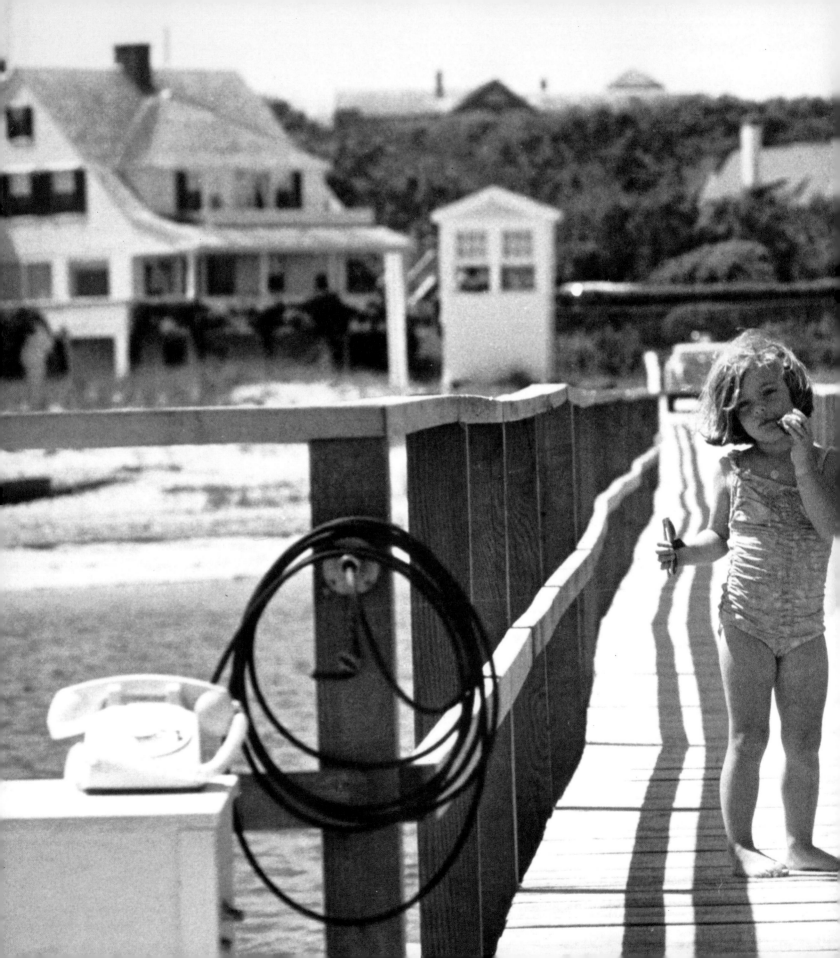

MRS. KENNEDY DID NOT GO FOR publishing the photos of Caroline because she said they were "too good," except for the one of Caroline and Maria arguing over JFK's picture. "Caroline looks bratty," said her mother, nixing the photograph. In fact, the only picture she allowed to be published showed Caroline from the back, which Mrs. Kennedy somehow felt preserved her little girl's anonymity.

"Let's hold the rest back for a while," Stanley told his editor, "and I'll work on her." Meanwhile, Ambassador Kennedy advised his family to get the negatives. "If you don't, the bastards will publish them."

The magazine held the forbidden pictures for a year, but once *Life* published a photo of Caroline, *Look* editors overruled Stanley and published his pictures under the title "Caroline's Wonderful Summer." The day the issue hit the newsstands, August 14, 1962, Pierre Salinger caught unshirted hell from the President and the First Lady. He then turned on Stanley. "You'll never get another $%✝&* story out of this White House as long as you live," he roared. The attorney general claimed *Look* had breached national security, adding: "My father always said you'd use those pictures."

Stanley stayed away from the White House for a few days. "It was rough over there for awhile. Even the President went into lockdown but I think it was because Mrs. Kennedy gave him the devil...he got over it."

But not before Stanley wrote to say he was sorry:

> Dear Mr. President:
>
> I feel that I owe you an apology and an explanation about the publishing of the Caroline pictures which came about as the result of an incredible series of snafus and lack of communication between my New York office and the White House....

Stanley explained that he had not been consulted on the decision and was extremely distressed over the entire affair:

Mr. President, you've known me a long time and I have never once personally broken my word to you, I have great respect for your feeling of good photographs and am attuned to your desire of creating an image of dignity, grace, and warm human qualities in photographs. My great desire is to pictorially record your term in a series of intimate studies which would be beneficial to both you and my magazine.

Ted Sorensen told me yesterday just how upset you were about this and that you tried to get hold of me… and I was lucky you didn't. I said I hadn't talked with you personally at all but that I was going to state my case in this letter. Ted said he thought that was a good idea.

While the President was angry at *Look* for publishing the photos without consent he apparently liked the Caroline story, at least as related to Stanley by Ted Sorensen, who said he had discussed the article with the First Lady.

"What did you think of it?" asked Jackie.

"We all read it on the plane coming up [to Hyannis Port]. The President liked it. Pierre liked it. I liked it," Sorensen said.

"That doesn't say much for your literary judgment," she said.

The Caroline photos caused a deep freeze that lasted for a few weeks, but the President and the photographer needed each other too much to remain adversaries. As Laura Bergquist, *Look* correspondent, said of JFK: "He was a reasonable man

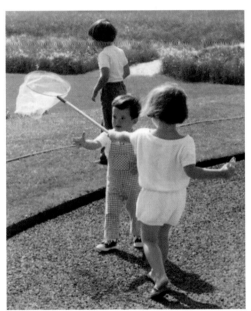

(*above*) Jackie said "yes" to *only* one of the many pictures Tretick submitted, and that was of Caroline standing on the lawn, butterfly net in hand, with her back to the camera…. In her note to the photographer, Jackie wrote: "So many thanks for the marvelous pictures in the album … You are right they are such good pictures…. It is partly because they are so good I must sadly tell you I just can't give you permission to publish them."

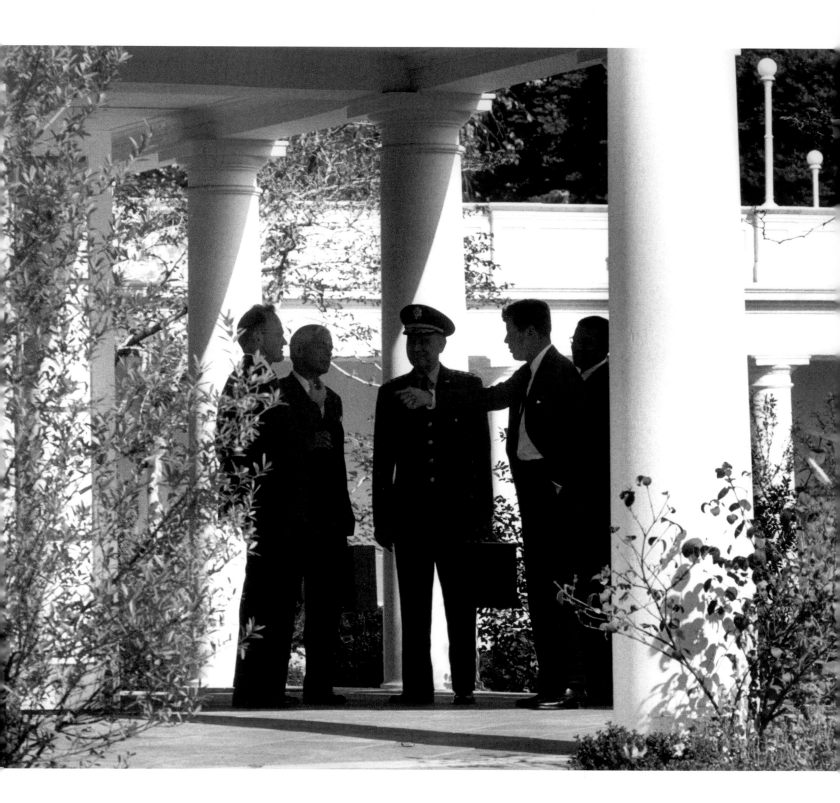

open to persuasion in matters of self-interest."

Thankfully for Stanley, he had come up with another idea that intrigued the President. In a memo to his editor, he proposed "a first-class picture book," saying: "I think I could sell Kennedy on allowing me the access which would enable us to get more intimate photos than anyone else. His 'sense of history,' I think, would make him go for both the picture stories of individual events and the idea of an intimate photographic record of his administration."

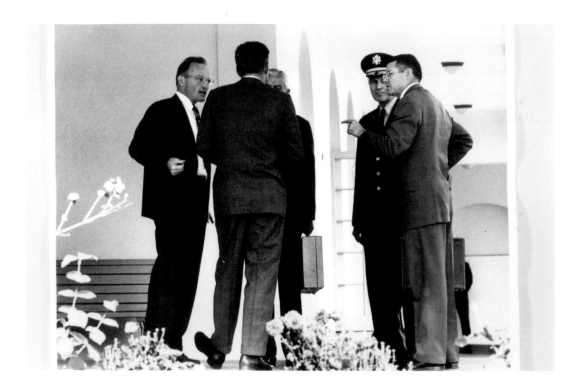

(opposite) The Cuban missile crisis lasted thirteen days, October 16–28, 1962. The President did not inform the country until October 22 that the United States was on the precipice of war with Russia. Many of his secret meetings with advisors were held outside, away from the Oval Office where he frequently tape-recorded conferences and calls. *(above)* Through a long lens the President can be seen conferring with his national security advisors McGeorge Bundy and Paul Nitze, and General Maxwell Taylor and Secretary of Defense Robert McNamara.

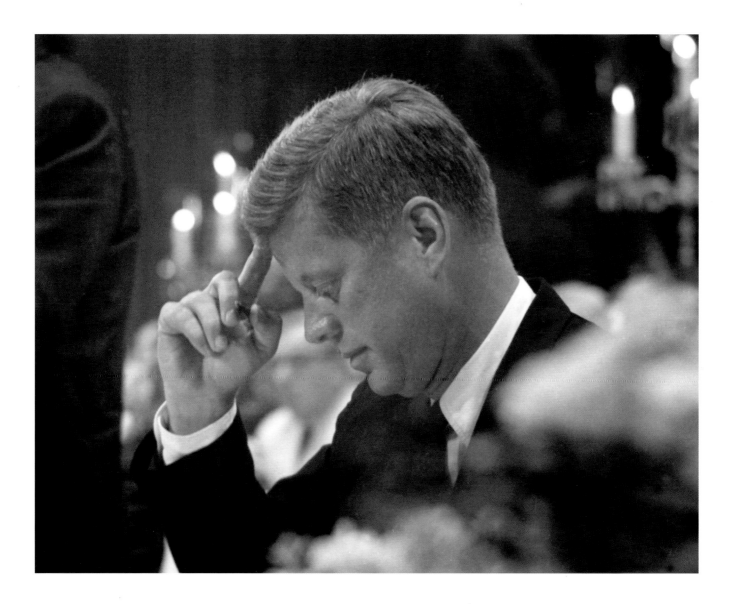

(opposite top) White House speechwriter Ted Sorensen drafts the remarks Kennedy will deliver on television, announcing to the nation that the United States has "unmistakable evidence" that the Soviets have established nuclear warheads in Cuba. (above) The President studies his speech, which states that the U.S. will respond to the Soviet threat with "a strict quarantine on all offensive military equipment" to prevent missiles from reaching Cuba. Six days later Khrushchev withdrew his bases.

★ ★ ★

October 28, 1962: Late that night, the President can be
seen alone at his desk, talking to the attorney general,
his most trusted advisor, who reassured him:

"If you hadn't acted,

you would have been impeached."

★ ★ ★

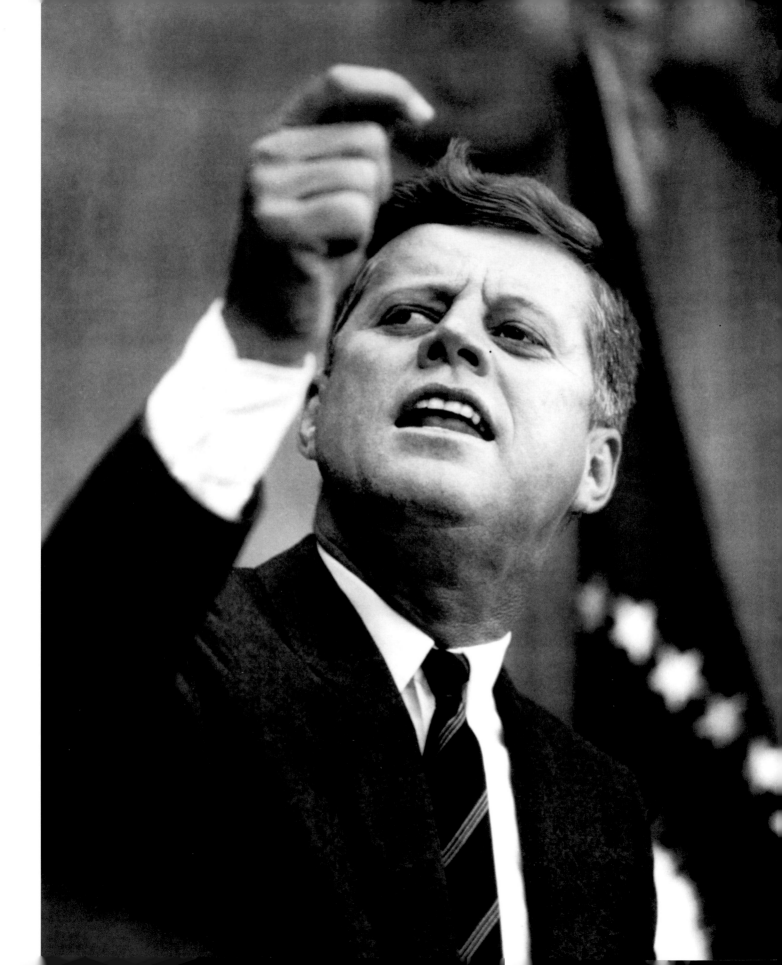

S TANLEY THEN WROTE TO KENNEDY proposing to do the first intimate photographic study of a President's term in office published in book form:

> There have been other picture books but they were put together after the events from a hodgepodge of photos gathered from a variety of sources. Never before has an effort been made to record a President's activities with the flow of events....

JFK loved the idea and the result was a book entitled *A Very Special President*, which sadly he never saw. Published after he died, the book was dedicated to his memory:

> It would be unthinkable to dedicate this book to anyone but John F. Kennedy. Still, both publishers and authors [Stanley Tretick and Laura Bergquist] owe a special debt of gratitude to Mrs. John F. Kennedy, who wrote the touching tribute to her husband quoted in these pages for *Look* magazine's John F. Kennedy memorial issue and also permitted the use of her picture inscribed [to Stanley] in a style as personal as her husband's. We owe apologies to Caroline Kennedy, for printing pictures of her at a time when her mother was doing her best to shield her from publicity and from spoiling by us vultures of the press, and a salute to John F. Kennedy, Junior, for just being himself—live-wire, talkative, natural as his father ever was.

In the midst of the Cuban Missile Crisis the President begins a trip to campaign for Democrats in the midterm elections. In Cleveland and Chicago, October 10, 1962, he calls for the defeat of Senate Minority Leader Everett Dirksen, who was reelected. The race Kennedy cared most about that year was the special election in Massachusetts for his Senate seat, won by his brother Teddy.

The attorney general reports to the President on the race riot at the University of Mississippi (Ole Miss), September 30, 1962, which killed three and left at least fifty wounded, when James Meredith tried to enroll. The Kennedys sent more than five hundred U.S. marshals to escort Meredith on campus but when mobs of segregationists attacked the marshals with guns, bricks, and Molotov cocktails, the President sent in the National Guard to restore order. Meredith, the first African American to attend Ole Miss, finally registered at the university, and graduated four years later.

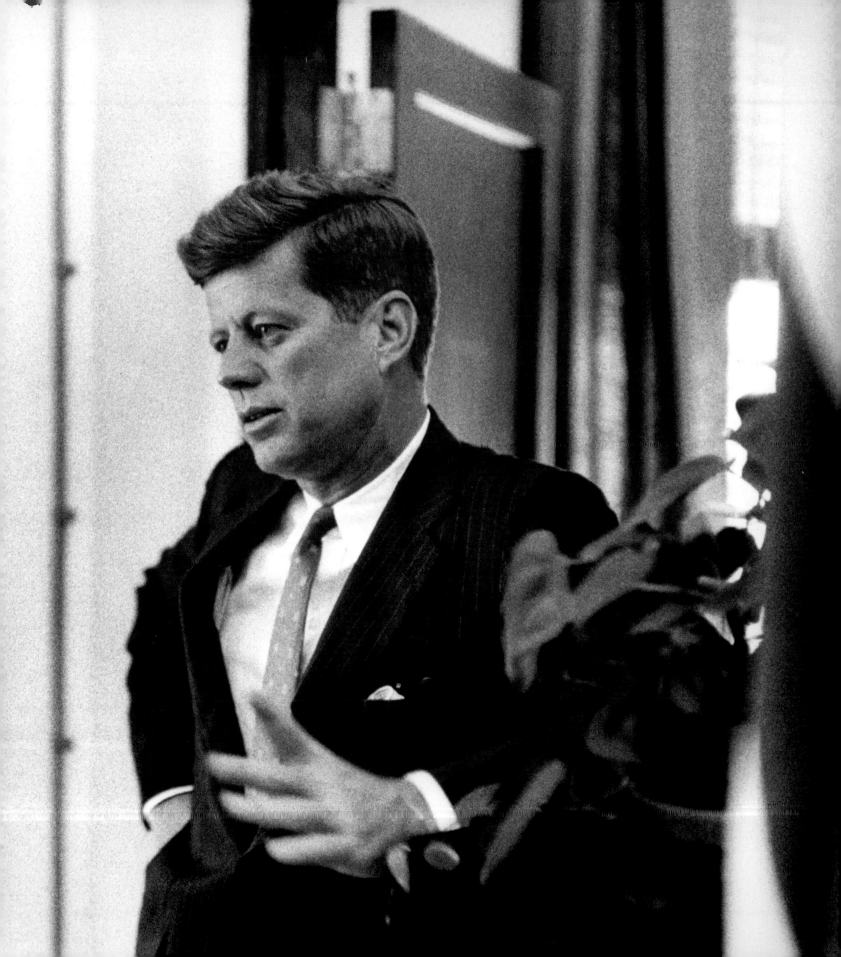

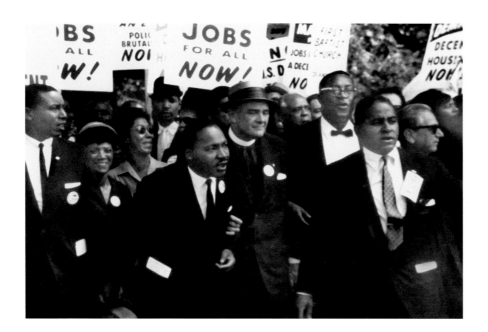

(above) "We need the President to do crusading work for us," said the Rev. Martin Luther King, Jr. On June 11, 1963, the President addressed the nation on civil rights, saying: "[This is] a moral issue. It is as old as the Scriptures and as clear as the American Constitution." He asked Congress to enact legislation. (opposite) President Kennedy said the March on Washington had advanced the cause of America's 22 million Negroes and made a contribution to all mankind.

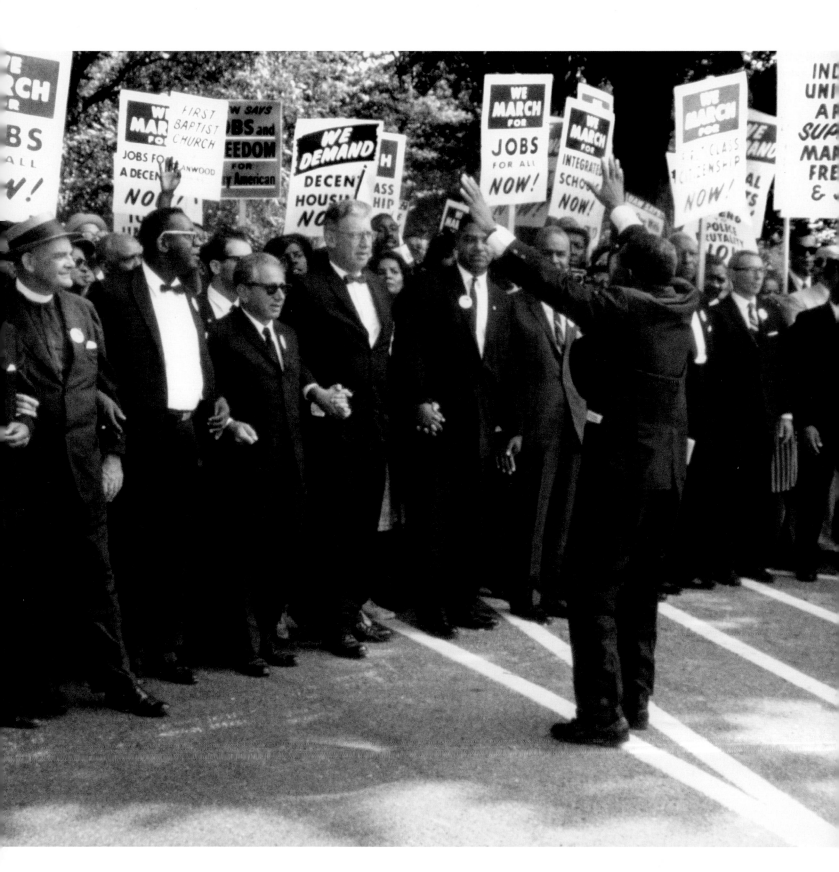

* * *

On August 28, 1963, more than a quarter million people
joined the March on Washington for Jobs and Freedom,
and Martin Luther King, Jr., stood on the Lincoln Memorial
to deliver his "I Have a Dream" speech.

* * *

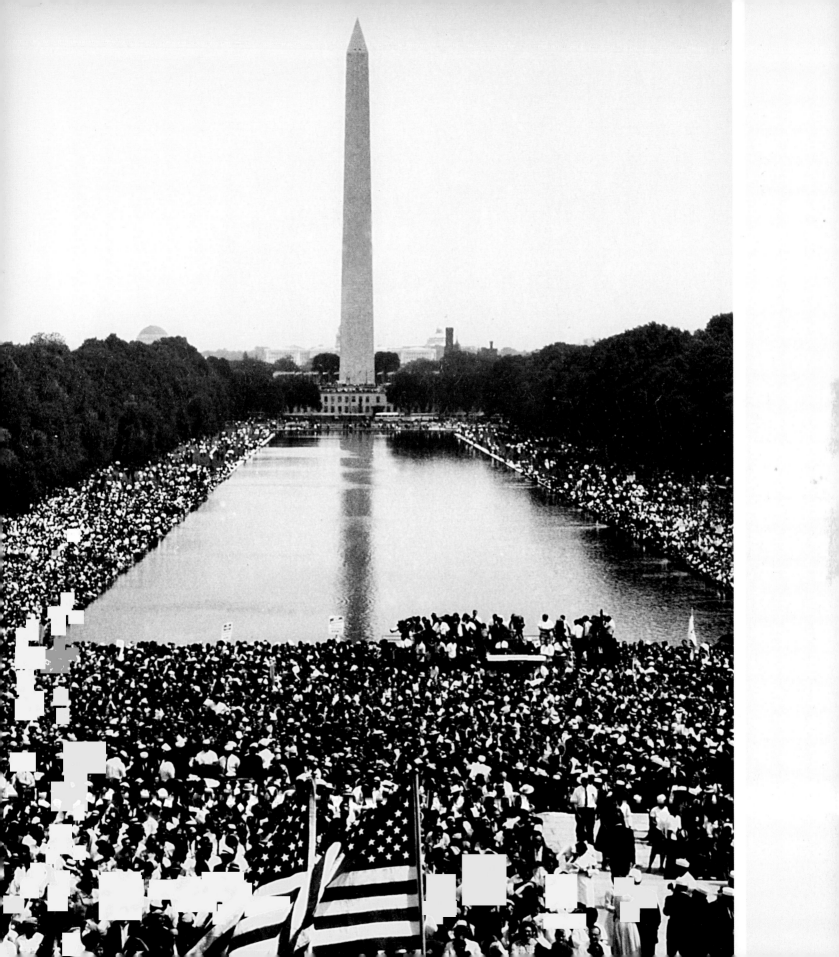

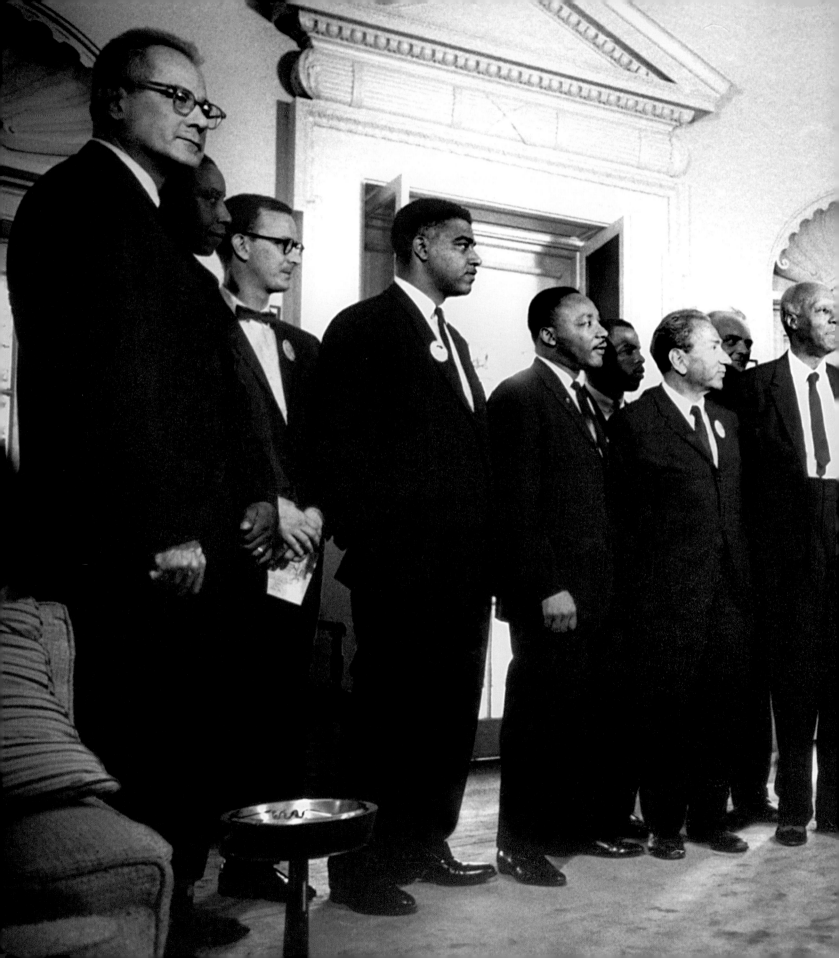

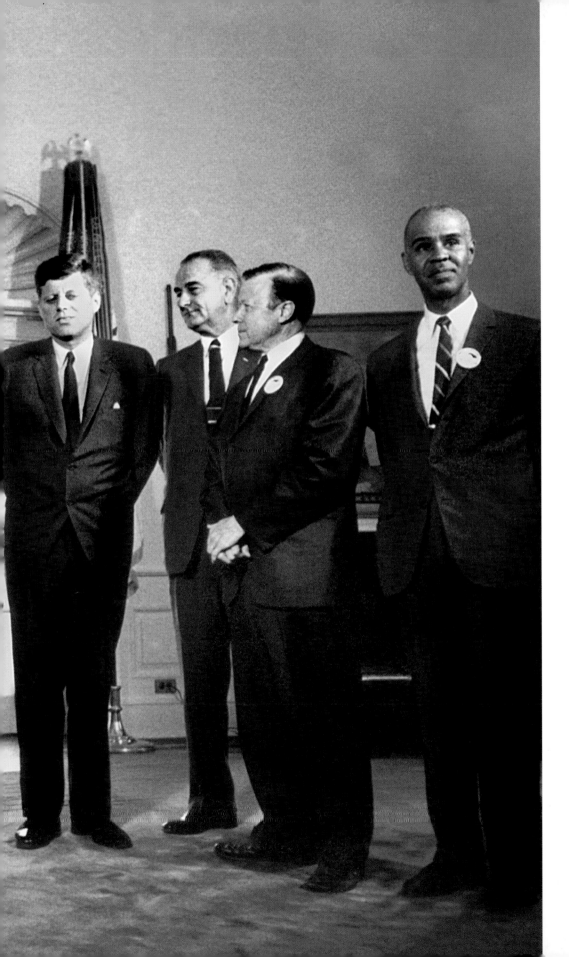

President Kennedy meets with leaders of the March on Washington at the White House. Left to right: Secretary of Labor Willard Wirtz; Floyd McKissick, Congress of Racial Equality (CORE); Mathew Ahmann, executive director, National Catholic Conference for International Justice; Whitney Young, executive director, National Urban League; Rev. Martin Luther King, Jr., founder and president, Southern Christian Leadership Conference; John Lewis, chairman, Student Nonviolent Coordinating Committee; Rabbi Joachim Prinz, president, American Jewish Congress; Rev. Eugene Carson Blake, president, National Council of Churches; A. Philip Randolph, president, Brotherhood of Sleeping Car Porters; President Kennedy; Vice President Johnson, Walter Reuther, president, United Auto Workers; Roy Wilkins, executive secretary, National Association for the Advancement of Colored People.

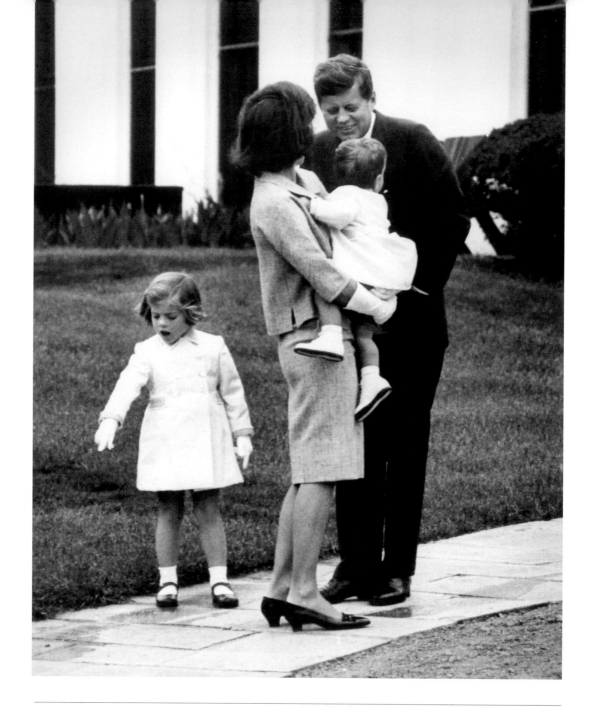

(above) Upon her return from a three-week trip to India and Pakistan with her sister, Lee, the First Lady says good-bye to the President at the White House, March 30, 1962. He will join her and the children for the weekend at Glen Ora, the four-hundred-acre home the Kennedys leased in Middleburg, Virginia. Months later they built their own home, Wexford, named for Kennedy's ancestral roots in Ireland. (opposite) On one of her many trips to the hunt country, Jackie is shown "hill-topping" (following the hounds) with binoculars. She applied for her own hunting license, March 16, 1961, and paid $15.75, good for one year for any kind of hunting in any county of Virginia. She spent many weekends hacking her hunter over the fields and attending point-to-points. She also entered Caroline's pony in lead-line classes, holding the lead rein herself, at small pony shows.

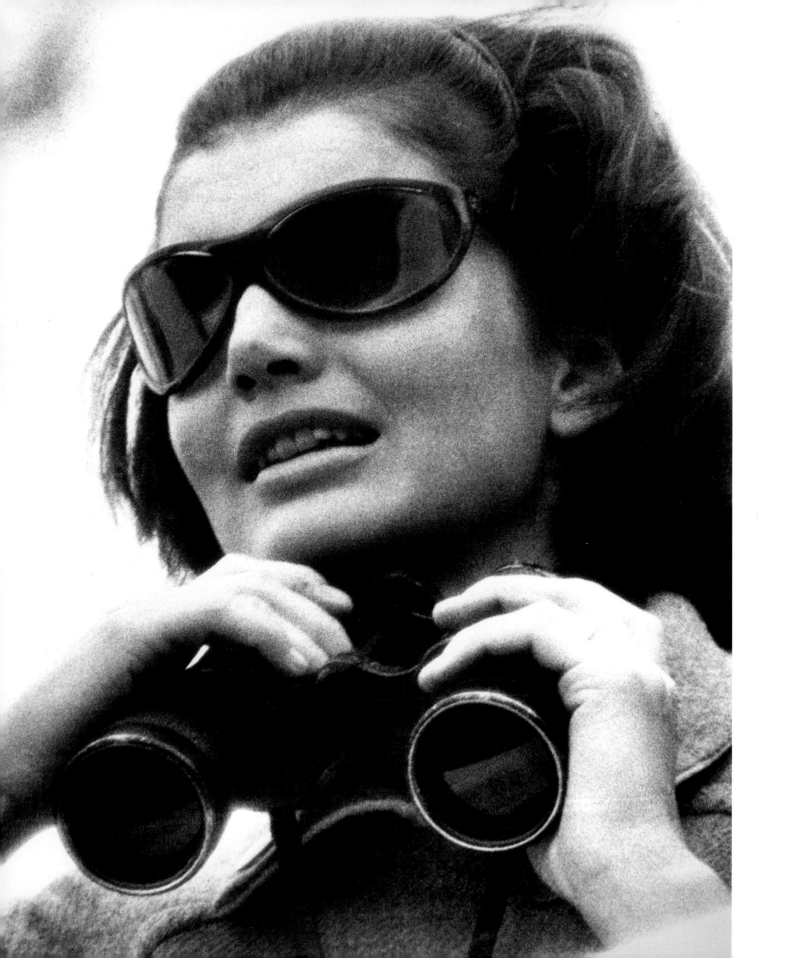

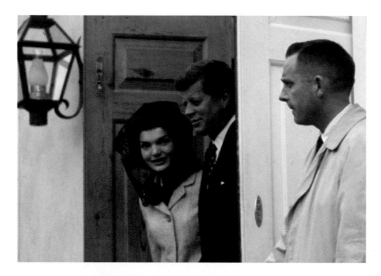

The President and First Lady leave the Middleburg Community Center where Catholics attended Mass in 1962. Until 1957, the only Catholic service conducted in the area was a Requiem Mass said for the deceased Catholic raiders of Confederate Colonel John S. Mosby in 1865. Mrs. Kennedy wears a black lace mantilla, the fashionable head covering for Catholic women in the 1960s.

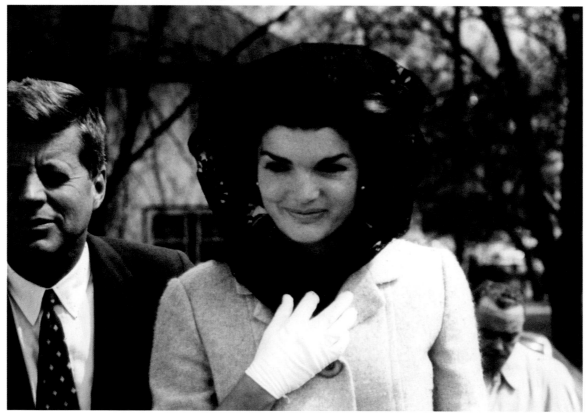

LOOK

NOW MORE THAN 7 MILLION CIRCULATION

A doctor talks about
WOMEN AND PREGNANCY

SONNY LISTON
The fighter nobody likes

25¢ JUNE 5, 1962

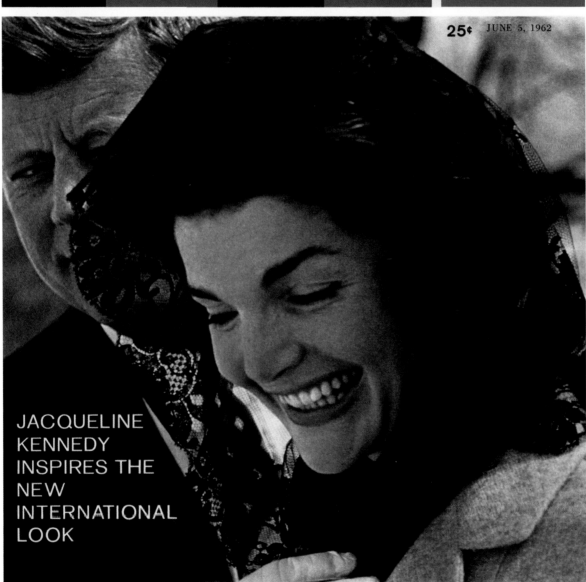

JACQUELINE
KENNEDY
INSPIRES THE
NEW
INTERNATIONAL
LOOK

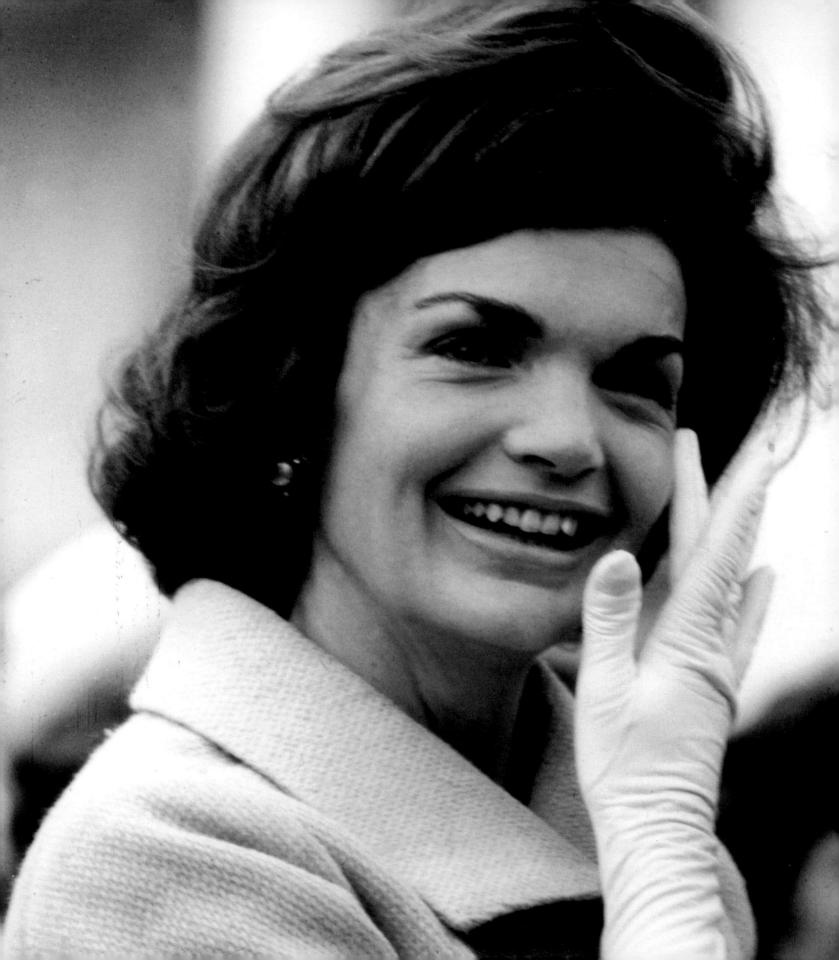

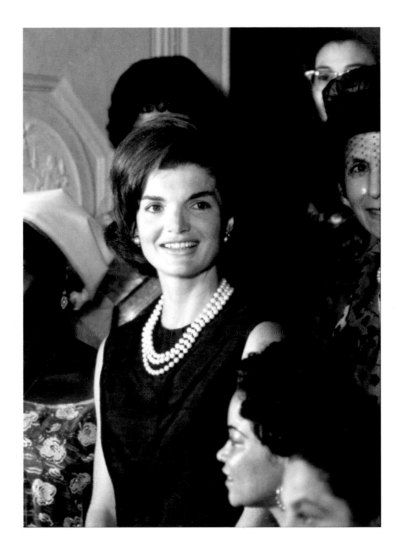

(opposite) Jacqueline Kennedy on the South Lawn of the White House, April 17, 1962, wearing white kid gloves, a fashion requisite for women in that era, listens to the Greater Boston Youth Symphony Orchestra and the Breckenridge Boys Choir from Texas perform in one of the musical programs for Youth by Youth that she started. *(above)* In the White House the First Lady greets foreign students, May 10, 1961. Standing next to her in a veiled hat is her mother, Mrs. Hugh D. (Janet) Auchincloss.

The First Lady at the White House state dinner, April 11, 1962,
for the Shah of Iran and his empress.

*"I heard the President teasing his wife about having
to borrow the best from the nation's leading jewelers
in order to stack up to Iranian royalty,"*

the White House social secretary told reporters. Mrs. Kennedy
wore a nineteenth-century antique diamond sunburst in her
hair that evening. The Shabanou arrived in a heavy crown of
diamonds topped b emeralds the size of hard-boiled eggs. The
President grinned.

"She's topped you," he told his wife.

"She's really topped you."

★ ★ ★

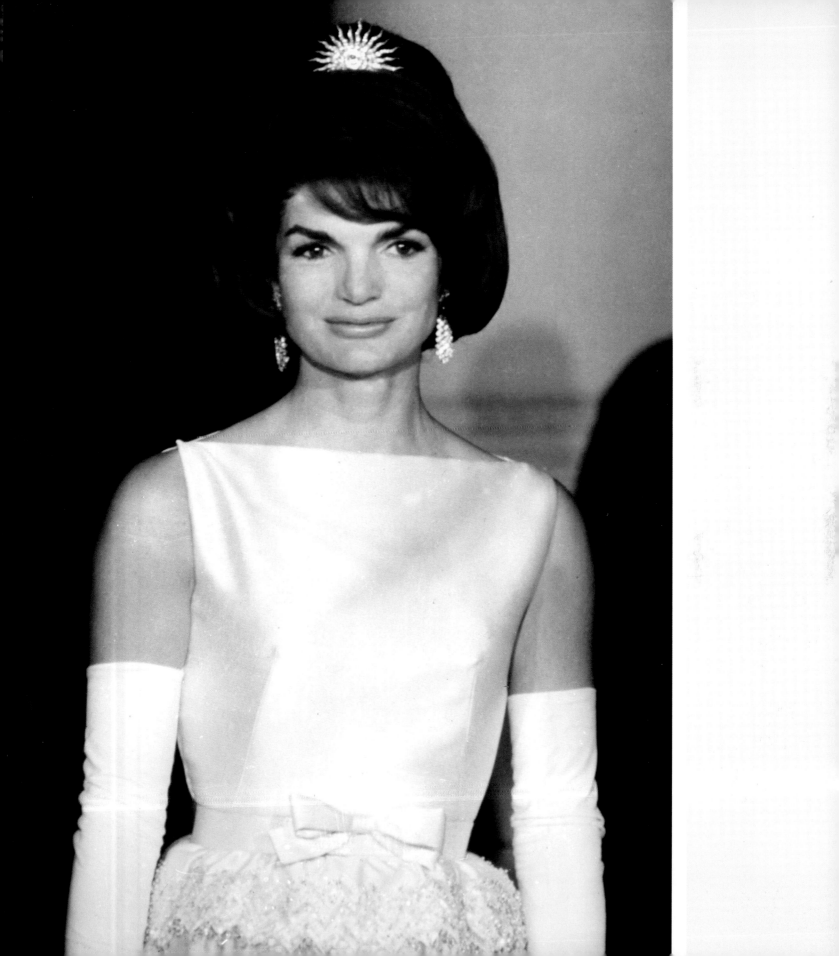

LOOK

NOW MORE THAN 7 MILLION CIRCULATION

THE WORLD
WE FACE
BY JOHN GUNTHER

KENNEDY
ONE YEAR
LATER

25¢ JANUARY 2, 1962

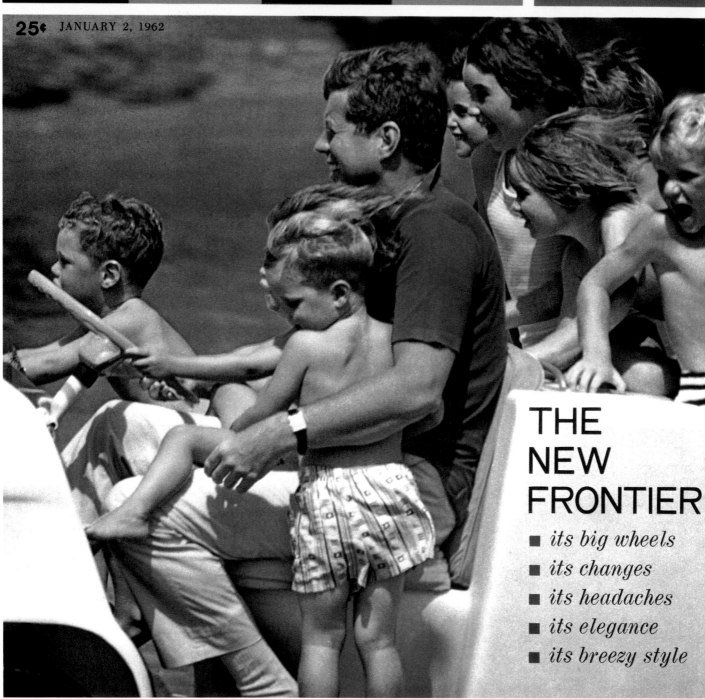

THE NEW FRONTIER

- *its big wheels*
- *its changes*
- *its headaches*
- *its elegance*
- *its breezy style*

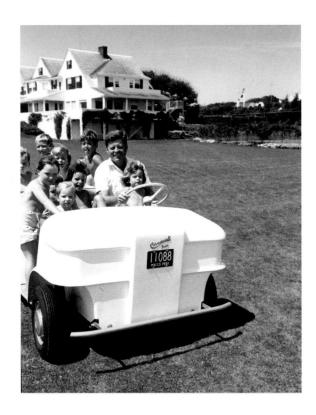

LOOK'S GOLF CART COVER APPEARED
January 2, 1962, showing President Kennedy clad in a sky blue polo shirt, his
thatch of chestnut hair glistening in the sun, surrounded by an adorable clutch of
squealing youngsters, who were yelling, "Run over the photographer, Uncle
Jack. Run over the photographer." The issue sold out at newsstands, which convinced the
President and the photographer that they had found an unbeatable combination: pictures
of the commander in chief with children. So began a collaboration that would produce
some of the most iconic photographs ever taken in the White House.

Stanley broached the subject in a letter, June 26, 1962, the first of six appeals, all
delivered through the President's personal secretary, Evelyn Lincoln:

> Dear Mr. President,
>
> Something you said last week . . . gave me an idea for a sensitive story with a lot of
> appeal. . . . The story I have in mind would be titled simply "The President and His
> Son" and would be composed of pictures of only the two of you together, preferably
> on a weekend at the Cape. It could possibly be done in one shooting session, the
> earlier in the summer the better.

The President approved the idea at once, but the photo session did not take place for almost a year and a half. Three months after JFK agreed, Stanley began nudging him:

> Dear Mr. President,
> Please accept this note as a gentle reminder about the picture story on "The President and His Son." It would be fine if we could work out something this weekend or anytime soon which would meet with both yours and John, Jr's convenience.

Stanley steered clear of Pierre Salinger on this project and communicated instead through Mrs. Lincoln, who called a few weeks later to say the President wanted to explain the delay.

"The first snag was 'Irving' [Stanley's nickname for John, Jr.], who was two at the time and going through some kind of kid stage in which he didn't get along with his father. It was a little embarrassing for the President when he told me why we'd have to hold off for a while."

In addition, there were presidential state visits to England and Germany, plus a sentimental trip to Ireland. Each time Kennedy returned to the White House there would be a note from Stanley, reminding him about the father-and-son photo shoot. But now the President was noncommittal, so Stanley persisted:

> Dear Mr. President:
> Once again, I would still like to do the John, Jr. story. It would be just great for a year-end cover. You have never actually told me no, something I don't want to hear. I'd sure like to get a yes answer, finally.

The President with his secretary, Evelyn Lincoln, who had worked for him since 1953. Kennedy told his speechwriter, Ted Sorensen: "Whatever I do or say Mrs. Lincoln [in ten years he never called her Evelyn] will be sweet and unsurprised. If I... said... 'Mrs. Lincoln, I have cut off Jackie's head. Would you please send a box?' She would reply, 'That's wonderful, Mr. President. I'll send it right away.... Did you get your nap?'"

* * *

President Kennedy, who enjoyed playing softball
when he was a U.S. Senator, throws out the first ball
on opening day, April 9, 1962, in the brand-new D.C.
Stadium where the Senators (then Washington's
major league baseball team) beat the Detroit Tigers
4–1. Sitting behind the President wearing glasses is
Lawrence O'Brien, special assistant to the President
for Congressional Affairs. The stadium was renamed
in 1969 in honor of Robert F. Kennedy.

* * *

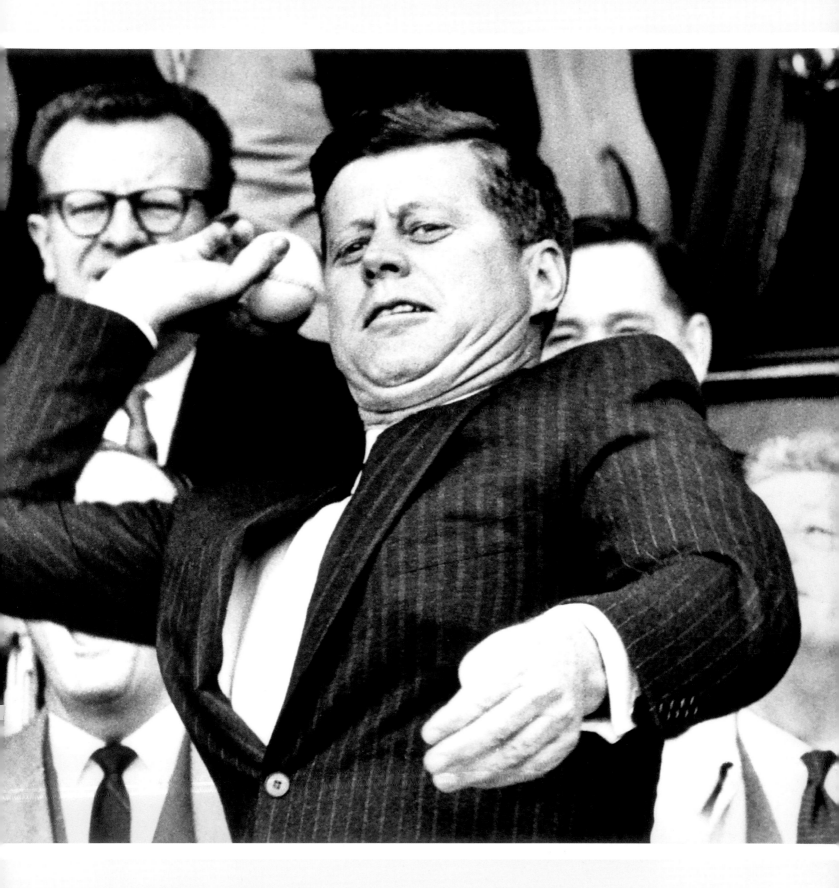

IN AUGUST 1963 THE PRESIDENT and his wife suffered the loss of their child Patrick Bouvier Kennedy, who was born five and a half weeks prematurely and died thirty-nine hours later from hyaline membrane disease, a respiratory ailment. Desolate over the baby's death, the President broke down in public.

> "IT WAS AN AGONIZING MOMENT *for a* MAN NEVER KNOWN TO HAVE HAD *an* EMOTIONAL OUTBURST."

"It was an agonizing moment for a man never known to have had an emotional outburst," said Boston's Cardinal Richard Cushing shortly after celebrating a Mass of the Angels for the infant's funeral.

Stanley wrote to the President, saying how sorry he was. "The toughest burden is now with Mrs. Kennedy. I wish her a speedy recovery."

Less than a month later, he was back in dogged pursuit, writing again to Mrs. Lincoln:

> This concerns the President and John, Jr., story which I still believe he is interested in doing.... I think I could get the magazine to run a year-end cover and story, but now time is getting short and if I don't make the pictures soon (within the next month, that is) I'm afraid I won't be able to make that deadline. So I would appreciate it if you would indicate this to the President sometime soon when he has a relaxed moment.

Stanley's lucky break came in October 1963 when the First Lady left for Greece to vacation on Aristotle Onassis's yacht, with her sister Lee and Lee's husband, Stanislas Radziwill, as chaperones, as well as Franklin D. Roosevelt, Jr., and his wife, Sue.

"Just as soon as Jackie left town I got a call that the coast was clear," Stanley recalled, "and I hightailed it to the White House.... When the President saw me, he said, 'Now, you know we better get this out of the way pretty quick. Things get kind of sticky when Jackie's around.' "

Stanley waited outside the Oval Office, cameras in hand, and at 7 P.M. John, Jr., appeared with the children's nanny, Maud Shaw. He was wearing his pajamas and robe in preparation for his pre-bedtime playdate with his father.

"I'm going to my secret house," he yelled as he raced toward the President's desk. He crawled under the ornately carved oaken timbers of the British ship H.M.S. *Resolute*, a gift from Queen Victoria to President Rutherford B. Hayes. Seconds later the front panel suddenly flew open and John looked up as Stanley clicked his camera. The little boy jumped out, scampered around the President's feet, skipped about the Oval Office, and dove under the desk again, giving Stanley a series of once-in-a-lifetime photos.

The President noticed Cecil Stoughton, the White House photographer, standing in the corner and asked Stanley if he'd let Cecil step in to take a picture of John in his secret house. Impressed by the President's consideration, Stanley stepped aside, and allowed Stoughton to take a similar shot. Stanley later recalled showing the proofs to Kennedy in the Cabinet Room. As the President looked at the photos of John, Jr., playing under the desk, he said, "You can't miss with these, can you, Stan?" As he turned to leave, he said to Cecil Stoughton, "You must have gotten some nice pictures, too, didn't you, Captain?"

> I DON'T THINK JFK EVER INTENTIONALLY HURT ANYONE'S FEELINGS.

"I think this was a courtesy to Cecil more than anything else because [during the four-day shoot] he was sort of left out of it. But it shows Kennedy's courtesy. He was concerned about Cecil's feelings. I don't think JFK ever intentionally hurt anyone's feelings."

Stanley's memos frequently mention the President's good manners and how much he appreciated courtesy in others. "I knew he played golf and I also knew he hated being associated with golf and didn't want to be photographed playing the game because of the identification with Eisenhower, who was criticized severely for golfing all the time. Although Kennedy couldn't stop people from writing about it, he made sure he golfed only at private country clubs where photographers were not permitted. When I was in Hyannis I saw him at the country club. I was on a hill about a mile away from him. I walked down and had my camera with me. I asked him if I could take a picture. He said no."

"...HE APPRECIATED COURTESY *in* OTHERS."

" 'You know everybody's writing about it,' I said.

" 'Well, that's a lot of words, but one picture, you know what that can do.'

" 'Okay, then.'

" 'Did you come all the way down here to ask me that?' He pointed up to the hill. 'Why didn't you just make a picture of me with your long lens?'

" 'I knew you didn't want it so I thought I'd ask, and it's a private course.'

" 'That's very considerate of you,' said the President, who invited me to walk the course with him but still wouldn't allow a photograph."

Stanley recalled the incident in his oral history, saying, "He liked the courtesy. It's what he liked more than anything else."

(*opposite*) **One of the most iconic images taken in the White House of the President's son, aged 2½ years old, taken in October of 1963. Sadly, a month later, his father would be assassinated in Dallas.**

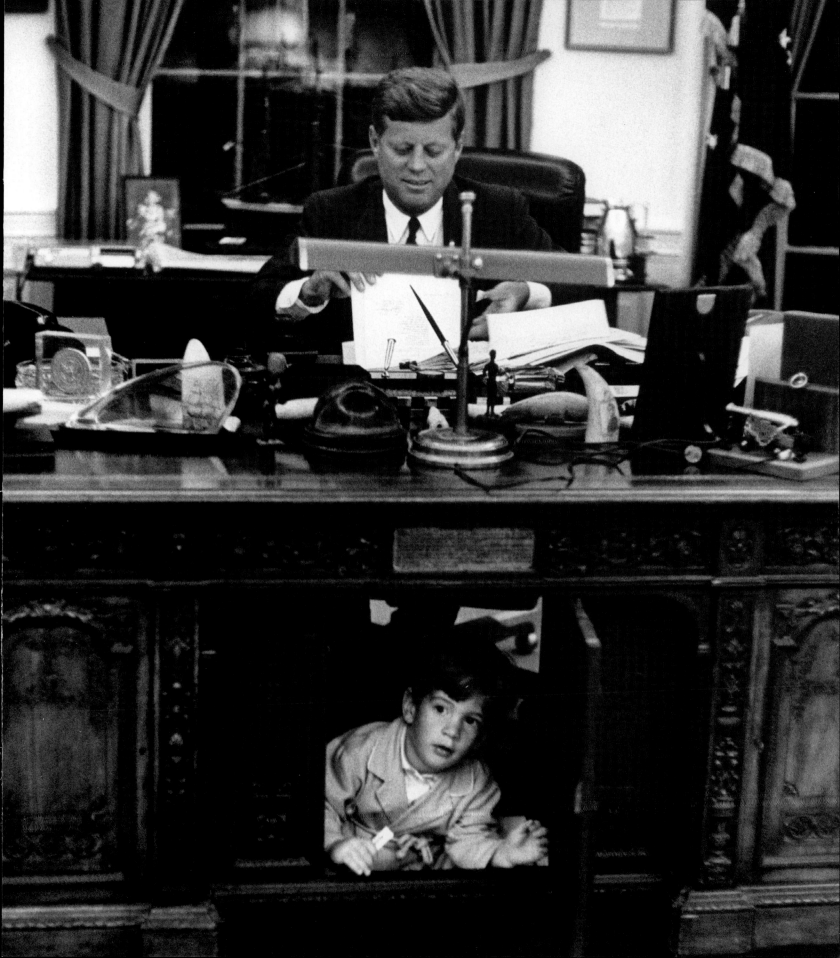

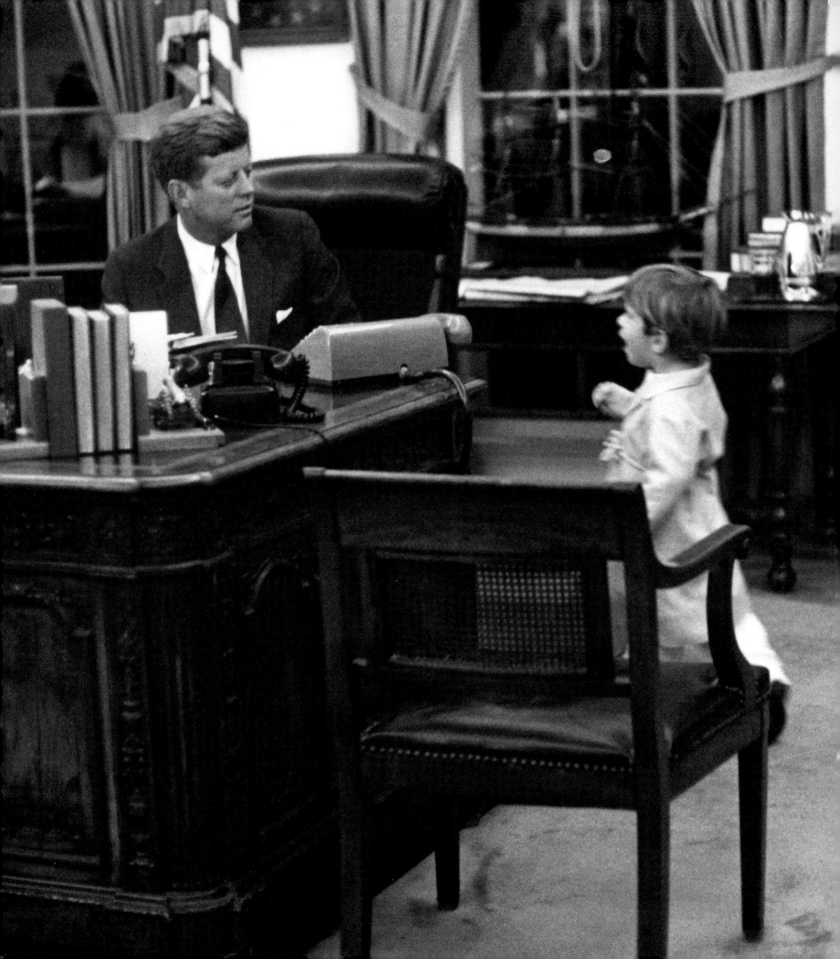

(opposite and above) The evening of October 9, 1963, John, Jr., comes to the Oval Office in his pajamas, bathrobe, and bedroom slippers to play "secrets" with his father.
(below) John, Jr., runs for his "secret" place under the President's desk.

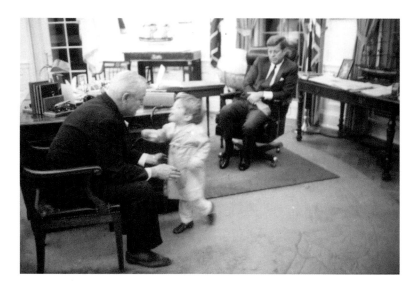

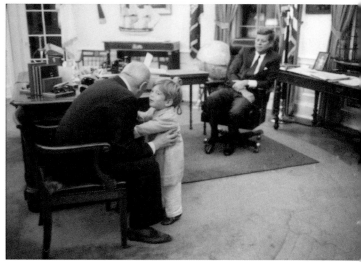

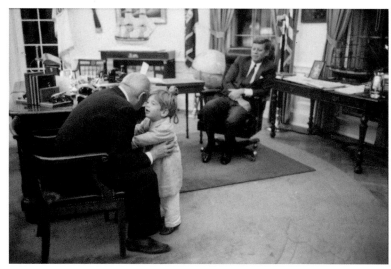

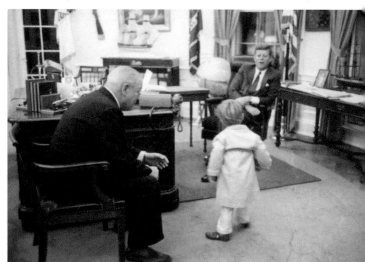

DURING THE JOHN, JR., PHOTO SHOOT, the President was visited by Randolph Churchill, the journalist son of the former British Prime Minister Winston Churchill, one of JFK's heroes. Seconds later a White House waiter arrived with a bottle of scotch and a bucket of ice. The President looked nervous about Stanley photographing alcohol being served in the Oval Office, but Stanley was focused on photographing "Irving."

"Just keep John away from the booze," he said.

After Churchill left, the President took his son by the hand and walked down the outside corridor to the living quarters. "Let's go see Granddaddy," he said, leading the youngster over to say good night to Ambassador Kennedy, who was recuperating from a severe stroke.

Randolph Churchill, son of the British Prime Minister, visits with the President, who says: "Well, John, why don't you tell Mr. Churchill a secret."

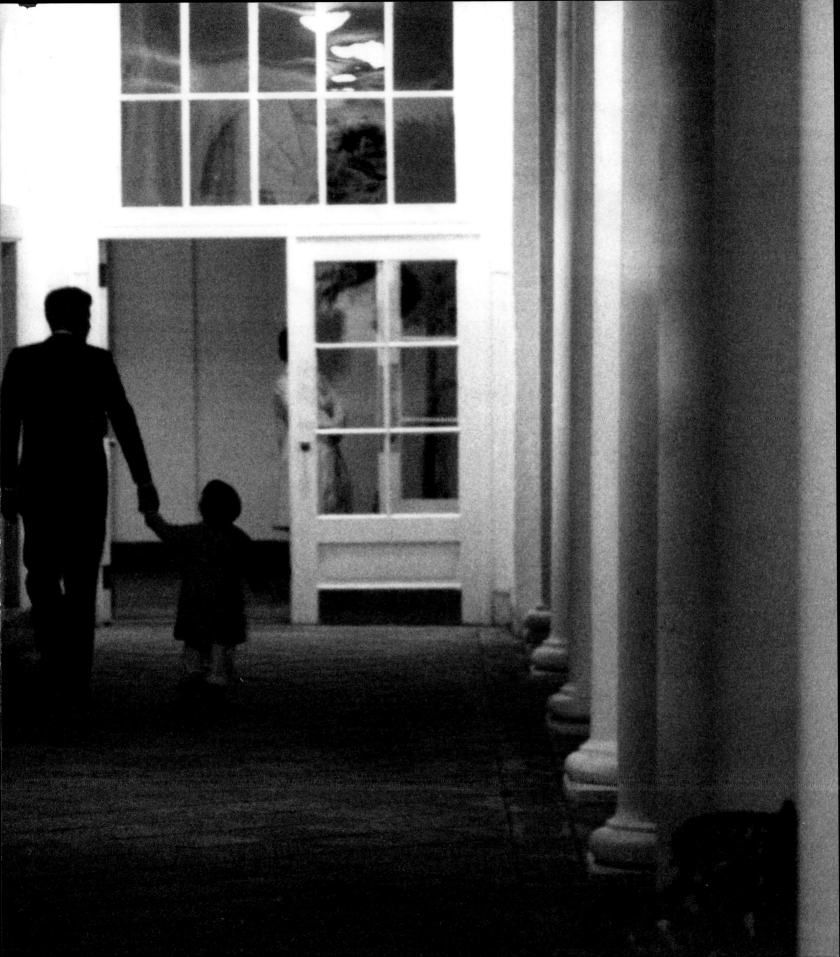

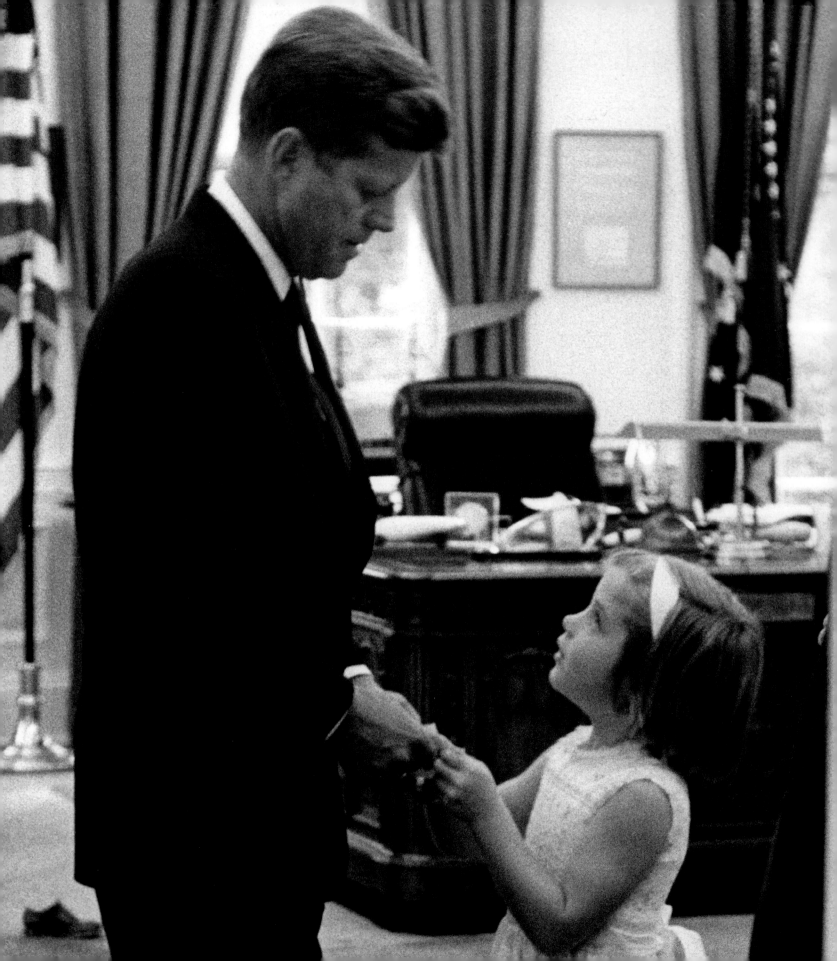

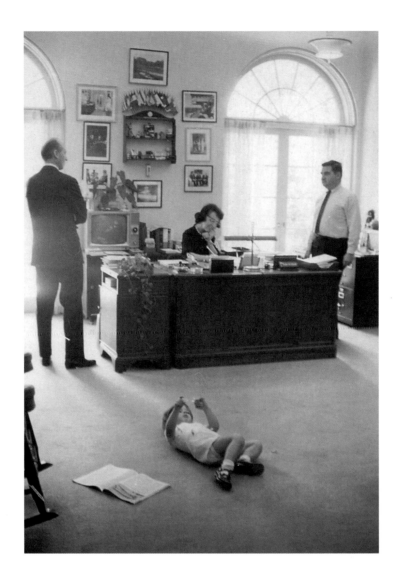

(opposite) The next day, October 10, 1963, Caroline visits her father in the Oval Office before she goes upstairs to school, which her mother started in the White House solarium for the children of administration officials. *(above)* John, Jr., too young to attend the White House school, reads the papers in his father's office, plays with a book, and tinkers with Mrs. Lincoln's typewriter.

(above) The President's son being interviewed by *Look* writer Laura Bergquist. (below) Dave Powers, one of the President's closest friends and confidants, was a White House assistant with no input into policy. Rather, he was the President's favorite storyteller, baseball authority, political statistician, and traveling companion. Here he plays "secrets" with John, Jr., October 11, 1963, in the Roosevelt Room. (opposite) John, Jr., salutes the President's two afternoon visitors: Anatoly Dobrynin, USSR ambassador, and Andrei Gromyko, USSR minister of foreign affairs.

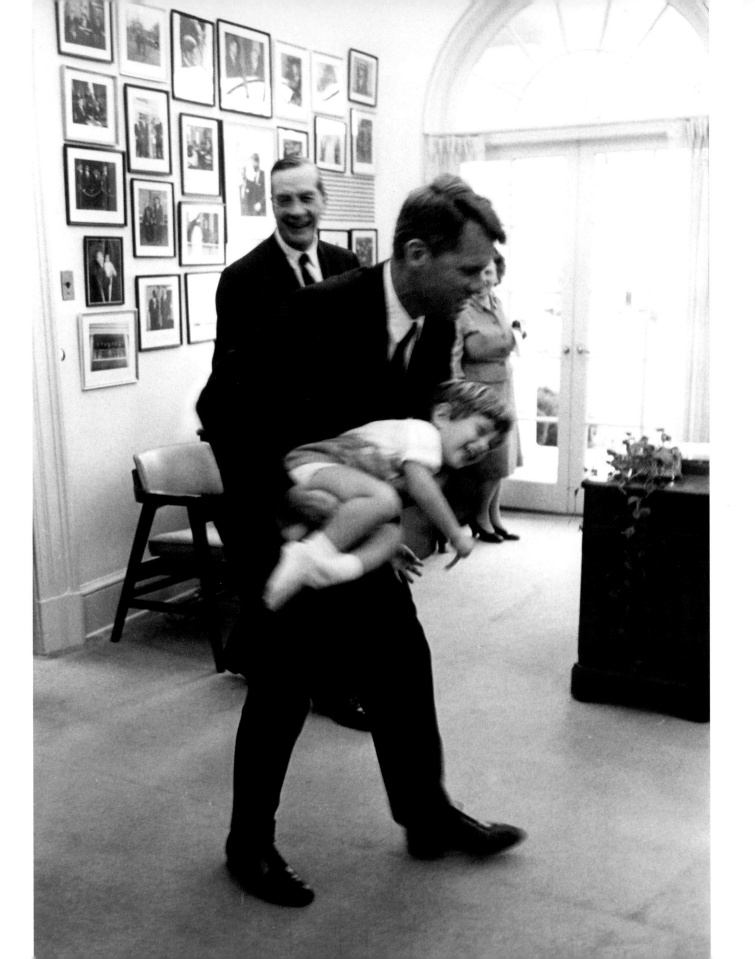

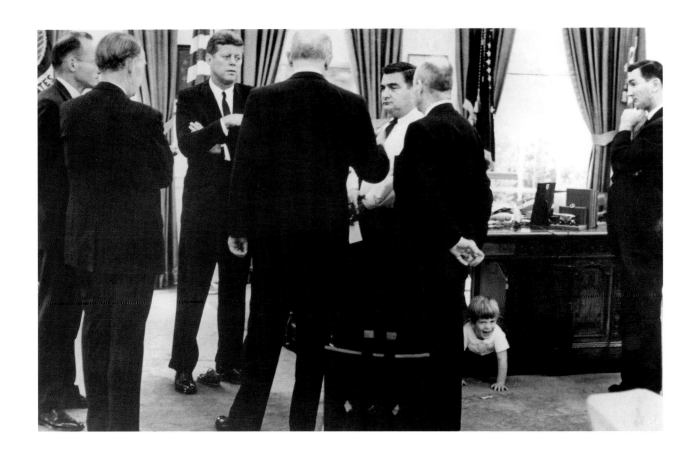

(opposite) "Uncle Bobby" at the White House, October 10, 1963, after conferring with the President about the church bombing in Birmingham, Alabama, that killed four girls. With the attorney general is Earl "Red" Blaik. *(above)* President Kennedy talks with White House advisors, including press secretary Pierre Salinger and presidential assistant Kenneth O'Donnell, as John, Jr., plays in the Oval Office. Notice his shoe underneath the President.

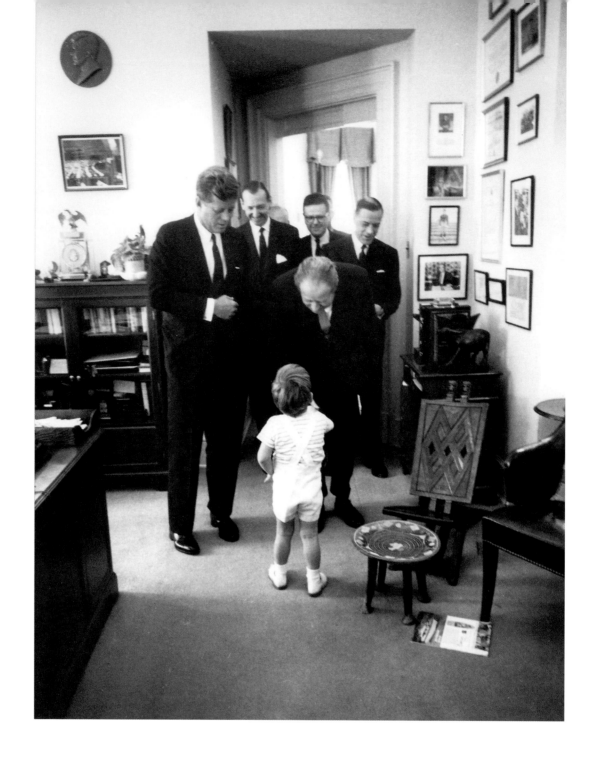

(*above*) John-John meets Austria's Prime Minister Bruno Kreisky, October 11, 1963. (*opposite*)
But John's nanny, Maud Shaw, won't let him play "secrets" with his father's visitor.

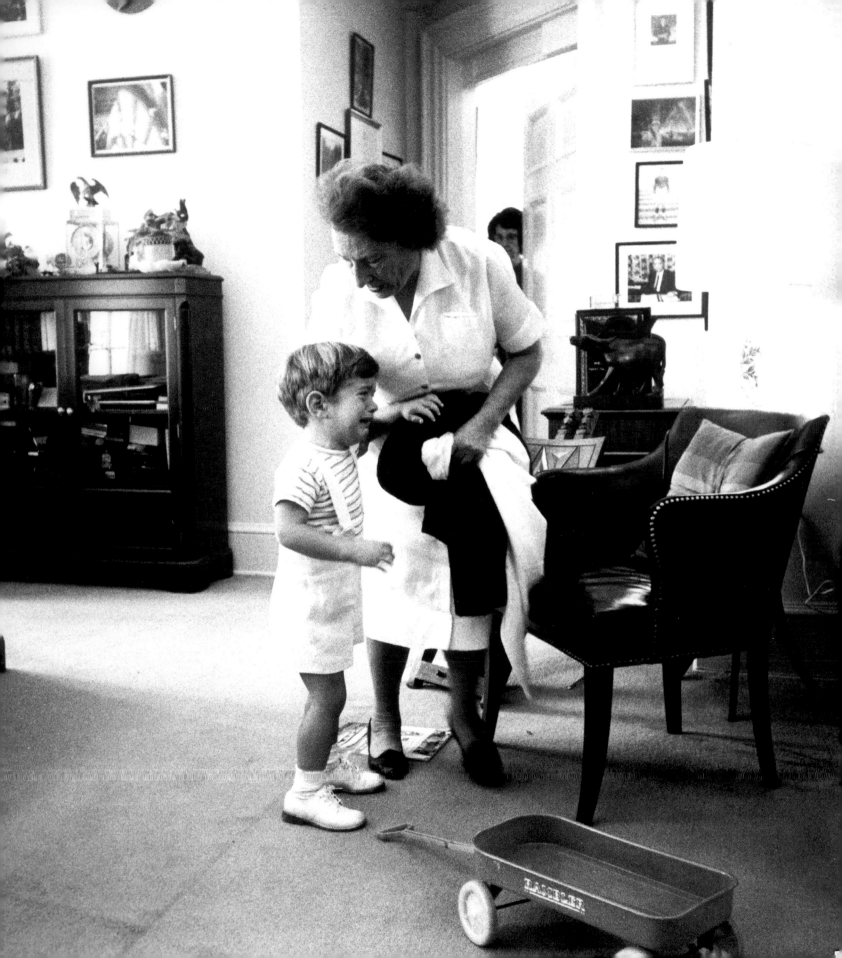

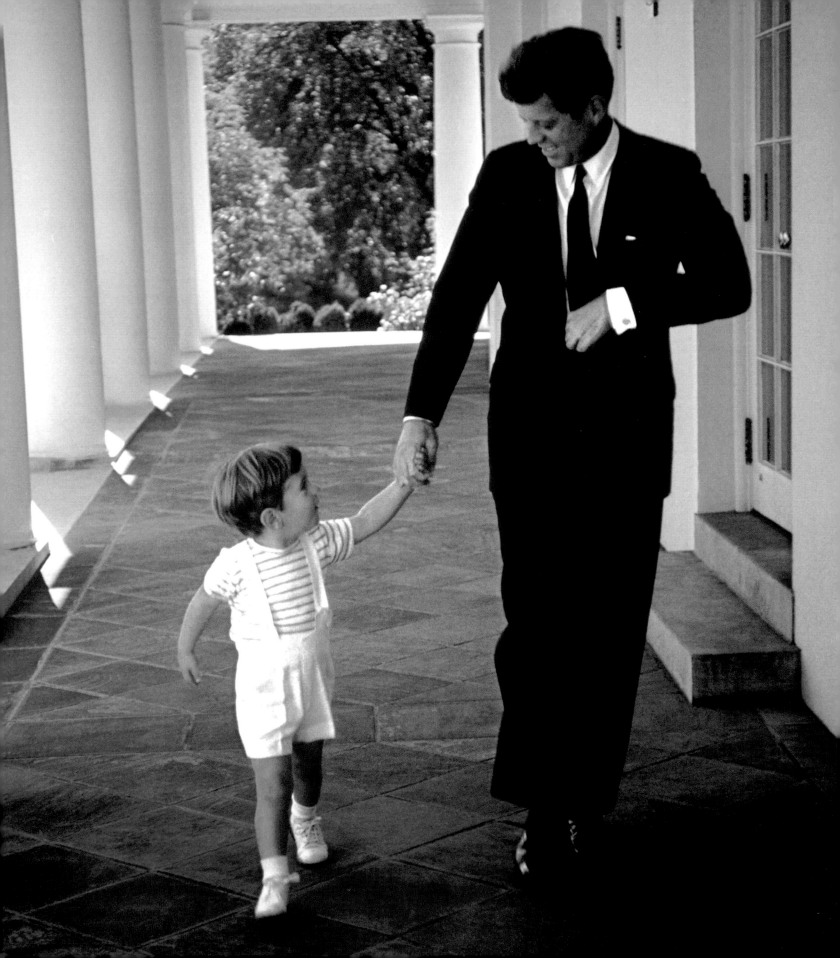

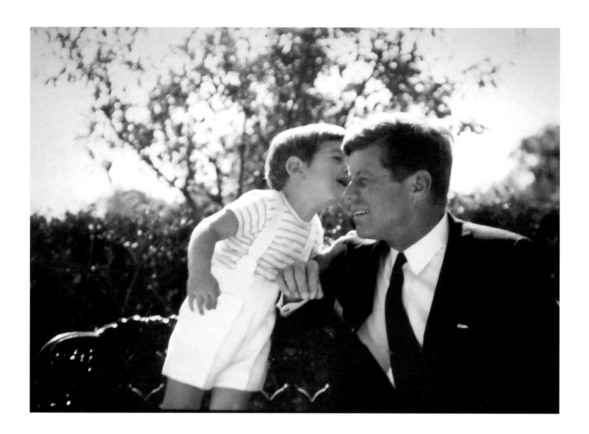

(opposite) President Kennedy and his son stroll along the White House portico, stopping to play "secrets" and get a pretend spanking *(following page)*.

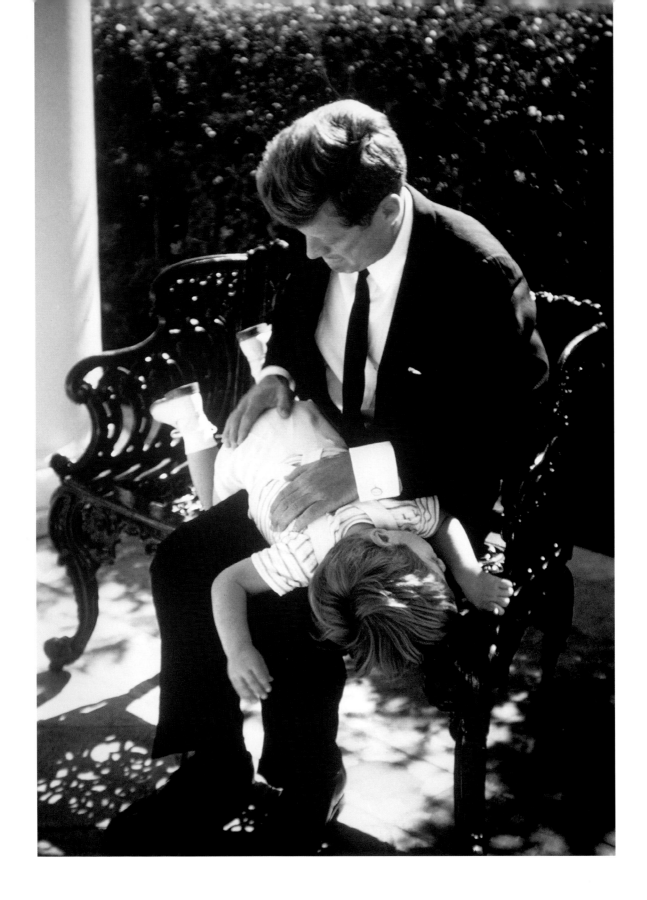

LOOK

NOW MORE THAN 7,400,000 CIRCULATION

5 CENTS · DECEMBER 3, 1963

**BIRMINGHAM:
I SAW
A CITY DIE**

**SUNDAY
FOOTBALL
MADNESS**

THE PRESIDENT AND HIS SON: an exclusive picture story

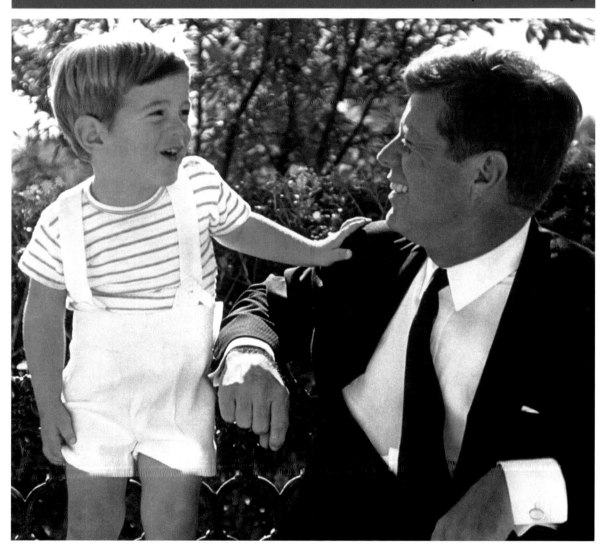

S TANLEY SPENT FOUR DAYS AND NIGHTS
with the President and his son at the White House and at Camp David, where
John was enthralled with his father's arrival on *Marine One*, the presidential
helicopter—or as John called it, "Daddy's hebrecop." Stanley noticed the
President kept a copy of *Aviation Week & Space Technology* in his office because John
was transfixed by airplanes and helicopters and loved looking at the pictures. "We've
lost him to the Air Force," said JFK's Army aide, Major General Chester "Ted" Clifton.

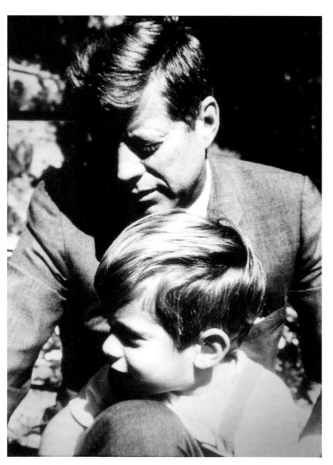

Stanley had suggested doing a story
on *Air Force One*, to be called "The Flying
White House," but the President would
not consider it. "I asked him three times
but he turned me down every time. He
and Mrs. Kennedy had a lot to do with the
colors, fabrics, interior design, and gen-
eral decoration on board and he didn't
want any cameras around because he said
the pictures would come out looking like
they were of a rich man's plane.

After the John, Jr., shoot Stanley gave
the President a set of all the pictures and
heard from secretaries and top aides that
Kennedy went all over the White House
showing off the photos. The only one he
vetoed using was John sitting in the
President's chair in the Oval Office. The
President was so proud of the pictures
that he showed them to his wife upon her
return from Greece.

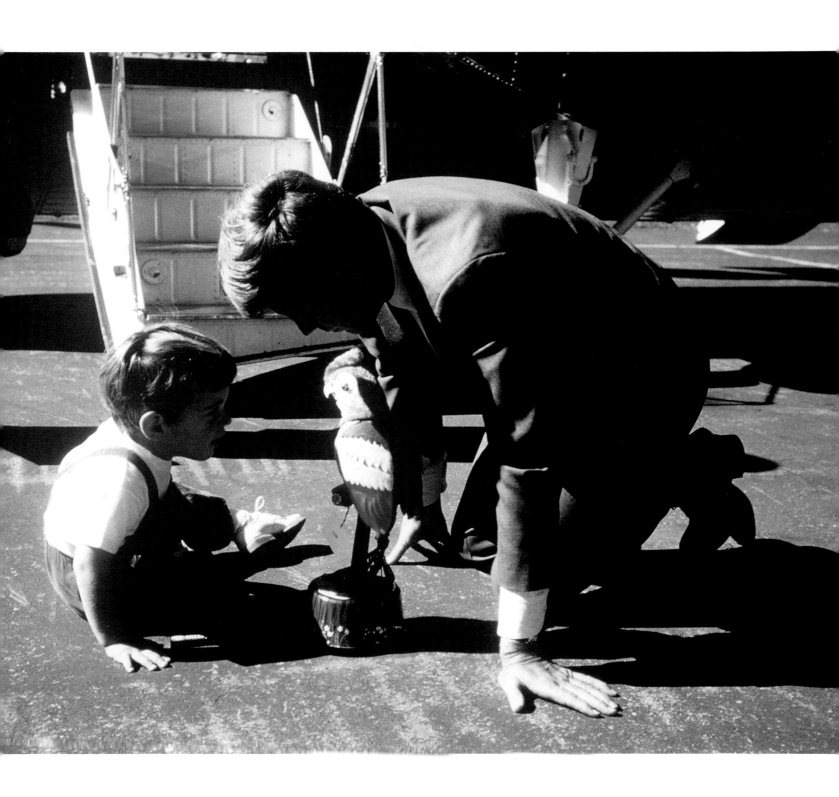

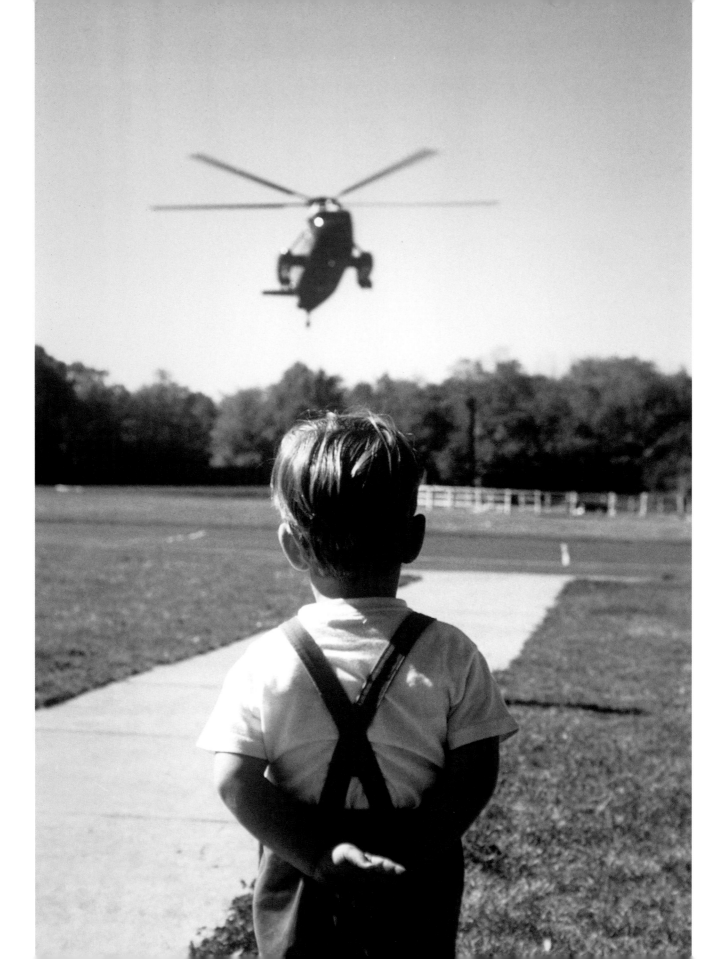

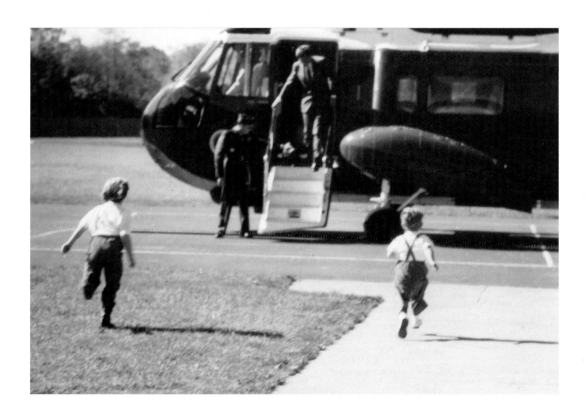

John, Jr., loved *Marine One*, his father's "hebrecop," and he and Caroline run to greet the President on his arrival at Camp David, October 12, 1963, where Kennedy spent the weekend with his children while their mother was away.

This photo of John, Jr., sitting at his father's desk is the only one from the four-day shoot that the President would not allow to be published, because he felt it presented too playful an image in the Oval Office.

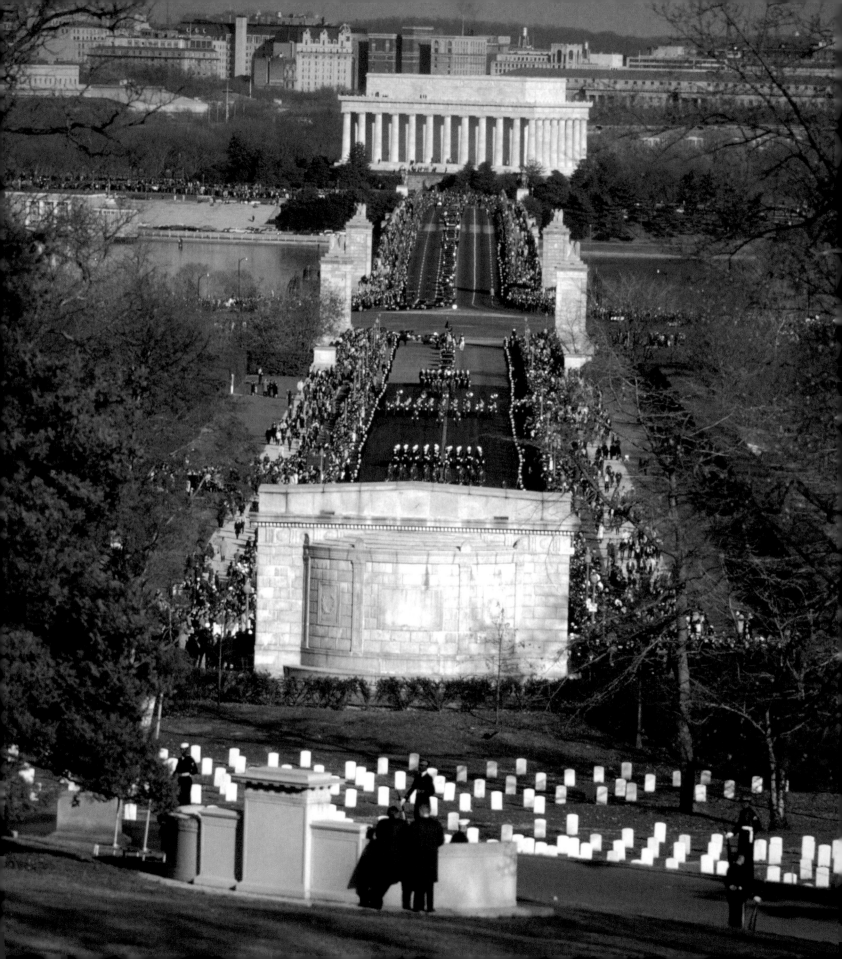

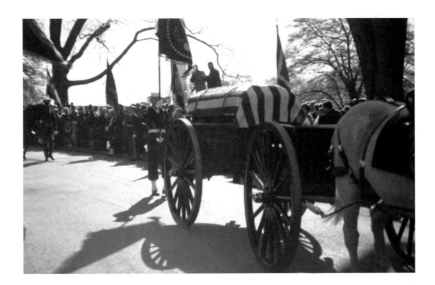

FTER THE ASSASSINATION, Mrs. Kennedy told Stanley how grateful she was that he had defied her orders and taken the photos. "It was an act of God," she said. Months later Stanley brought her a leather-bound album with all the photos. "It will be my most precious possession," she told him. In his memo of their meeting at her house in Georgetown, April 6, 1964, he recalled her saying how impressed the President had been by his persistence and his absolute refusal to give up on the project, despite all the delays. Stanley also quoted her as saying: "Pierre and Jack were like two sneaky little boys letting you do the story when I went off to Greece on vacation." She said that when she returned the President had shown her the pictures. "Are you mad at this?" he'd asked. She said, "No—I guess it's your year, Jack, and you can use the children any way you want, and if you want me to pose in the tub for photographers I suppose I should do that, too, to help out this year."

Knowing how jumpy the White House press secretary got dealing with the First Lady, the President suggested she give him a scare. "Why don't you go over and tell Pierre you're frosted about this. It'll really shake him."

"When lilacs last in the dooryard bloom'd...." The nation buried its martyred president, November 25, 1963, after a Requiem Mass at St. Matthew's Cathedral, attended by dignitaries from ninety-one countries.

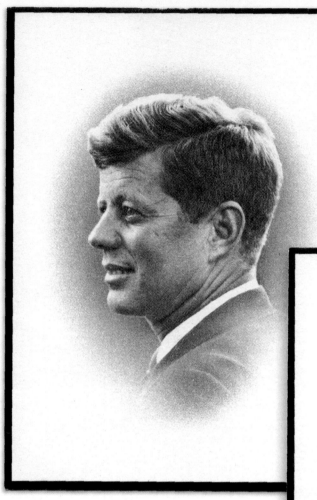

JOHN FITZGERALD KENNEDY
President of the United States
May 29, 1917 – November 22, 1963

Dear God,

Please take care of your servant

John Fitzgerald Kennedy

Now the trumpet summons us again—not as a call to bear arms, though arms we need—not as a call to battle, though embattled we are—but a call to bear the burden of a long twilight struggle, year in and year out, "rejoicing in hope, patient in tribulation"—a struggle against the common enemies of man: tyranny, poverty, disease and war itself . . .

In the long history of the world, only a few generations have been granted the role of defending freedom in its hour of maximum danger. I do not shrink from this responsibility—I welcome it. I do not believe that any of us would exchange places with any other people or any other generation. The energy, the faith, the devotion which we bring to this endeavor will light our country and all who serve it—and the glow from that fire can truly light the world . . .

With a good conscience our only sure reward, with history the final judge of our deeds, let us go forth to lead the land we love, asking His blessing and His help, but knowing that here on earth God's work must truly be our own.

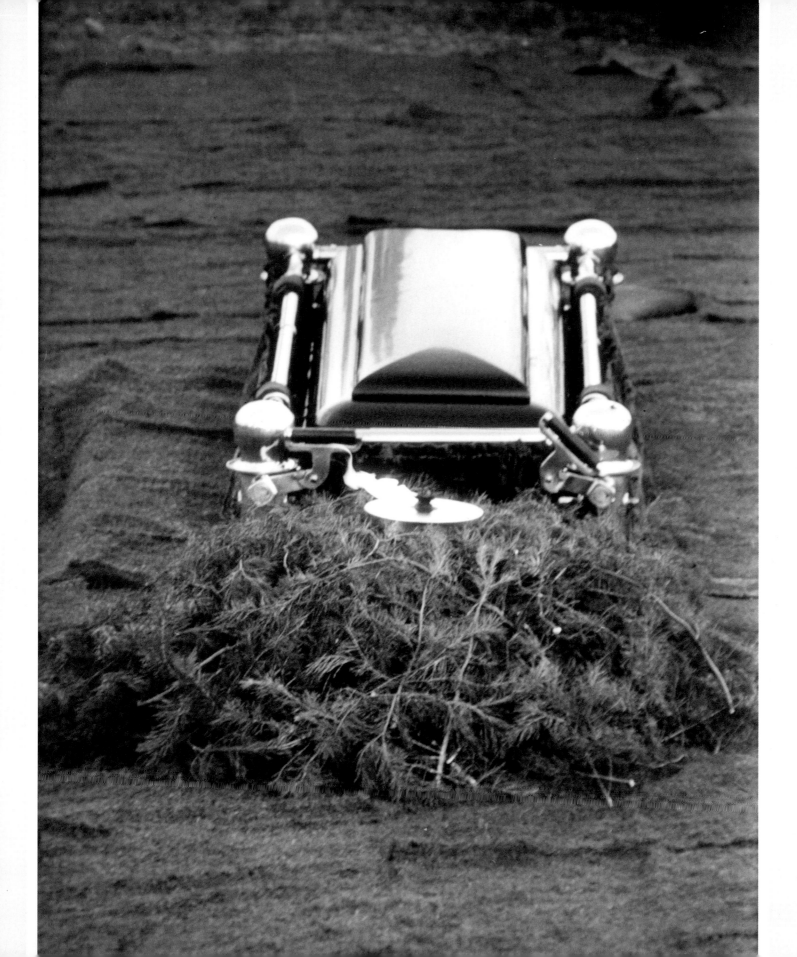

D URING STANLEY'S VISIT
with Mrs. Kennedy, Caroline knocked on the door and her mother told
her to come in. Stanley stood up.

"Caroline, this is Mr. Tretick. You remember him."

Caroline shook hands and curtsied, then sat down on the couch next to her mother.
Mrs. Kennedy showed Caroline the set of pictures in the album Stanley had brought
and pointed to the one of her running with John, Jr., to meet their father at Camp
David. Mrs. Kennedy said, "See, Caroline—see all those little arms wrapped around
your daddy's legs." Stanley noted that Caroline, then six, did not show much emotion
one way or the other—unlike her mother, who had earlier asked him, "What are we all
going to do now? I go on a trip and it's all right when I'm on the trip, but it's so empty
and depressing when I come home. I went to a party for Arthur Schlesinger last night
and they were twisting and dancing—they looked so depressed even doing it. You know,
Jack was everything to all of us."

Stanley said, "It doesn't seem the same in this country with him gone."

"And overseas, too," said Mrs. Kennedy. "You know, Jack was something special and
I know he saw something special in me, too.... I remember my mother used to have all
these beaus for me but Jack was so different—and these past three years we were in the
White House were really the happiest for us and now it's all gone.... There's a small group
of people who *really* [Stanley's emphasis] loved Jack, and you're one of them."

The President's widow appreciated Stanley's affection for her husband and, ac-
cording to his notes, expressed disgust with those who sought to "cash in" on him. In
particular she mentioned the photographer Mark Shaw, who was selling all the early
photographs he had taken of her and her husband at their home. "I'm disappointed in
Mark Shaw," she said. "He's in it just for Mark Shaw." She objected to Maud Shaw (no
relation to the photographer) for writing *White House Nanny*, because she did not
want anyone to know that it had been the nanny, and not Jackie, who told Caroline of
her father's death. She became incensed with Paul "Red" Fay, Jr., for writing *The Plea-
sure of His Company*, a charming recollection of his navy days with JFK. When Fay
donated three thousand dollars in royalties to the John F. Kennedy Library, Mrs. Ken-
nedy returned the check as if it were Judas's silver. She fought William Manchester for
profiting from his elegiac book, *The Death of a President*, a book she had commissioned,

and she never spoke to Ben Bradlee after he wrote *Conversations with Kennedy*, although he had been a Georgetown neighbor and close friend through the White House years. Those whom she felt had exploited their relationships with her husband received nothing but her enmity.

Before leaving her that day, Stanley, who had enjoyed his photo romp with "Irving," asked if he could say hello to John, Jr. "Next time would be better because he's had a fever and he's sleeping now," said his mother. As Stanley stood up to leave, Mrs. Kennedy escorted him to the door. "You must come by and see me. If you're in the neighborhood, just drop in." Stanley said he would call first and check with Clint Hill, her Secret Service agent. "As we stood there I leaned over and kissed her on the cheek and said good-bye," he wrote.

Several weeks later he began working on the John F. Kennedy Memorial issue for *Look*, which, he said in a letter to Mrs. Kennedy, "would show the emotional impact President Kennedy had on all human beings here and abroad, how he gave them hope, how he was the impetus for drawing them out creatively, what he did for the arts, letters, music, etc., and how he gave a new tone, elegance, and respect to the presidency."

Having discussed the issue with Robert Kennedy, Stanley promised Jackie that she and Bobby would see all the photos before publication. He then asked her if she would write an article for the memorial issue. "Your article could give a personal touch about the things he stood for and did, and those things you feel the world should know about him and not forget; things he sparked which will go on and on through coming generations."

He concluded by saying: "Lastly, for myself, I believe you know how I feel personally about John F. Kennedy. It will give me much pleasure to work on this tribute to a man I loved and admired."

The former First Lady had already wrapped her husband's presidency in the ribbons of Camelot in an interview with *Life* shortly after the assassination, in which she said, "When Jack quoted something it was usually classical but I'm so ashamed of myself—all I keep thinking of is the line from a musical comedy. At night before we'd go to sleep Jack liked to play records and the song he loved most came at the very end of this record. The lines he loved to hear were: 'Don't let it be forgot / that once there was a spot / for one brief shining moment / that was known as Camelot.' "

JACQUELINE KENNEDY THRUMMED

the magical lute of mythology as the country was still reeling from the horror of Dallas. Revered for her elegant composure during the President's funeral, she became the most admired woman in the world and a cynosure of mass adulation. Shrouded in widow's weeds she proclaimed a year of mourning for herself as she vowed to keep alive the memory of her husband. "I'm going to live in the places I lived with Jack. In Georgetown and with the Kennedys at the Cape...."

Before leaving the White House she asked President Johnson to rename Cape Canaveral in her husband's honor so that when the first Americans arrived on the moon they would be coming from Cape Kennedy. President Johnson immediately had the space center renamed and then offered Mrs. Kennedy anything else she wanted, including ambassadorships to France or Mexico, both of which she declined.

Soon her adoring public became invasive. Crowds of gawkers lined the sidewalks in front of her Georgetown house and each morning busloads of tourists arrived flashing their cameras. Curiosity seekers camped out, waiting to catch a glimpse of her and the children.

Within months she sold her house in Washington, D.C., and moved to New York, where her brother-in-law would soon run for the U.S. Senate. The Kennedy family, especially Bobby, continued to surround her with their support, as Stanley indicated in a memo to his editor, May 12, 1964:

> In doing the Kennedy Memorial issue I think it is very important to keep on good terms with all those around Jackie. As near as I can determine the entire family (the good ones and the bad ones) is taking a hand in keeping her busy and active. She plays tennis with Ethel, takes dinner with Bobby at their house and hers; sees Steve and Jean Smith when she goes to New York; sees a lot of Teddy and Joan and even plays host to Peter Lawford when he's in town....

The entire Kennedy family wanted to contribute to the memorial issue, except for Jackie. While she devoted herself to enshrining her husband's memory, she balked at commemorating the anniversary of his death.

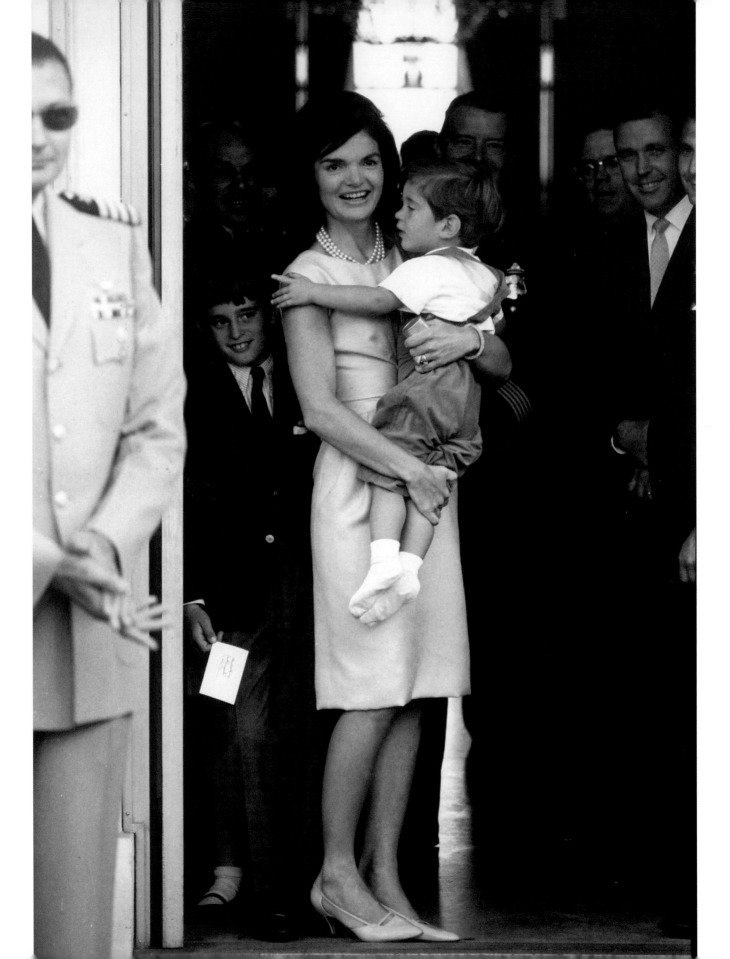

Still torn by grief and her own punishing mood swings, she told Stanley she felt like a Ping-Pong ball being bounced back and forth, which prompted his letter of July 12, 1964, asking her to hear him out and not to take offense:

> Going back to the very beginning of the John, Jr., story I had the feeling that it was something which had to be done for the reason that John F. Kennedy had this marvelous thing with children which I thought should be shown. I saw it back in 1961 when I did the Golf Cart series and I was certain that it was coming into full bloom with his own son. I knew you were against it because of your feelings for the children but I still kept after it because of my own strong feelings. I believe to this day that President Kennedy did not let me do the story for his own political gain in an election year (as some people would like to think) but for the reason that he wanted the rest of the world to see his son because he was so proud of him. During the shooting sessions your husband would say, "How do you like him—he's really a charge," and other things like that. And when I gave him the prints before the magazine came out he went all over the White House showing the pictures, not because he thought my photography was that good, but more like a father who pulls out a wallet full of pictures of his son and shows them proudly around. John F. Kennedy never approached me to do this story; he was not that kind of person. I approached him and he liked the idea and I think he liked the idea for the above reasons.
>
> Now I come to you and want to photograph you and your children for the Memorial issue and I believe have hurt your feelings. And like you said, "I am like a Ping-Pong ball in the middle," but when I tell them [his editors] you don't want to [allow the children to be photographed], they throw a copy of *Life* magazine with the story on Bob in my face.

Jacqueline Kennedy holding John, Jr., thirty months old, stands in the north portico of the White House to meet Maj. L. Gordon Cooper, Jr., at a ceremony, May 21, 1963, honoring the astronaut who flew the last *Mercury* mission. He spent a day in space and completed twenty-two orbits of the earth. Days later the President addressed Congress: "I believe that this nation should commit itself to achieving the goal before this decade is out of landing a man on the moon and returning him safely to the earth."

LOOK

NOW MORE THAN 7,500,000 CIRCULATION

25 CENTS · NOVEMBER 17, 1964

THE JFK MEMORIAL ISSUE

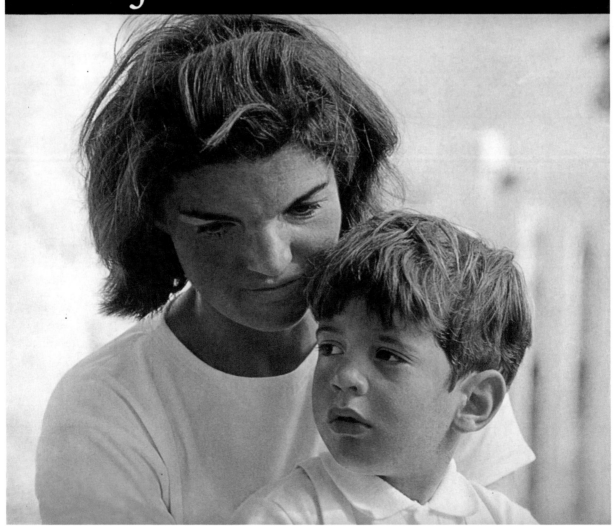

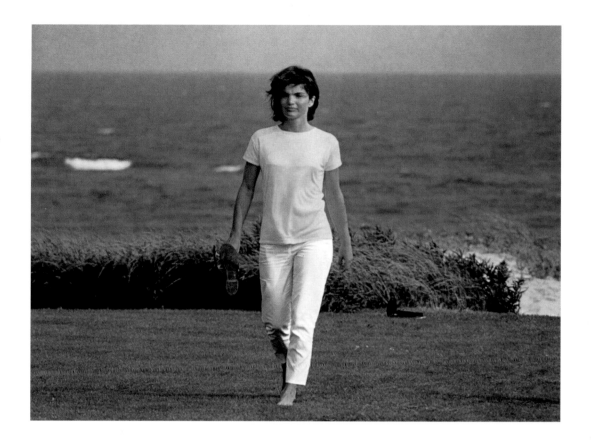

The July 3, 1964, cover of *Life* had shown Bobby being embraced by six little children, including Caroline and John, Jr. The headline read: "A Happy Moment at Home with His Brother Jack's Children."

"As for myself," Stanley concluded, "I am selfish enough to want to do the photographing because there is no photographer who is as sensitive to the Kennedys as I am. No photographer who has felt them the way I have. No photographer who has loved them the way I have."

In the end, Bobby helped convince Jackie to contribute to the *Look* memorial issue, and he and Ted Sorensen accompanied her and her children to Hyannis Port where Stanley photographed them on the beach. Jackie loved Stanley's pictures, especially the one of her walking into the winds of Cape Cod. Dressed in white pants and a yellow T-shirt with her hair blowing she looked strong and resilient.

(above) **Jacqueline Kennedy, backed by Nantucket Sound, signed this picture for the photographer.**

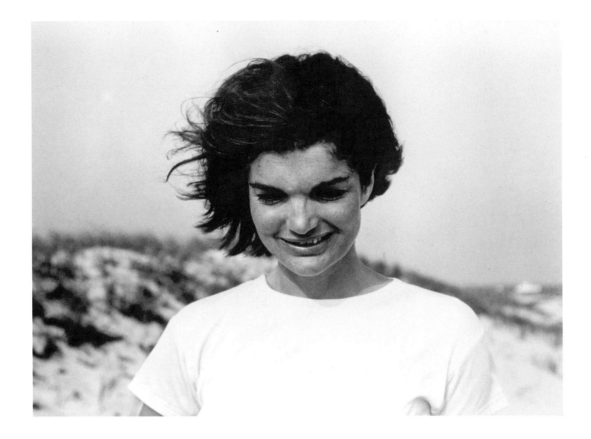

Jackie agreed to write a short memoir for the issue, in which she lamented: "Now, I think that I should have known that he was magic all along. I did know it—but I should have guessed that it would be too much to ask to grow old with him and see our children grow up together. So now, he is a legend when he would have preferred to be a man."

Stanley produced a moving tribute to JFK in that issue, which contained seventy-seven photographs, and featured Jackie on the cover in her yellow T-shirt holding John, Jr., on her lap. Yet as much as Stanley admired the President's widow, he could be pushed only so far—even by her.

Jacqueline Kennedy declared an official year of mourning for herself as her husband's widow but tried to keep life as normal as possible for her children.

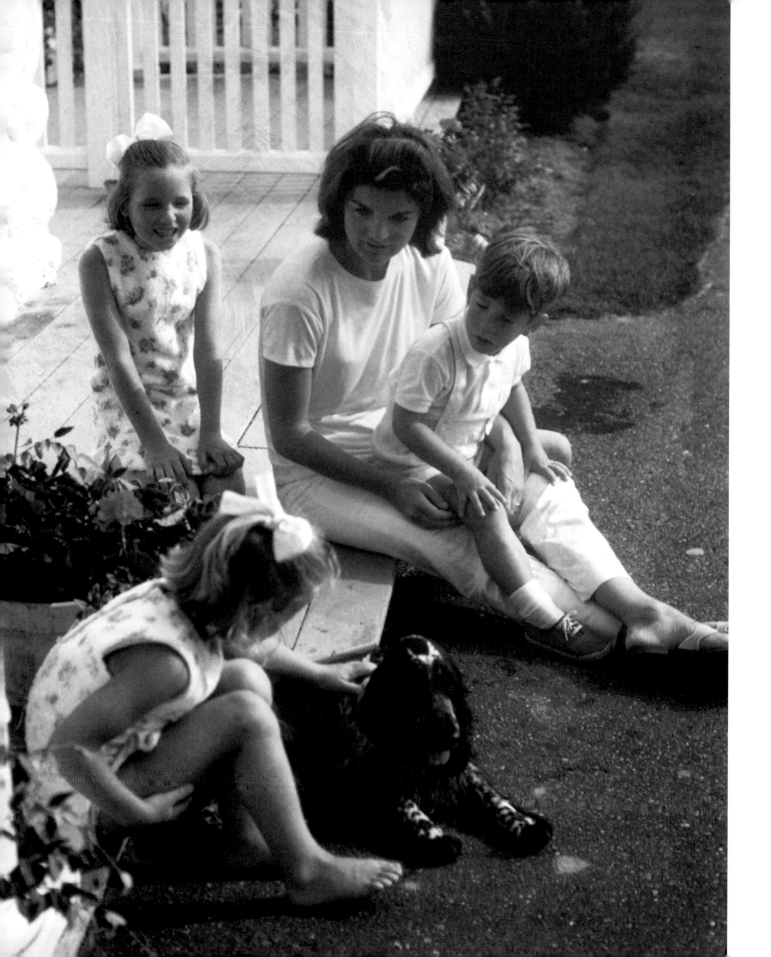

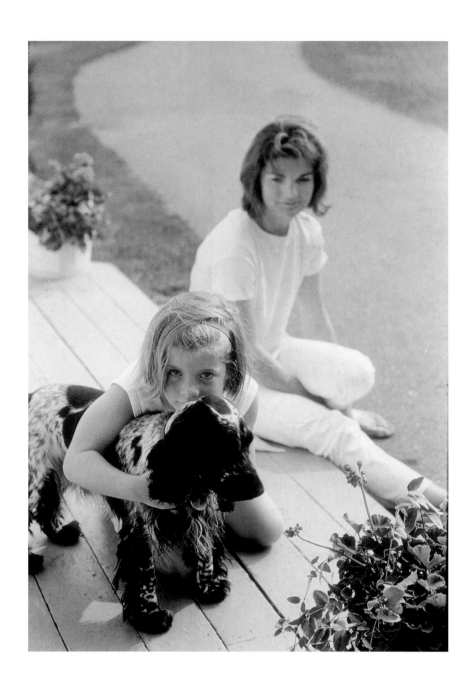

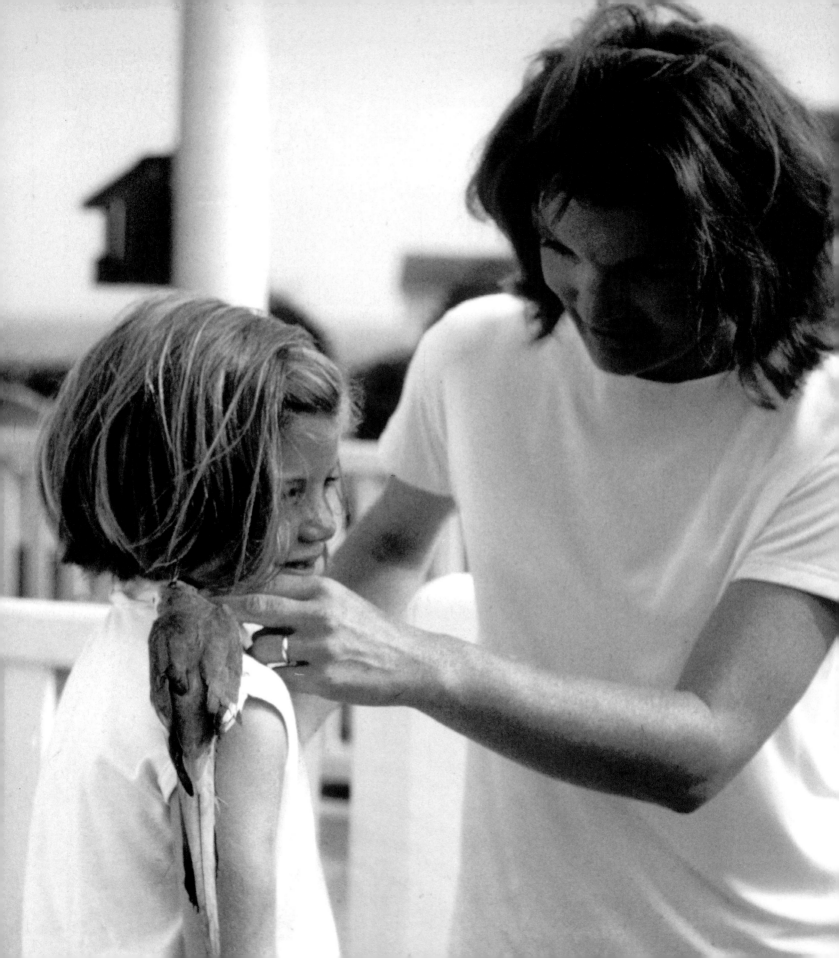

(above) Like her mother, Caroline loves horses. Here she's hanging on to Leprechaun, the pony she received from Ireland's President Eamon de Valera. Earlier, she had taken a tumble and broken a small bone in her wrist. Hence, the bandage. *(opposite)* Caroline shows her bandage to Uncle Bobby.

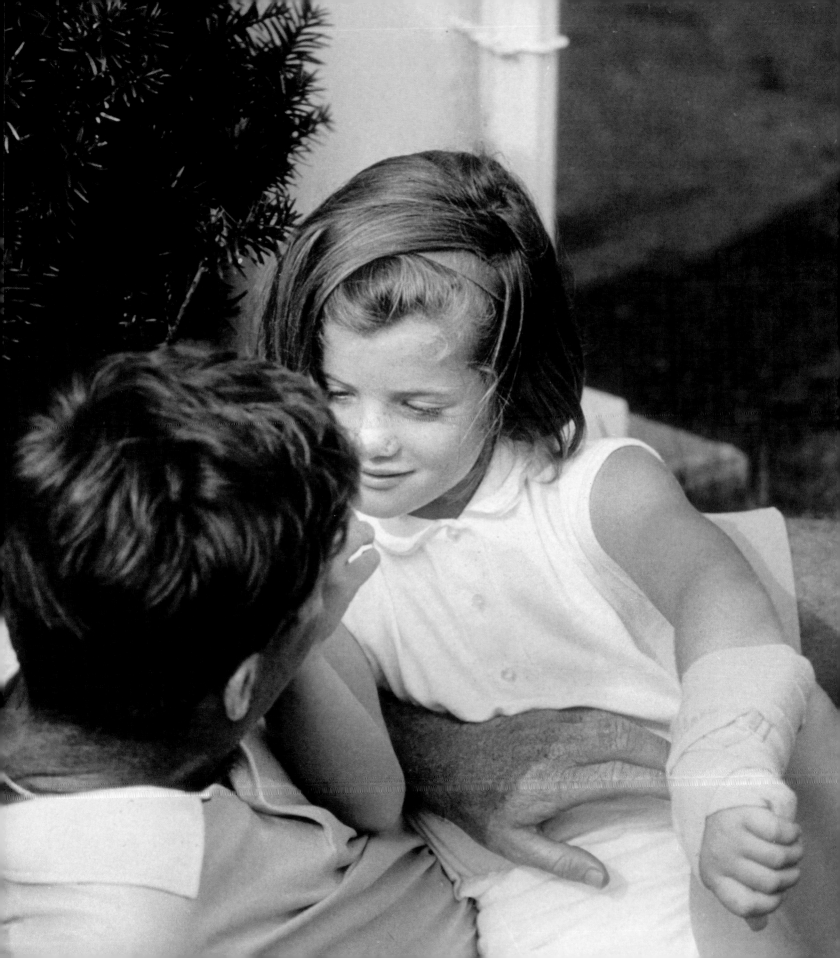

FOLLOWING JACKIE'S ANNOUNCEMENT that she would fly to London for the Queen's dedication of the JFK Memorial at Runnymede, Stanley suggested that he go along to make a personal record of the trip for her while photographing the story for *Look*. She agreed, after making him promise not to chase her all over like other photographers. He agreed, and to his regret, he kept his word. His diary of the experience reveals the tensions that can develop when a photojournalist becomes too committed to his subject.

> May 13, 1965:
>
> First thing bright and early I checked to find out what Jackie was going to do. Her assistant [Pamela Turnure] said: "Oh, I don't think she's going to do anything— she's going to rest in the house all day. She has no plans but if I hear anything I'll let you know."

Stanley took a walk later in the day and bought an evening newspaper that revealed his first missed photo opportunity:

> Spread all over the front pages were pictures of Jackie's morning walk with John and Caroline and the Princess [Lee Radziwill] and her children at the Changing of the Guard. Decided it was time to stop going through Pam.

Stanley made arrangements to cover the dedication ceremony the next day.

> May 14, 1965:
>
> The British in their handling of the press are very efficient…but hard-nosed. I decided I would stay by the memorial stone and then I would sneak behind and go up on the stand, which they claimed I wasn't supposed to do.

When John, Jr., saw Stanley approaching the stand to take his picture, he pointed to him and started laughing. Watching the playfulness going on behind the Queen's back, Bobby could barely suppress a smile.

In a simple ceremony Queen Elizabeth bequeathed an acre of land to the American people as a memorial to the assassinated President "whom in death my people still mourn and whom in life they loved." The Queen recalled JFK's close ties to Britain— his days in London, where his father served as the ambassador to the Court of St. James, his book on the prewar crisis (*While England Slept*), his brother Joseph P. Kennedy's death over the English Channel as a wartime pilot, and his sister Kathleen, the Marchioness of Hartington, who was buried in England.

(left) Former Prime Minister Harold Macmillan speaks of President Kennedy during the Runnymede dedication. Behind him, to the right, Senator Edward M. Kennedy, [unidentified man], Lady Harlech, Sen. Robert F. Kennedy. Front row: Lord Harlech (David Ormsby-Gore), British ambassador to the United States during the Kennedy administration and a close personal friend of the President. Between Harlech and Mrs. Kennedy is John, Jr., pointing his finger at Stanley as he took this photograph *(right)* Queen Elizabeth, Lord Harlech, Caroline Kennedy, Jacqueline Kennedy, and John F. Kennedy, Jr.

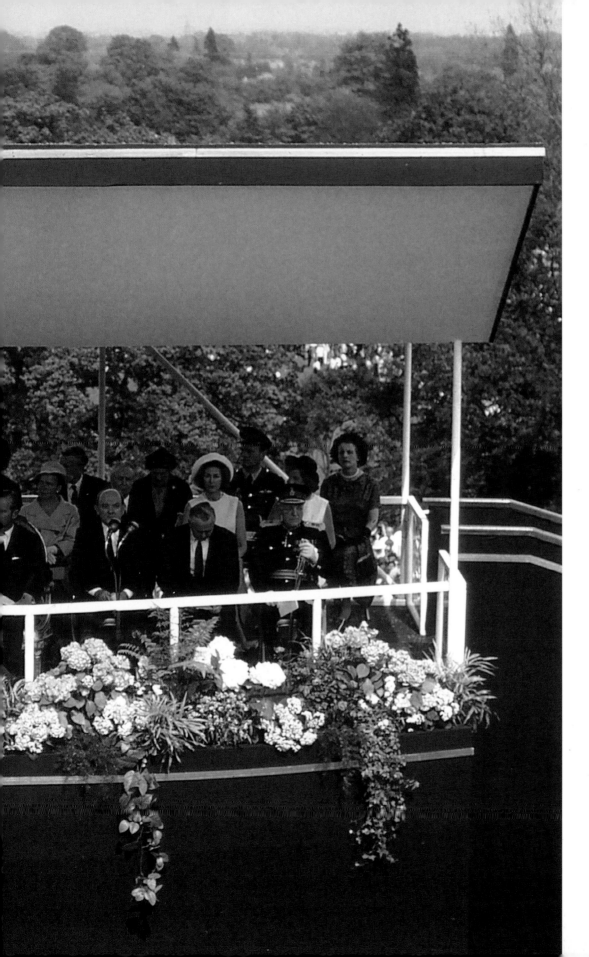

The official viewing stand for the dedication by Queen Elizabeth II, who bequeathed one acre of British soil at Runnymede, England, to the American people May 14, 1965, as a memorial to the assassinated President "whom in death my people still mourn and whom in life they loved."

Jackie did not make a speech at the Runnymede ceremony, but released a statement of thanks to the British people:

My husband loved history and what you have done today in his honor would please him more than my words can express. He had the greatest affection for the British people for what you have accomplished down through the ages in this land and for what you present around the world. Your literature and the lives of your great men shaped him as did no other part of his education. In a sense he returns today to the tradition from which he sprung. To the British people and the John F. Kennedy Memorial Trust, I express the deepest gratitude of the people of the U.S. For my part I thank you for making it possible for me to be here today with my children. One day they will realize what it means to have their father honored at Runnymede. To all of you who created this memorial I can only say it is the deepest comfort to me to know that you share with me your thoughts that lie too deep for tears.

After the Runnymede dedication, Stanley trailed Mrs. Kennedy to Windsor Castle for tea with Queen Elizabeth, who would not allow photographs. He followed her to a cocktail party at Lord Harlech's apartment, but was told the apartment was too small for photographs, and two days later he accompanied her to a luncheon at former Prime Minister Harold Macmillan's country estate where he was told photos would be inappropriate.

Following the luncheon Macmillan led his guests on a tour, pointing out the bedroom where JFK had stayed after his April 1963 trip to Ireland, a trip the President made without his wife, who was pregnant at the time.

May 16, 1965:
Because President Kennedy had slept there the house held a lot of memories for Jackie. She fell into a very low mood...and I realized that I was in for some real trouble as far as getting pictures.

The next day Stanley called Nancy Tuckerman, who had flown to London to take over from Pamela Turnure:

Nancy said Jackie was going to stay in bed all day, that she didn't feel good and that Jackie had reached another of her really low moods where nothing was right and you couldn't ask her any questions. Nancy explained this to me and said she couldn't talk to her either, everything was negative.... Later Nancy called and said Mrs. Kennedy said she was very upset again and I seemed to be jinxed [on getting pictures] and she didn't think she and the children would do anything else and there was no use to my staying in London anymore....

Fed up, Stanley fired off a "Dear Jackie" letter, which he characterized to his editor as "nasty." While candid and direct the letter was in no way disrespectful. He said that in keeping his word not to chase her he had lost all photographs to the chasers:

I know that in the eyes of my editor at the moment I look very bad. However, that's not your problem....

He told her that the real story of the Runnymede memorial was not the royal dedication by the Queen, but the small group of people Mrs. Kennedy had personally invited to London for the occasion:

I have talked to several of them about how this dedication has revived their strongest memories of the President.... I think this part of it would make an excellent story that you yourself should write on just why you chose these people to accompany you.

Her guests included: the late President's two brothers, Robert F. Kennedy and Senator Edward M. Kennedy; his sisters, Patricia Kennedy Lawford and Jean Kennedy Smith; his former White House aides, Dave Powers and Ted Sorensen; and Mrs. Kennedy's half-sister, Janet Auchincloss.

Stanley then vented his frustrations:

My sense of history is as strong as yours, and I think that my magazine has shown you in the past that we can treat a subject like this in the best taste and with the most impact.

May 18, 1965:

At 10:30 A.M. I got a call from Jackie personally. She said she had just read my letter and was very sorry about everything and thought that my story suggestion was very good but she really didn't want to write it personally.... I said I'm not getting anything and I'm trying to play ball with you but I get <u>screwed</u> every time [his emphasis]. She agreed with me again and said she was in a very low mood and the children were cranky and not doing anything more than going to school with the other children.... After another long agonizing discussion I decided that there was no more sense to this whole trip and I'd call my editor to see if I could go home. He said to keep plugging ... so I cancelled my plane reservation, called Jackie back and said she wasn't getting rid of me so easy.... She seemed in a better mood. She told me she was going to visit Dame Margot Fonteyn's husband, Roberto Arias, and that if I didn't follow her and went out on my own that I could be an accomplice of hers and then it wouldn't look like she's taking her own private photographer.

(opposite) The Macmillans invited Jackie and her Runnymede guests for lunch, May 16, 1965, at their country home, where President Kennedy had stayed after his trip to Ireland. *(above)* Teddy Kennedy, Jackie, and Bobby Kennedy share a laugh during a private cocktail party hosted by Lord and Lady Harlech in London, May 14, 1965.

[Jackie] also said that Caroline and John were going riding in Hyde Park and I could go there too and that maybe by then they would all feel better. "After all, having pictures taken is like playacting, you know, and we'd all have to get ready and look good and feel good in order to do the best job."

I told her I just had to get something on her to fill the story out or I had no story and she said, "Well, if they want you to stay, why don't you just stay and have a good time in London and buy china and things?"

Stanley was beyond irritated by Jackie's "frivolous suggestion" that he shop for china, but his wife thought it was a great idea, so they went to Thomas Goode and bought a full service of gold and ivory Minton, which Stanley always referred to as his "Jackie plates."

May 19, 1965:
Woke up this morning with the attitude of "No More Mr. Nice Guy to the Kennedys." I called the house [where Jackie was staying with her sister, Lee Radziwill] and talked to Lee, who was in a bad mood as they'd been up late the night before and she had a hangover.... Lee called back and apologized for being in a bad mood, said why don't you come over ... for Bloody Marys ... then she asked if I'd go with her and make a photo with her drama coach in case we wanted to do a story on the beginning of her acting career.... Jackie was going to Ambassador Bruce's residence for dinner that night, so on the off chance I asked her maid to ask if I could photograph her in her formal attire. Jackie sent word back, turning this down cold.

May 20, 1965:
I learned from the Secret Service that Caroline was going to a ballet school with Tina Radziwill and thought this might make a sweet picture. Put in a request through Nancy to photograph Caroline at the school. Word came back Jackie says absolutely not.... At this point I had really reached my last straw. It just seemed to me that it was very degrading to chase after somebody who doesn't want to be chased and particularly since I've had a rather close relationship with her, I felt I was going to ruin what was left of that and also I was getting pretty mad at her myself.

(above) The JFK dedication at Runnymede was Caroline's and John's first trip to London. Here John, Jr., plays with his cousin, Christina Radziwill, and her cat at the Radziwill's home in Buckingham Place. *(left)* Caroline Lee Bouvier Canfield (first husband) Radziwill, Jackie's younger sister, frequently described as "the pretty one." She enjoyed being called "Princess" during her marriage to Radziwill, a Polish prince who lived in London.

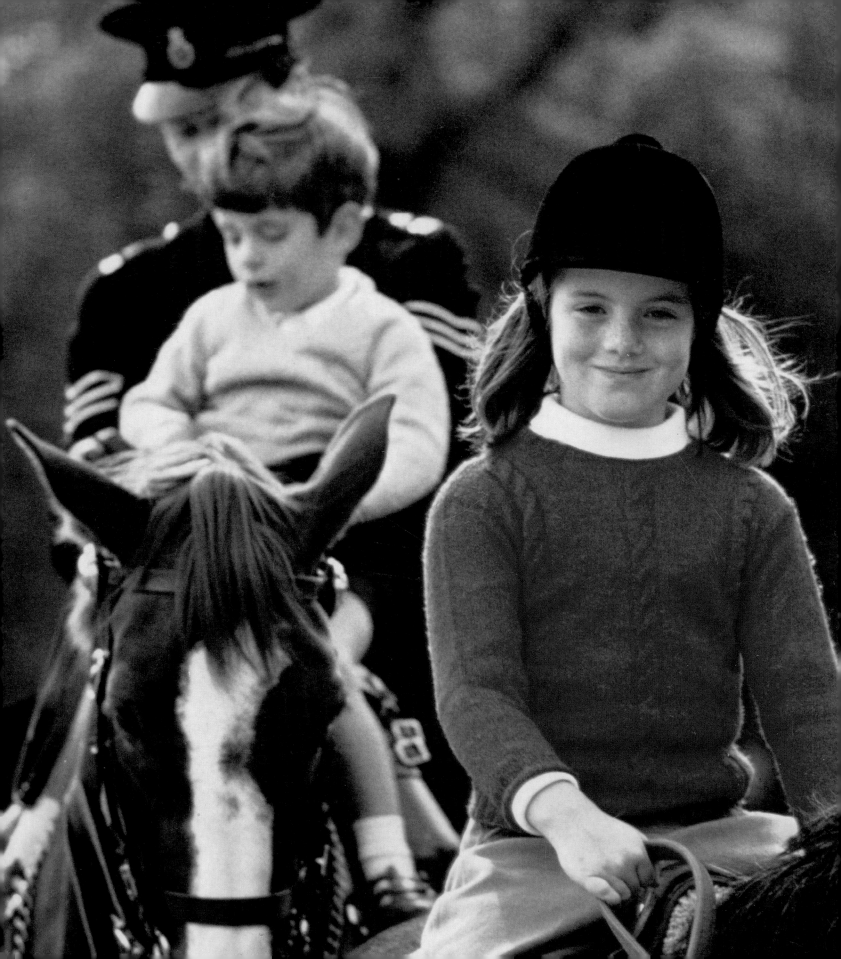

May 21, 1965:

Nancy called and said the weekend was absolutely out. Jackie doesn't want any more photographs made—that she was going away at least for Saturday and just didn't want any more pictures taken. That did it for me but I decided to go to Rotten Row in Hyde Park to photograph Caroline and John and the two little Radziwills, Tina and Anthony, riding…When I arrived on the scene all four children ran to me yelling my name and throwing their arms around me. The warmest welcome I've had from anybody in that family. At least the children were glad to see me.

The children's Secret Service agent, John Walsh, was extremely cooperative about the pictures and was only concerned about one thing and asked me not to make pictures of John crying. He said Mrs. Kennedy doesn't like that. (What does she like?)

John got on the horse with Caroline, which looked like a cute picture. Caroline in my judgment is getting very pretty and looks quite lovely in her riding outfit. I believe she's going to be very much like her mother. I had this exchange with Caroline, 7, which I thought was rather interesting. Mr. Walsh wanted John to get on the horse with her to pose for a picture. Caroline objected to this and said she didn't want John on her horse. I went over to her and told her that she didn't have to have him on her horse if she didn't want to, that she didn't have to do anything she didn't want to for photographs. I think she was a little surprised at this and then said, "Well, I guess John can get on my horse." So John got on…but he has allergy to horses and his eyes itch when he gets near them.

I called my editor, who said I could finally come back home, and so I called Jackie to say good-bye. She said she was sorry that a lot of things hadn't worked out.… Then she closed by saying she hopes she and I would always be friends.

Later in the day John goes horseback riding with his sister, Caroline, in Hyde Park.
Interest in the late President's children continued around the world.

MRS. JOHN F. KENNEDY

Jan 5, 1965

Dear Stanley

Admit that you never took such action packed photographs in such vibrant color in all your career!

And to think that you couldn't work the flash Brownie at John's birthday —

Who looks the most pleased with the little helicopter — you or John?

I send you all my wishes for a Happy New Year — As ever

Jackie

JACKIE INVITED STANLEY TO JOHN, JR.'S fourth birthday party in November 1964 at her New York penthouse. Stanley arrived in a suit and tie and presented "Irving" with a battery-operated toy helicopter that the youngster wanted to fly immediately. Stanley sat on the floor with him, trying to assemble the batteries while Jackie took their picture like the Inquiring Photographer she had been for the *Washington Times-Herald* when she first met the young senator from Massachusetts.

Jackie sent the birthday photos to Stanley with a note on the black-rimmed stationery she used during her year of mourning:

> Dear Stanley,
> Admit that you never took such action packed photographs in such vibrant color in all your career.
> And to think that you couldn't work the flash Brownie at John's birthday.
> Who looks the most pleased with the little helicopter—you or John?
> I send you all my wishes for a Happy New Year—
> As ever, Jackie

A few months later Caroline wanted pictures of herself with her father so Jackie asked Stanley if he would send all that he had taken in the White House. He responded:

> Dear Jackie,
> Tell Caroline that just as the pictures show—her father loved her very much.
> It is such a nice tribute to me that she should request them and I am happy I was there to record these precious moments.
> My very best to you and the children.

John F. Kennedy, Jr., celebrated his fourth birthday, November 24, 1964, at his mother's Fifth Avenue apartment in New York City. Knowing the little boy's love of airplanes, Stanley brought him a toy plane and sat on the floor to help him assemble it. Jackie photographed them and later sent her two pictures to Stanley with a personal note on the black-lined stationery she used during her year of mourning.

STANLEY CONTINUED COVERING the Kennedys for *Look* and in 1967 he accompanied Jackie, Caroline, and Sydney Lawford to the Carlton House in New York City to see Jamie Wyeth's portrait of JFK. Scion of the noted illustrator N. C. Wyeth and the acclaimed artist Andrew Wyeth, Jamie was only twenty years old when he painted the portrait, which Jacqueline Kennedy hoped would hang in the White House as her husband's official portrait. When she first saw the painting she burst into tears. Caroline said, "Daddy looks like he's in a meeting."

"Mrs. Kennedy loved the portrait," Stanley recalled, "and could not get over how much it was like her husband, even saying that it was almost as if Jamie had known him—the eyes were slightly bloodshot and they were always like that. Caroline told Jamie that on the way over in the car she asked her mother if she thought she would like the portrait and Mrs. Kennedy said no, she didn't think she would like it at all. Mrs. Kennedy was a little embarrassed when Caroline said this and admitted that that was true."

Jackie returned the next day to look at the portrait again, and told Jamie that she was anxious to have Bobby and Teddy see it. In fact, she said, she wanted the whole world to see the portrait. She wanted it to hang in the White House and she also wanted it on the cover of every magazine. However, Bobby Kennedy did not like the portrait at all. He felt it portrayed the President as he had looked during the Bay of Pigs, the biggest political disaster of his administration. (Shortly after that debacle Stanley was photographing the President as he looked at the Rose Garden, which had been designed and landscaped for him by Jackie's friend Rachel "Bunny" Mellon. Turning away from the window, Kennedy said: "That will probably be the greatest accomplishment of this administration.")

Bowing to Bobby's wishes, Jackie commissioned Aaron Schickler to paint her official White House portrait as well as her husband's. The Wyeth portrait remained in the artist's private collection and was exhibited at the John F. Kennedy Library.

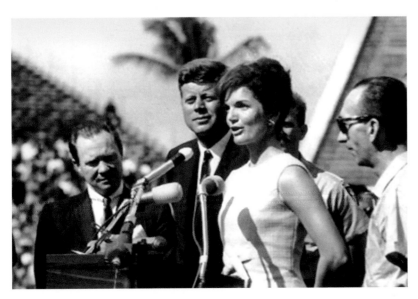

(above) Painter Jamie Wyeth in his studio at Chaddo's Ford, Pennsylvania, looks at Tretick's photos of JFK. (left) Before a crowd of 40,000 in Miami, December 29, 1962, the First Lady addresses in Spanish the 1,113 Bay of Pigs prisoners ransomed and airlifted out of Cuba. "It is an honor for me to be here today with a group of the bravest men in the world," she said, "and to share in the joy that is felt by their families who, for so long, lived hoping, praying, and waiting."

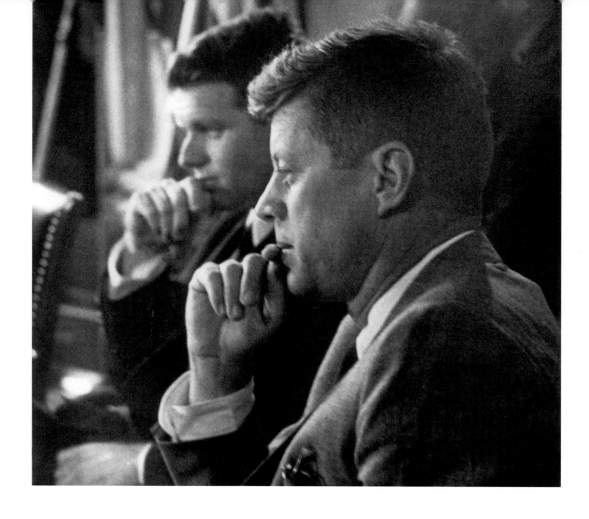

S TANLEY REMAINED CLOSE TO
the family, especially to Bobby. Their relationship had developed years earlier,
even before his brother became President. Stanley had covered Bobby when he
served as counsel to the Senate Labor Committee from 1957 to 1959. (During
the hearings, Johnny Dioguardi, one of the mobsters subpoenaed to testify, took a swing
at Stanley, which made front-page news. Stanley was disgusted, but only because he missed
taking the picture himself.) For the next decade he covered RFK: as his brother John's
campaign manager in 1960; as attorney general 1961 to 1964; as U.S. senator 1965 to
1968; and every day of his twelve-week campaign for President.

Like all those who loved the Kennedys, Stanley wanted to see Bobby inherit the
mantle of his brother, and with others he encouraged him to challenge President Johnson
on the Vietnam War, but the senator was afraid of the political backlash.

In November 1967, after Bobby said he would not step forward, Senator Eugene J. McCarthy (D-Minnesota) announced his candidacy and galvanized the growing antiwar movement in the country. After McCarthy nearly won the New Hampshire primary in March, Bobby saw how vulnerable Lyndon Johnson was on Vietnam. Four days later he jumped into the race, causing a divisive split among Democrats—"doves" who supported McCarthy, "hawks" who supported the President, and others who supported Kennedys. Two weeks after Bobby announced he was running for President, Lyndon Baines Johnson announced he would not seek a second term.

(above, left) Jacqueline Kennedy remained close to her husband's family and lent her charisma to her brother-in-law, Robert, when he ran for the U.S. Senate in New York. Here she helps him host a Christmas program, December 16, 1965, for the children of the William Hodson Community Center in the Bronx. *(above, right)* Jacqueline Kennedy and her daughter, Caroline, attend the christening of Robert Kennedy's ninth child, Matthew Maxwell Kennedy, January 17, 1965, at St. Patrick's Cathedral in New York City. Kathleen Kennedy, 13, the eldest of RFK's children, holds the baby.

February 9, 1966

Dear Stanley:

It is with the deepest appreciation that I write thanking you for the time and effort you have devoted to the oral interviews for the John F. Kennedy Library.

Your contribution will -- in future years -- be of the utmost importance to those compiling a history of the President's Administration, and I shall always be grateful to you for the part you have played in this project.

Sincerely,

Jacqueline Kennedy

Mr. Stanley Tretick
4101 Cathedral Avenue, N. W.
Washington, D. C.

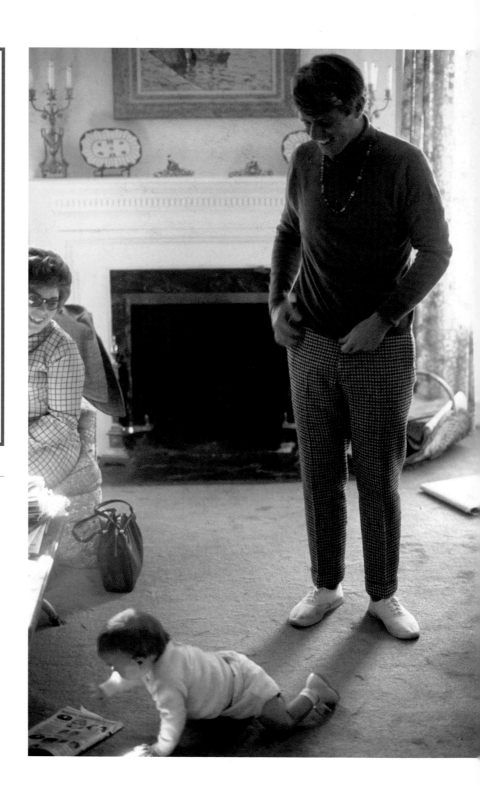

(above) Jacqueline Kennedy worked on behalf of the John F. Kennedy Library in Massachusetts, which under her direction, amassed over 1,000 oral histories of the President's time in office. (right) Bobby Kennedy, wearing the hippie love beads in vogue in 1968, watches his youngest child, Douglas, crawl across the living room at Hickory Hill.

S TANLEY BELIEVED BOBBY COULD win the nomination, despite the fact that most of the delegates to the Democratic National Convention would be pledged to Johnson and his vice president, Hubert H. Humphrey. Sensing an historic campaign, Stanley proposed a story he had envisioned doing for JFK's reelection campaign: an intimate portrait of how a candidate pursues the presidency—win or lose. He told Bobby the story required unrestricted access and Kennedy immediately agreed, giving Stanley and *Look*'s Washington correspondent

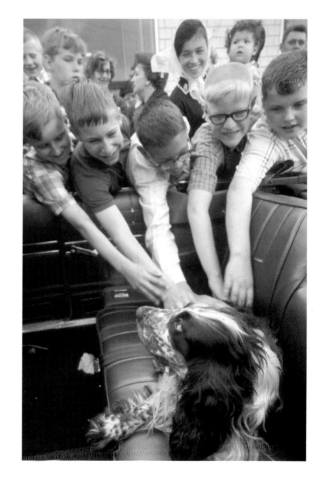

Warren Rogers something no journalists had been given before. The photographer and the reporter were allowed to walk lockstep morning, noon, and night with the candidate through the campaign as if they were personal staff, seeing and hearing everything with nothing held back. For the next eighty-five days and nights Stanley and his cameras became as much a part of Bobby Kennedy's life as Freckles, his dog with the droopy ears (see right).

Amassing thousands and thousands of pictures, Stanley photographed the candidate in motorcades and parades engulfed by smiling faces, grasping hands, and surging crowds, waving signs that read "Camelot Again." He showed him skiing and skating and sailing; with children and nuns and celebrities and Native Americans and Chicanos, all cheering and screaming. He photographed him comforting African Americans in riot-torn streets after the assassination of Martin Luther King, Jr., and standing shoulder to shoulder with César Chávez as he organized farmworkers.

"What you really are is a revolutionary," Stanley told him. "I know it," said Bobby.

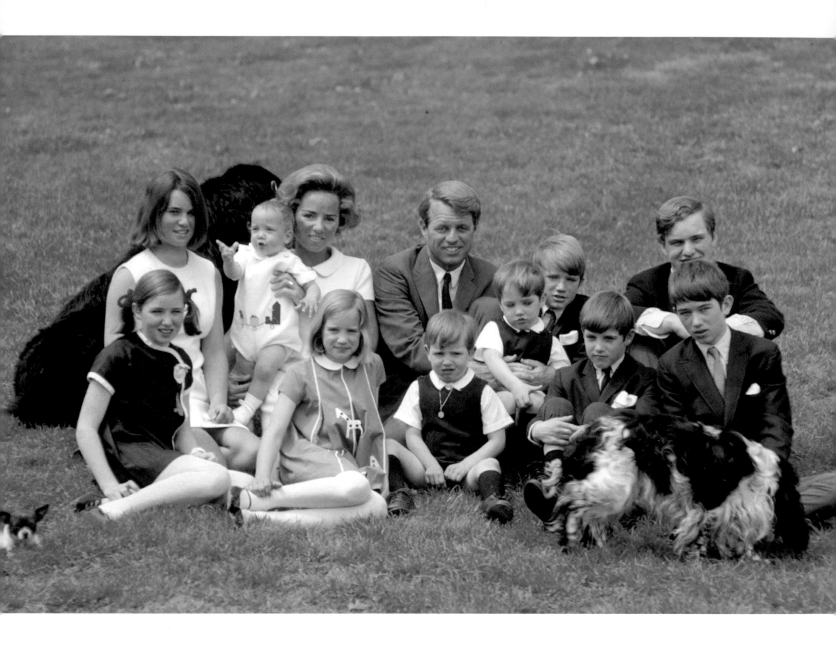

Dogs and children surround RFK and his family on Easter Sunday, 1968, at Hickory Hill, their Virginia estate. Back row: Kathleen, 17; Brumus (black Newfoundland); Ethel holding Douglas Harriman, 1; RFK; David Anthony, 13; Joseph Patrick II, 16. Front row: Mary Courtney, 12; Mary Kerry, 9; Christopher George, 5; Matthew Maxwell Taylor, 3; Michael LeMoyne, 10; Robert Francis, Jr., 14; Freckles (Springer Spaniel). Picking up the mantle of his brother, Robert F. Kennedy announced his candidacy for President, March 16, 1968, in opposition to the war in Vietnam.

O N J U N E 4 , 1 9 6 8 , T H E N I G H T of the California primary, Stanley joined the Kennedys and their huge contingent of friends and aides at the Ambassador Hotel in Los Angeles to watch the primary returns. Winning California was crucial to the candidate, who had positioned himself as the heir apparent to the White House, especially since he had lost the Oregon primary to McCarthy a few days earlier. That was the first time a Kennedy had ever been defeated in a political campaign. It was considered such an upset that it triggered a *Washington Post* headline: "Oregon Shakes Kennedy Myth."

When the California primary results came in shortly after midnight and showed a 4 percent win over McCarthy, jubilation erupted in the Kennedy suite. As Bobby headed for the Embassy Room to join his supporters and celebrate his victory, Stanley photographed him from behind walking down a long hallway, not realizing that it would be their last photograph. Not long after midnight on June 5, 1968, an assassin's bullets felled the senator, who died the next day, capping one of the most violent years in U.S. history.

Stanley was one of several newsmen asked to stand vigil by Kennedy's coffin at St. Patrick's Cathedral in New York City. He was invited to attend the funeral and ride the train carrying RFK's body to be buried alongside his brother, in Arlington Cemetery. Stanley then returned to *Look* with Warren Rogers to help lay out a special issue entitled "The Final Private Hours: The Bob Kennedy We Knew."

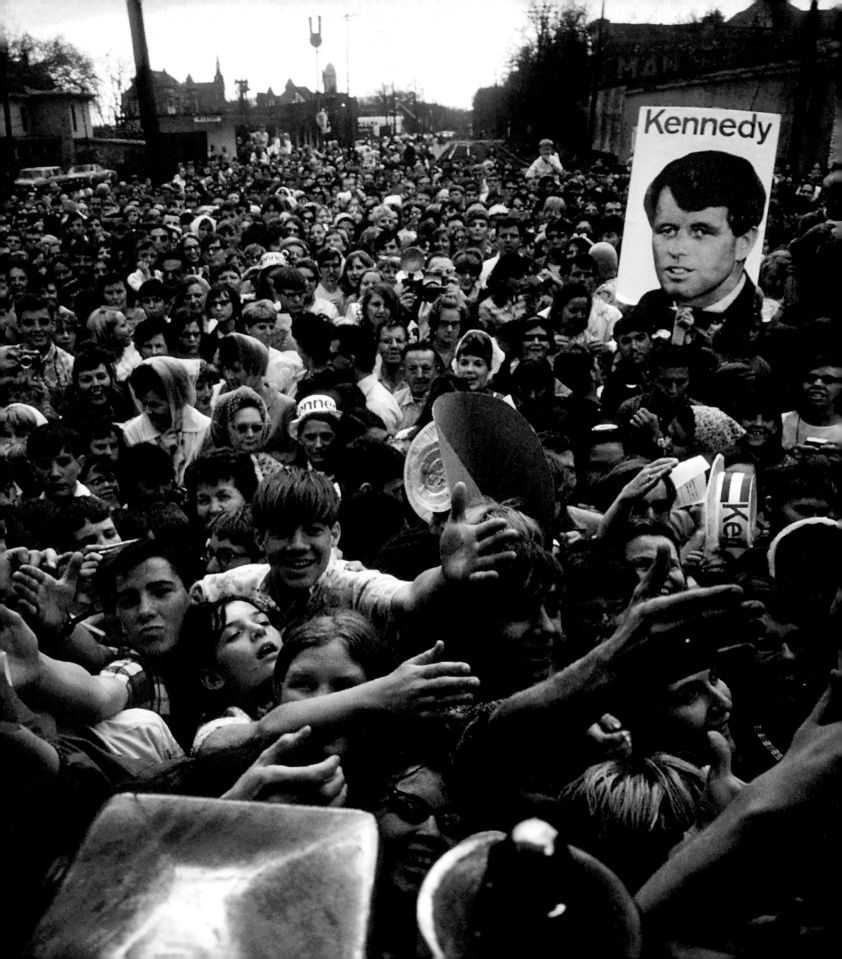

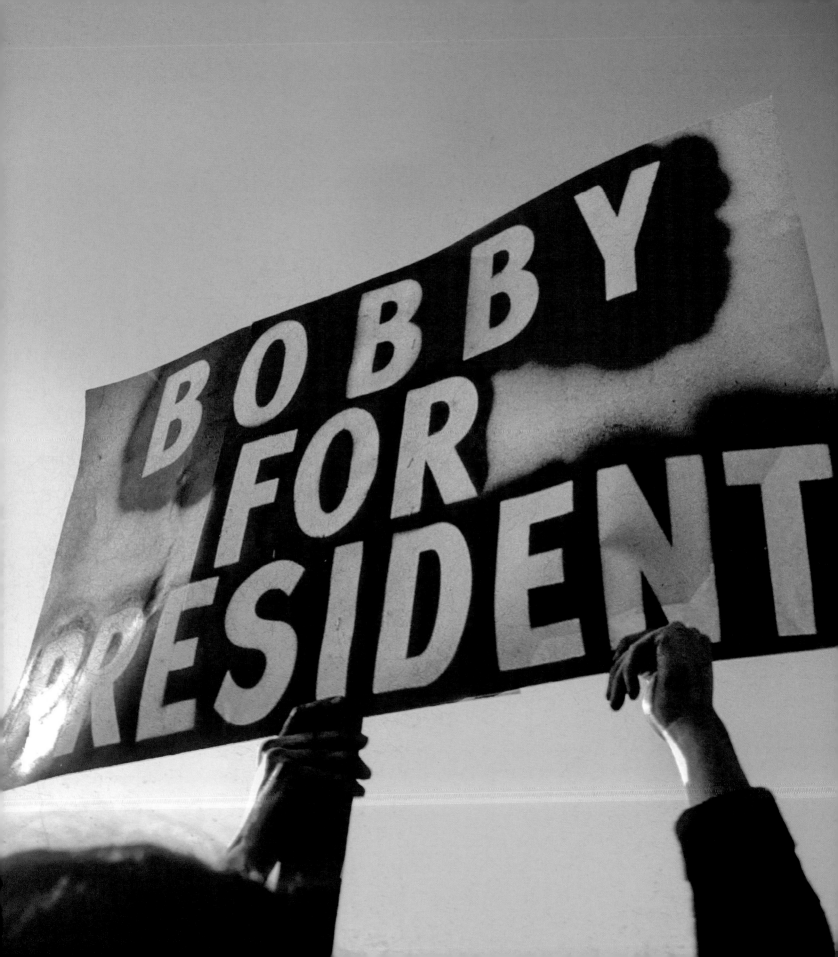

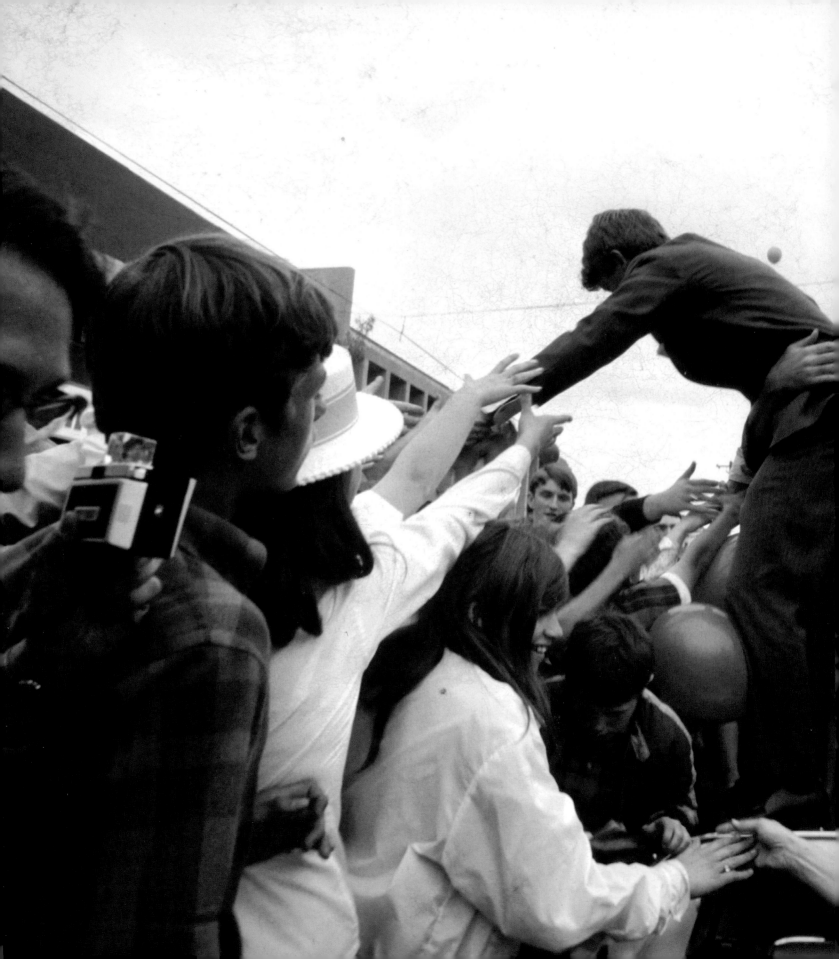

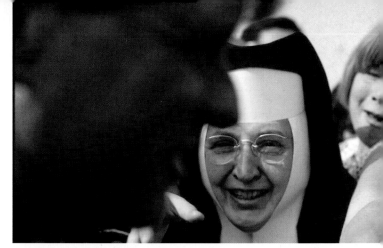

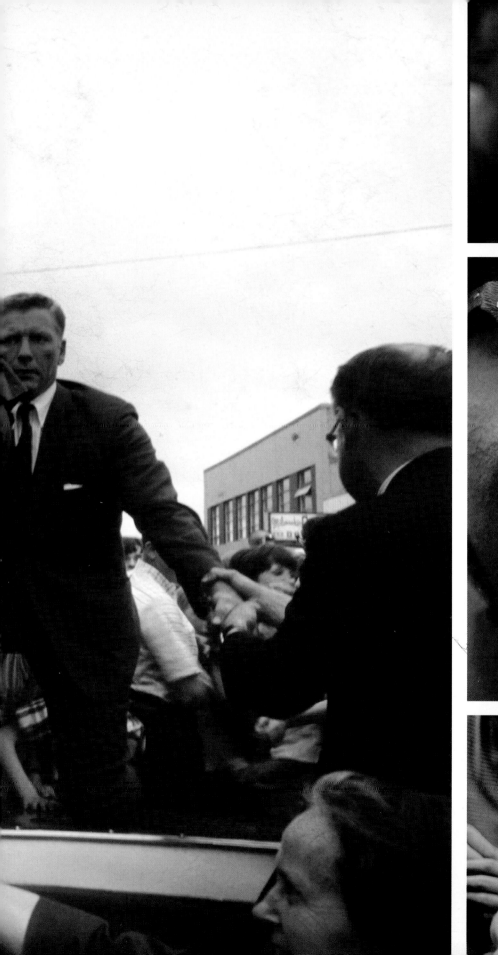

* * *

"This is the last photograph I ever made of Bobby
Kennedy as he walked down the hall from his suite
in the Ambassador Hotel on the night of June 4,
1968," Stanley wrote on the back of this image.

"A day later he

would be dead from

an assassin's bullet."

* * *

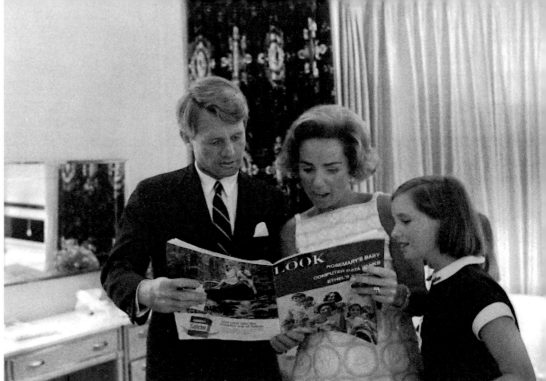

THE SECOND KENNEDY ASSASSINATION, following that of Martin Luther King, Jr., two months before, numbed the country, which had to relive the horror of yet another leader being gunned down, this time leaving behind a widow pregnant with her eleventh child.

The next week *Look* appeared on newsstands with a cover story on "Ethel Kennedy and Her Children at Hickory Hill," written by Laura Bergquist and photographed by Stanley. It was a sad irony of timing, just as had happened days after JFK's assassination when *Look* had been on the stands with a cover story by the same writer and photographer entitled "The President and His Son."

"It was never planned," said Stanley of the eerie coincidence. "It was just a function of our long lead time. In those days it took six weeks to get a story into print."

Robert Kennedy's death left a tragic mark on his family as some of his children succumbed to drugs and alcohol. His eldest son would be involved in an accident that paralyzed a woman for life; one son died of a cocaine overdose, another in a skiing accident. Divorce would rack the devoutly Catholic family and scandal upon scandal would follow, eventu-

Bobby, Ethel, and Courtney Kennedy, June 4, 1968, in the Ambassador Hotel, Los Angeles, waiting for the returns of the California primary and looking at the *Look* cover story Stanley had photographed.

ally choking the presidential hopes of the last remaining brother, Senator Edward M. Kennedy.

"A lot of people lost their way for a while," said Stanley, who was so slammed by the assassination that he took a four-month leave of absence. During that time he emptied the bullets of his Marine Corps revolver into the Potomac River. He returned to work about the same time Jacqueline Kennedy announced she was leaving the country to marry the Greek billionaire Aristotle Onassis.

The following year Ethel Kennedy planned a memorial folk mass for her husband at his grave site, where her children held a banner that read: "Happy Are the Dead Who Die in the Name of the Lord." She invited three hundred guests to attend and join her later at Hickory Hill for drinks and dinner. She included family, friends, and campaign aides, as well as JFK's Irish mafia and his widow, the newly married Mrs. Onassis, but she disinvited the person her husband had wanted to be his official White House photographer.

"When I put together the photos for the RFK memorial issue, I had included one of Bobby riding the shoulders of Roosevelt Grier [former tackle for the N.Y. Giants and the L.A. Rams], which I had taken at a party at Hickory Hill," Stanley recalled. "Bobby was wearing Rosey's thick glasses and horsing around, having a helluva good time. I included it because it showed his sense of fun and high spirits. But Ethel hated the picture because she said it made Bobby look 'undignified.' She insisted Frank Mankiewicz call me to say I was not allowed to go to the memorial mass. I think it killed Frank to make that call but he had no choice. It was very hurtful to me and things were never the same after that. . . ."

Hickory Hill became famous for the Kennedys' celebrity parties. *(above)* Bobby wears Roosevelt "Rosey" Grier's glasses as he rides the former football player's shoulders. This photograph appeared in *Look*'s memorial issue of RFK and angered Ethel Kennedy because she felt it made her husband look "undignified." *(below)* Teddy and Bobby sing Irish songs with Rosey Grier.

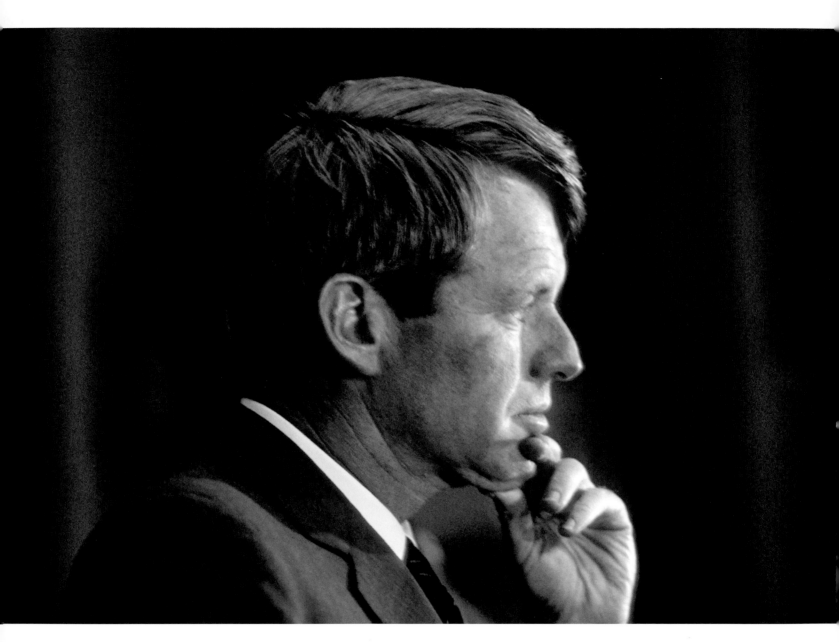

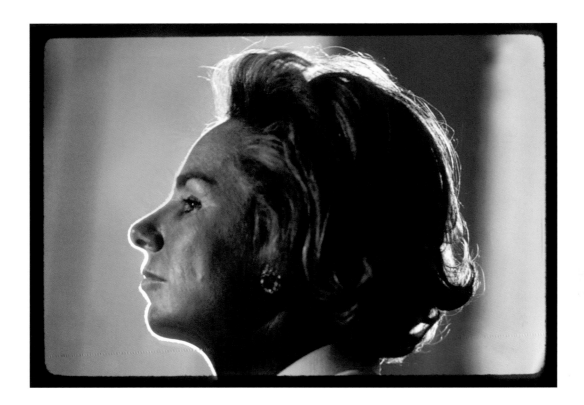

L OOK STILL CONSIDERED STANLEY
to be the best photographer to assign to the Kennedys, and until the magazine
went out of business in 1971 he produced several Kennedy cover stories, including
profiles on Senator Edward Kennedy and his wife as well as Rose Fitzgerald
Kennedy, the family matriarch. He continued covering politics, but no longer with the
personal commitment he once had. After Jimmy Carter's presidential campaign, the
President-elect offered him the job of White House photographer, but Stanley declined.
He said he didn't think Carter would give him the access required to do the job effec-
tively, but it may have been that Stanley no longer had the heart for the White House.

(opposite) **Ethel Kennedy selected this photograph by Stanley Tretick for the RFK memorial
stamp issued in 1979.** *(above)* **Mrs. Robert F. Kennedy, 40, gave birth to their eleventh child, Rory,
six months after the assassination. Never remarrying, Mrs. Kennedy lived at Hickory Hill until she
sold the estate in 2010 and moved to Hyannis Port.**

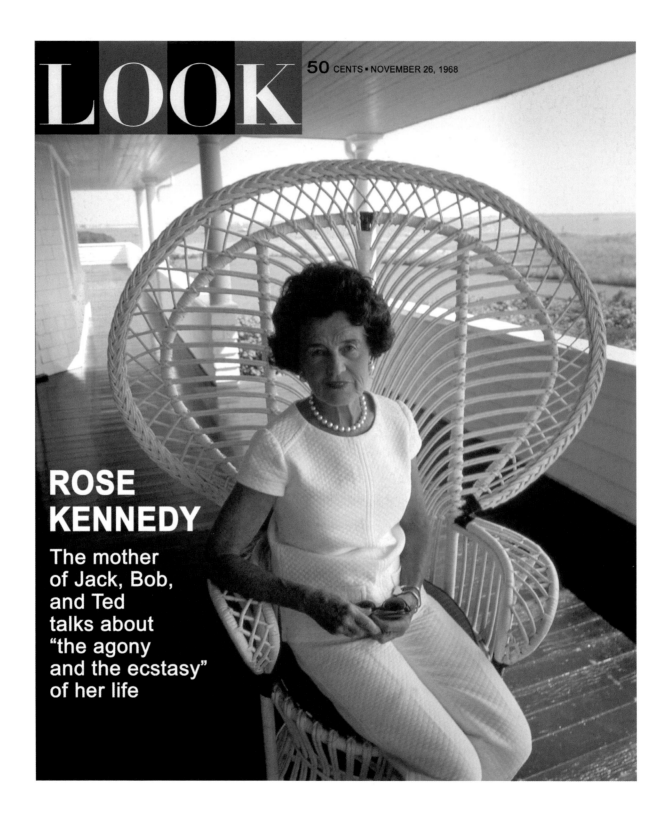

LOOK

50 CENTS ▪ NOVEMBER 26, 1968

**ROSE
KENNEDY**

The mother
of Jack, Bob,
and Ted
talks about
"the agony
and the ecstasy"
of her life

After Ambassador Joseph P. Kennedy's death in 1969, his widow, Rose Fitzgerald Kennedy, reigned as the family's matriarch until she died in 1995 at the age of 104. A devout Catholic, she attended daily mass for most of her life, and appeared regularly on the annual list of America's most admired women.

**HYANNIS PORT
MASSACHUSETTS**

November 13, 1968

Dear Mr. Tretick,

 May I thank you again for the time
and efforts you devoted to the assignment
for the photographs for the Rose Kennedy
Story.

 Every one who has seen the article has
been most enthusiastic about the pictures
as well as the story. I realize the success
was due to your patience and perseverance
as well as to your unusual talents in the
field of photography.

 My renewed thanks to you, dear Mr.
Tretick, for the very moving photograph
of our beloved son, Bobby, which you sent
me last month. I cannot gaze upon it too
long. The sense of urgency which he per-
sonified and which you captured in such a
superlative way overwhelms me.

 Very sincerely,

 Rose Kennedy

 Mrs. Joseph P. Kennedy

Mr. Stanley Tretick
LOOK MAGAZINE
825 National Press Building
Washington, D.C.

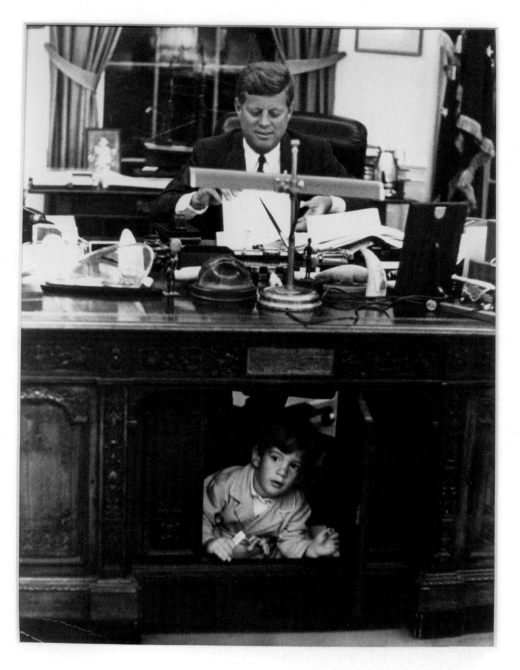

To Stanley
With best wishes.
John Kennedy

IN 1974 STANLEY HELPED RICHARD
Stolley launch *People* magazine and worked in the Washington bureau until he
suffered a debilitating stroke at the age of seventy-six. At that point I stepped
in to care for him, not simply because I had his power of attorney, but because
he meant so much to me.

I had hoped he might be able to stay in his house in Washington, D.C., but his
physical condition demanded round-the-clock medical care. So I tried to find the best
place for assisted living, but even the highest-rated facility with landscaped grounds and
sunny patios is still, as Stanley himself once put it, "just a way station until the end of
the road where the woodbine twineth."

Yet, I wanted to make his way station as cheerful as possible, so I moved in a few
of his belongings to make his room feel warm and familiar. There was nothing I could
do about the hospital bed, the hospital gown, and the hospital food, but I could
fill the barren wall. So I began looking through Stanley's photographs to find
something happy, and was struck by the enchantment of the little boy playing
under his father's desk in the Oval Office.

> "WHEN I SHOVE OFF THAT'S
> PROBABLY *the* ONLY SHOT
> I'LL BE REMEMBERED FOR."

Even Stanley had known that photograph was his most famous, having once
remarked, rather mordantly, "When I shove off that's probably the only shot I'll be
remembered for."

John Kennedy, Jr., was then thirty-seven years old and editor in chief of his own
magazine, *George*. I wrote to him in hopes he'd remember Stanley and sign the famous
photograph for me to hang in his room. He graciously agreed, saying he remembered
Stanley well. He signed the mat in silver metallic ink and I hung it on Stanley's wall hop-
ing it would make him smile.

IN JULY 1999 I GOT THE CALL
THAT STANLEY'S TIME WAS RUNNING OUT, AND
I HURRIED TO BE WITH HIM AT THE END.

Sitting on his bed, holding his hand, I looked up at the muted television and saw the search-and-rescue operation being conducted for John Kennedy, Jr., whose plane had gone down the night before in the cold waters of Cape Cod. I looked at the picture on Stanley's wall, taken when he and the President and his young son seemed as fresh as morning and so full of promise. Now the photographer was slipping away at the same time as his most famous subject.

Days later John Kennedy, Jr., was buried at sea, and Stanley's ashes were placed in the Columbarium at Arlington National Cemetery, not far from the Kennedy grave sites and the glow of the eternal flame.

Photographer A. Stanley Tretick, 77, Dies

Took Celebrated Images of President Kennedy and Family for Look Magazine

By Claudia Levy
Washington Post Staff Writer

A. Stanley Tretick, 77, the former Look magazine photographer whose intimate portraits of President John F. Kennedy and his children are among the classic images of American photojournalism, died July 19 at the health care center of Asbury Methodist Village in Gaithersburg. He had suffered strokes.

Mr. Tretick's picture of John Kennedy Jr. as a toddler, peering out from a small door in the front of the presidential desk, has had a poignant return to the news in recent days, as searchers looked for Kennedy's missing plane.

A month before he was assassinated in Dallas, the president invited Mr. Tretick to the Oval Office to photograph the children. The two men had conspired to wait until Jacqueline Kennedy was out of the country, according to ——— Kitty Kelley, Mr. Tre——— friend.

"Jackie ———
the ———

happ———
and St———
Kelley ———
not have ———
is a refrain ———
er between ———

In the year———
death, Mr. T———
accompany Mr.———
children on trips———
al pictures for Lo———

Mr. Tretick was born in Baltimore and raised in Washington, where he lived for most of his life. ———s a graduate of Central High ——— He was trained as a photog——— by the Marine Corps and ———ed in the Pacific during World ———II.

———r. Tretick worked early in his ———er for the Acme News Service ——— for The Washington Post, ———re he was a copy boy. He joined ———ed Press around 1950 and was ———gned to battlefield coverage of ——— Korean War. Later assignments ———ded Capitol Hill and presi——— al campaigns.

———e left what had become United ———s International for Look to cover ——— e Kennedys in 1960 and con——— d with the magazine until it ——— d in the 1970s. After that, he ——— a founding photographer of ———le magazine. He retired in ——— as a contributing photogra———

———addition to his news work, ——— appeared in Life magazine ———ther publications, Mr. Tretick ———pecial still photography for ———than 30 movies, working with ——— n Beatty, Robert Redford, ——— Hoffman and others. He did ———ork for movies that included ———he President's Men," "Reds," ——— Candidate" and "Electric———man."

——— also contributed photo——— s to three books, "A Very Spe———-——— dent" about Kennedy, ——— the King," ——— M. Nixon ——— Portrait of ——— the story

———DISCOVER ——— f the White ———phers Asso——— an Society of ———
——— ges to Doro——— een Tretick ———vivors include ———retick of New ———
———ign of ———

Stanley Tretick, 77, Photographer Of Kennedys at the White House

By NICK RAVO

Stanley Tretick, the Look magazine photographer known for his intimate pictures of the Kennedy White House, including one of John F. Kennedy Jr. as a toddler playing under his father's desk, died yesterday at a nursing home in Gaithersburg, Md. He was 77.

The cause ——— pneumonia, said the au——— Kelley, a close fri——— ded that Mr. ———pacitated for ———fter several ———

———ened over ——— re he was ——— d of the ——— dy in a ———yard. ———aphs ———

Stanley Tretick

———dent Jimmy Carter to become Mr. ———l photographer. ———d an inti———man. ———around ———ter———

Fotog famed for JFK pix dies at 77

By RITA DELFINER

Stanley Tretick, the former Look magazine pho——— of John F. Kennedy Jr. as ——— the touching photo ——— youngster peeking th——— from under his father's Oval Office desk, died ——— nursing home. He was 77.

That candid shot of the youngster peeking out ——— panel of the desk while his father ——— looked at papers overhead was ——— taken in October 1963, just weeks ——— before President Kennedy was as——— sassinated.

The president had invited Tre——— tick — who took many family ——— shots during the Kennedy White ——— House years — to come pho——— graph young John and Caro——— while his wife, Jacqueline ———
away on a trip.

Tretick also captured ———
in other unforgettable ———
including JFK driving ———
filled with Kenned——
Kennedy as a presi———
date, standing on ———
car with hands r———
touch him.

The photographer later c———
Robert F. Kennedy's 1968 pre———
dential campaign and snapped ———
the famous shot of him standing ———
——— in Baltimore, Tretick, a ———
———ne with his arms crossed. ———
———ine, worked at several ———
———covering the Ko———
———ton.

MILESTONES

———nt Anwar Sadat. A deft handler of ———y different factions in his country, ———mong them Islamic militants, the charismatic ruler was said by Moroccans to have baraka, or blessedness. Hassan, who had been ill for several years, will be succeeded by his son Crown Prince Sidi Mohammed, 35.

DIED. STANLEY TRETICK, 77, photojournalist who captured the iconic image of an almost-three-year-old John F. Kennedy Jr. peeking out from underneath his father's Oval Office desk in 1963; after several strokes, three days after the death of his famous subject, John Jr.; in Gaithersburg, Md.

———tegrating liar." A Republican appointee, Johnson always insisted he was simply upholding "the supremacy of the law."

After the m———
nedy fam———
1970s, he becam———
founding photographer in———
magazine. He retired in ———
———hearings, in which he had so ———
———gered a gangster named Johnny ———
Dio that Mr. Tretick had to duck ———
when Mr. Dio swung at him. He got ———

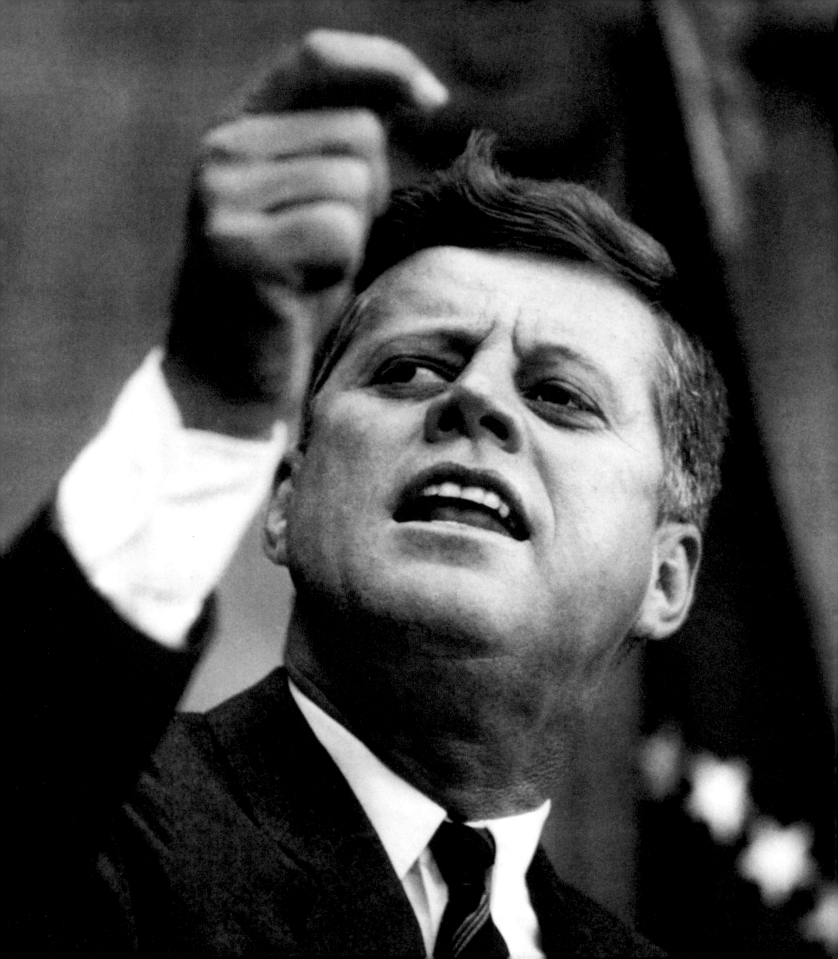